Confessions of a {Female} Chauvinist

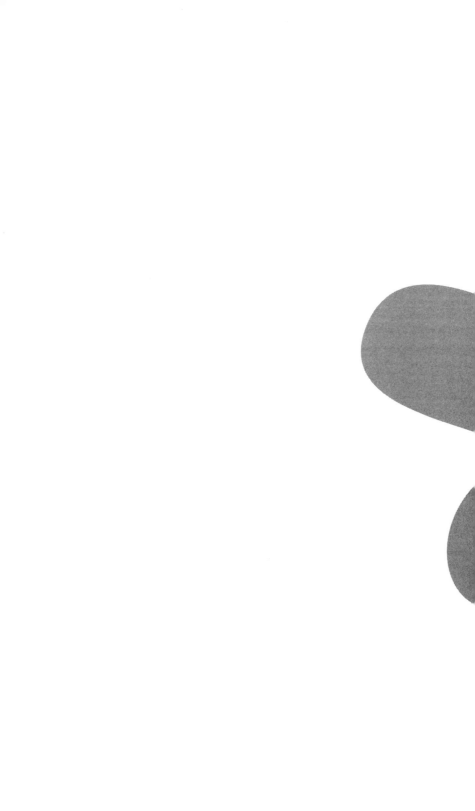

Rosemary Daniell

Confessions
of a
{ *Female* }
Chauvinist

d

HILL STREET PRESS
Athens, Georgia

A HILL STREET PRESS BOOK

Published in the United States of America by
Hill Street Press LLC
191 East Broad Street, Suite 209 Athens, Georgia 30601-2848 USA
706-613-7200 info@hillstreetpress.com www.hillstreetpress.com

Hill Street Press is committed to preserving the written word. Every effort is made to print books on acid-free paper with a significant amount of post-consumer recycled content. / No material in this book may be reproduced, scanned, stored, or transmitted in any form, including all electronic and print media, or otherwise used without the prior written consent of the publisher.

Copyright ©2001 by Rosemary Daniell. All rights reserved.

Text and cover design by Anne Richmond Boston.

Printed in the United States of America.

Library of Congress Cataloging-in-Publication Data

Daniell, Rosemary.
 Confessions of a (female) chauvinist / by Rosemary Daniell
 p. c.m.
 ISBN 1-58818-033-6 (alk. paper)
 1. Women—Southern States—Social conditions. 2. Man-woman
 relationships—Southern States. 3. Southern States—Moral conditions. I. Title

 HQ1438.S63 D36 2001
 305.42'0975—dc21 2001016769

ISBN # 1-892514-033-6

10 9 8 7 6 5 4 3 2 1

First printing

Endsheet photos:

Top row (L to R):
In her Savannah, Georgia, apartment, 1981; in her backyard in Atlanta, Georgia, circa 1968; Atlanta, circa 1972; at work in Atlanta, circa 1970, the year "The Feminine Frustration" was published

Middle row (L to R):
With cowboys in Wyoming, 1993; Savannah,1992, courtesy of Jim Holmes; with James Dickey, far right, and other writing group members at Dickey's house in Atlanta, 1963; writing in Savannah, 1984, courtesy of Jane Creech

Bottom row (L to R):
At her desk in Savannah, 1981; in her office in Savannah, 1983; posing for Timothy Ward, Savannah, 1985, courtesy of Timothy Ward; with Zane (Timothy Ward), in Savannah, circa 1983, courtesy of Bud Lee

All photos courtesy of the author, except where noted.

For Laura, Darcy, Anne, Lia,
and all the glorious women of Zona Rosa

—may the Inner Bitch live!

The words *risk* and *risque* have the same French etymological root.

"Until you lose your reputation, you never know what a burden it was, or what freedom really is."
—Margaret Mitchell

Wild Women Don't Get the Blues

Contents

Foreword

In seventh grade at Bolton Grammar School, my teacher—a Yankee—took me aside to tell me that I shouldn't get married young like the other girls. She told me that I had a special quality—flexibility—which meant that I would be able to be with all kinds of people. Naturally, I thought she was an old fogey, and planned to marry as soon as possible. When she told me I was talented, I spent my creativity on drawing plans for the house with round rooms and glass floors with goldfish swimming beneath them I hoped to share with my boyfriend Troy and our six children.

As an eighth grader at West Fulton High School in Atlanta—surrounded by tougher girls who smoked, knew how to apply black eyeliner, and looked like they already knew about sex—I wrote that I wanted to be a missionary or a dancer. Though I had had hints as to my destiny as a writer—indeed, Mother, a frustrated writer (and later a suicide), had laid my role out whole cloth—I still imagined infinite choices. I would become a missionary of sorts, though of language and ideas, and definitely not the kind Mother or the Baptist Church would have approved.

A decade later, as a young wife and mother of three, in the grips of an agonizing identity crisis cum postpartum depression, I began a journal in which I examined the rules with which I had grown up: Was God as punitive as the Baptist preacher, red-faced, exhorted? Was marriage as sacred as Mother and

Grandmother said? And how important was it, really, to follow The Rules?

When I fell in love with modern poetry via a continuing education class at Emory University, I thought I had found salvation. I would simply continue writing about the birds in my backyard, the kids on their swing sets, and baking lemon meringue pies in my Betty Crocker kitchen while my young architect husband laid out the zoysia grass in perfect squares. My poems would be the place where I could write my truths; and writing them well would keep me safe.

But as often happens, my search for truth was soon to make life more perilous. I could no longer remain the docile wife and mother I had been; divorce was in the air, and I needed to make money. The first time I was assigned an article by the *Atlanta Magazine* (on the newly instituted Georgia Arts Council), I referred to a book Mother had bought for one dollar at Davison's Department Store on Peachtree Street; *Writing Made Simple* was an oversize paperback with chapters on how to write an article, a short story, a novel, a play, and so on; in each case, the process was broken down to its simplest elements. Then, following my instincts, I typed up my interviews and ideas, and, as my three kids watched, cut the pages up, arranging stacks on the carpet according to subject, then scotchtaped them together again to create a sequence, a method they would watch me use for article after article after I came home from my job as an advertising copywriter. Then I wrote and rewrote, holding myself to the same standards I used for poetry. (Indeed, that was how I did my "real" work, too: I would type up alternative images and stanzas, then lay the taped yellow sheets of the poem in progress out on the bed, asking the kids which versions they liked best.)

At first—the product of a mother who had been taught that the

use of the word "I" was improper, egotistical—I wrote "objectively," leaving myself, and my reason for my interest in my subject, out. Later, as I began writing more directly out of my own experience in my poetry, I began putting myself into my essays as well.

I was already known for my nosy questions, and as a journalist, I now had an excuse to ask them. The tolerance for ambiguity imprinted on me by my Southern roots also stood me in good stead, allowing me to look at a subject without having made up my mind in advance. Though I never thought of the articles as my "real" work—that was still the poetry—the pieces were not unlike the rest of my writing, springing from my particular way of looking at the world and/or some burning imperative. I would feel a magnetic glow resonating around an idea, maybe someone I had read about, and find myself picking up the phone to call an editor. Or else, as in the case of my stint on an offshore oil rig, I would find myself in a situation that begged to be put into words. For I was also a sensation seeker, willing to experience the new, even the unpleasant or dangerous. I had learned over the years that when I felt afraid of something, *that* was exactly what I should do; like the novelist Colette advised, I was in the habit of saying yes to everything.

(Even when I demur, I am torn: once I reluctantly declined an invitation to drive through Guatamala and war-torn Nicaragua, into Costa Rica, in a convertible with an Indiana Jones-type on the advice of an ex-Special Forces pal who wrote for *Soldier of Fortune*—even he thought it was too dangerous—making the excuse that I had agreed to write an article on deadline. But I felt my gut wrench over my craving for adventure and my desire not to have an M-16 in my face. And I had a pang a few weeks later when I received a letter saying that I had "missed a great trip . . . got stopped by guerillas in the jungle. . . .")

"The two things people think they need but don't are security and defenses," an Atlanta psychiatrist once said to me in passing in an elevator. In Zona Rosa, the creative writing groups I lead for women, I ask the participants to list all the things they think they have to have, then cross off as many as they can. "Security" and "comfort" ("I couldn't believe all the things you didn't have," a woman said after subletting my apartment while I went away to teach) had long been crossed off my list, along with "approval," which is often the hardest one of all for women to give up.

Yes, people often got mad at what I wrote, but such censure rolled off my back. What was real was the stress of taking the risks, of "the shock of the new;" of sleeping in unfamiliar beds while pursuing interviews with people who didn't want to talk; of dealing with places and rules with which I wasn't familiar, with none of my usual support system around me. "I was amazed at the insecurity of your life," a Junior Leaguer from South Carolina said after interviewing me for her magazine. But what she may not have realized was how driven, obsessed—and therefore happy—I was.

Indeed, what I recall about these pieces is not the writing, but the experiences behind them. Like a visceral memory, the stresses of certain moments, some of which were mercifully masked at the time by a protective naiveté, or even denial, were imprinted on my very cells. "You're wearing *that?!*" my art director pal exclaimed, staring at my homemade wrap-around burlap dress, its neckline gaping to show a bit too much bosom, the day I left the advertising office where we worked to go to the huge corporate offices of Coca-Cola to interview—in the presence of company lawyers—the executives a woman chemist and interviewee for "The Feminine Frustration" had accused of sexual discrimination. But they had agreed to an interview, and my dress was the last thing on my mind—what *was* first was getting the story.

Even the women oil riggers I met while writing "Magnolia Among the Mesas: A Southern Woman Out West," were amazed to learn that I was driving all over Wyoming, from Rock Springs to Gillette, in a rental car by myself. When the piece first appeared (in *Playgirl*), I was on yet another jaunt out West, researching my book-in-progress, *Sleeping with Soldiers,* (research that would also include a trip alone to a Soldiers of Fortune convention in Charlotte, North Carolina); and picked my copy up at a 7-Eleven on the way to Jackson Hole.

And before my pal Madge and I left by helicopter for our first stint on the oil rig—a job we considered a lark—we had hysterical phone calls from boyfriends and family members: "You'll be gang-raped and thrown overboard!" my adult daughter protested via long distance—and within days I would be having moments when I would wonder if she was right.

To cover Ginny Foat's trial, I had to contend with hostility from Foat and her attorney, Tsenin, as I had just turned down their offer to tell Foat's book-length story—told her way. "We can't talk to you now, you're part of the press," Tsenin growled on the first day of the voir dire. After the piece was published (in *Mother Jones*), readers wrote objecting to the purple boots I wore to the trial.

Before I wrote "How to Be a Belle without Traveling South of the Mason Dixon Line: Some Things I Learned from My Mother, A Costa Rican Hooker, and a Few Others," I said yes to an invitation to visit San Jose from a man I had only met through letters; it turned out to be a trip during which I would be the only non-prostitute North American woman in the Park Hotel for eighteen days, during which time I would be driven to the Nicaraguan border (a war was going on), taken to a contra refugee camp in a bullfight ring, and strip-searched before being allowed into a prison to interview would-be contras.

"You're going over there alone?" my downstairs neighbor, an attorney, asked as I left my apartment to interview Jim Williams about the Danny Hansford case in his mansion six blocks away for "The Scandal That Shook Savannah;" and it was indeed disconcerting to sit with Williams in his huge house, watching him pull out a German Luger to show me exactly how he had shot Hansford, then to hear his story of self-defense. It was at his house, still on the story, and at a dinner during which we ate with Hitler's flatware (a part of Jim's collection of Nazi memorabilia) that I met John Berendt, who was newly arrived in the city. After dinner, the guests repaired to the parlor, and the gentlemen opened their jackets to compare sidearms, "Did you see that?" John said to me over the phone the next day; "They had guns!" By then, I had been living in Savannah too long to notice. But I did notice when John called a bit later to say, regarding my article, which Jim apparently didn't like, that Jim said he had "met people in jail who could take care of me" (ironically, as Emily Banister, Danny Hansford's mother, had dropped out of Zona Rosa, where she had been writing Danny's story, because she thought I was colluding with Jim Williams by writing the article.)

When I went to Fort Bragg to write "The Invasion of Fort Bragg"—my interest in the military titilated by my new lover, Zane, a paratrooper in the 82nd Airborne—I was at first amazed at the cooperation given me by the public information officer in setting up interviews. But then I did a few interviews on my own, and when *Us Magazine* sent their photographer down to Fayetteville for photos, the Lt. Colonel, CID, a tough-looking woman in camouflage fatigues, refused to be in the same picture with Molly, a Thai, and the most popular topless dancer at Rick's Lounge on Hay Street (Molly appeared in a picture alone, in skimpy "professional" costume).

After "Blood, Heat and Mayhem: A Memoir," was published, I received a copy of a letter of censure by five-time Savannah mayor Johnny Rousakis; never mind that the now-defunct, but Pulitzer-Prize-winning *Georgia Gazette* had already exposed Rousakis' administration as being a hotbed of illegal gambling and prostitution. By the time I wrote "Why I Like Tough Guys (The Real Kind)," I knew enough about blue-collar men—even men at the extremes of testosterone poisoning—to be able to travel among the classes, even in an intimate relationship, with relative ease. Besides, Zane, now my husband, was the real thing, not the psuedo-macho man my once-lover James Dickey had been; when I came to write "The Deer Who Love to Be Hunted: A Reflection on James Dickey's Women," I felt fortunate that I had escaped—and compassion for the women who had not.

And how did my children react to their mother's vision? My daughters have long known me as a female chauvinist—and thus their partisan. My adult son, on the other hand, called the morning CNN News was sending a crew to Savannah, after the publication of "The Pill and Me: Before and After," to interview me on the fortieth anniversary of the Pill. When I explained that I couldn't do the favor he wanted and why, there was a long pause on the line. "Why can't you just be normal?!" he said before hanging up.

I could have explained to him that what he meant by "normal" would have meant my turning into the self-sacrificing "nice" woman I had spent a lifetime determined not to be ("if you can't say something nice, don't say anything at all," is a mantra repeated throughout these pages—and *not* because I agreed with the sentiment). That my mother, his grandmother, a talented writer in her own right, had worshiped "normal," and it had led to her suicide. That breaking taboos—especially those taboos that

had held Mother and the women like her clamped for so long into place—was what I was about.

And was it worth it? Yes.

Rosemary Daniell
Savannah, Georgia
November 2000

The Deer Who Love to Be Hunted:
A Reflection on James Dickey's Women

S*urviving a Powerful Man.* Women who give up their work and life—sometimes literally, often to their detriment—to share a man's vision are legion.

William Burroughs shot his spouse, drunkenly thinking to shoot an apple off her head. Norman Mailer stabbed—though not fatally—one of his wives. In her memoir, Claire Bloom confirmed everything I had always suspected about Phillip Roth, revealing the inequities of living in proximity to the prolific author. In her later years, Simone de Beauvoir, author of the glorious *The Second Sex,* revealed, to her followers' disappointment, her subservience, even unto pimping for Jean Paul Sartre. In *At Home in the World,* Joyce Maynard described her seduction and her treatment at age eighteen by fifty-year-old J.D. Salinger, a powerful man who demanded the teenager's isolation and adherence to a strict set of rules for living as proof of her love for him.

Claire Bloom and Joyce Maynard survived to continue in work of their own, and Simone de Beauvoir's accomplishment cannot be diminished. But to the disgust of some feminists, some women, such as Nabokov's wife, Vera, have been glorified in biographies of their lives—as though their purpose was as noble as the creation of the art itself. (A recent cartoon in the *New Yorker* shows a woman saying to her husband, "I just realized that if I just write all day, and you bring me my meals, it will be

1

just like I was at a writers' colony." And as every woman who saw that—and laughed—knows, the reason the cartoon is funny is because such a thing is so unlikely to happen—even though, as we women writers suspect, such a situation exists for male writers by the droves.)

I went to New York alone for the first time when I was a young poet in my twenties and visited artists' studios, hovels, and bars with Ce Roser, a glamorous painter who had been born in Hong Kong, had lived all over the world, and who I had the good fortune to meet in Atlanta, where her husband, a CEO, had been transferred. Ce had made one kind of trade-off—her well-off husband supported her, much as diarist Anais Nin's husband had supported her endeavors, including the studio she kept in Manhattan, through the years. But I noticed: many of the wives and women of the painters we met had once had the same aspirations, the same talents. Yet now, they were struggling to care for babies, to work as waitresses—each, to protect her man's creative space, rather than her own.

Many women artists and writers are fools for love—and genius. Frida Kahlo hung in there with Diego Rivera, reconciling with him even after his affair with her sister, even unto his painting her sister's face into one of the murals that adorn the National Palace in Mexico City. Camille Claudel, at first Rodin's brilliant apprentice and lover, soon an accomplished artist herself, went mad, then was permanently institutionalized because of her obsession with him—a story vividly and poignantly told in the movie, *Camille Claudel*.

That such obsession is something artists oft indulge is portrayed in another biographical movie, *I Shot Andy Warhol:* Andy, gay, and basically relationless, is shown as being ultimately permissive, not caring who hangs out at the Factory, or what condi-

tion they're in; indeed, even feeding off the surrounding chaos—as in what psychologists call "an acceptance of inappropriate behavior." (In *Edie,* a biography of society girl Edie Sedgewick, a Factory afficianado who died of a drug overdose, Andy never once comments on her condition, or advises his "friend" that perhaps she needs help.) And on the very day Valerie Solanis, his disappointed groupie, and author of *S.C.U.M.*—Society for Cutting Up Men—will shoot him, he compliments her on looking nice: "Look! Valerie's wearing lipstick!" he says to his entourage as they go up in an elevator together, not knowing that the crumpled paper bag in her hand contains the weapon with which she will seek to kill him.

Perhaps the most vivid example of this kind of attachment is portrayed in the film, *Surviving Picasso,* the story of Françoise Picasso's life with her cruel and womanizing husband. At the time of their marriage, Picasso, played by Anthony Hopkins, had already used up Olga, Marie Therese, who had a child by him, and Dora Maar. At the time, he was still keeping the embittered and more worldly Dora Maar "on a string," as we say in the South, and Marie Therese was still faithful, writing to him daily of her love.

It was years into the marriage before Françoise realized that Picasso enjoyed—indeed, would set the scene for—his women to fight over him physically while he watched, only occasionally looking up from his painting. That the elegant Françoise would refuse to thus perform for him, as Marie Therese and Dora Maar had done in the past, would disappoint. "She'll be passive and submissive," Picasso pointedly tells Françoise of their infant daughter, "like a woman, like a mother, should be!" And as Françoise becomes stronger in her own right, he only becomes more outrageous in his behavior: already involved with Jacqueline, soon to be

the next woman in his life, the one who will be properly submissive (the lover whose face was already appearing in his paintings, just as Rivera's lover had in his), effacing herself at all times, he tells Françoise: "I come and go as I please, I sleep with whom I please."

While watching the scene in which Picasso toys with a man who has waited all day in an outer room hoping to be allowed to buy a painting, I suddenly knew who Picasso—the sneer on his face, the smile of pleasure at the man's discomfort—reminded me of—my first mentor in poetry, my paramour from the past, James Dickey.

Françoise turned out to be one of the lucky ones—one of those women blessed with a natural sense of self, of resilience, of her own talents, even in the face of genius.

And I was one of the lucky ones, too.

In 1961, as I sat among a small audience, listening to James Dickey read from his first book, I was transported, caught up in a near-religious trance. At the time I was newly in love with modern poetry, and, at a white-hot speed that had come to dominate my life, I was writing poems every day. I was also, as a young housewife with three small children, more naive than I would ever be again in my life.

But that naiveté was about to come crashing down, first as I sat at the Famous Southern Poet's feet, as his student, in the thrall to his every utterance (our little poetry group each paid him two dollars apiece to read our poems; he would carefully count the money before commenting); then later when, before I barely knew that adultery existed in the world, I became his lover. I was twenty-six, he was thirty-nine. He was a Greek God, and I was head-over-heels; after all, he had actually published a Book, and was the first living poet I heard read from his works, at Judy Alexander's little gallery on Peachtree Road. As I drove to our assignations, torn by

guilt and excitement, I felt that I was living in a dream. The very maple leaves on the trees that fell on Atlanta's Virginia Avenue glowed as though drenched in real gold. "You're a red-headed Marilyn Monroe, one of those people who look better naked than with their clothes," he said the first time we undressed to make love. I was too shy to ask why he had shaved the hair on his chest, something I had never before known a man to do.

This was just before the Pill, and I was about to indulge in what I now consider to be the Dumbest Thing I Ever Did for Love: for Jim insisted that our trysts be conducted sans birth control as a proof of that love—that if I bore a child as a result, it would be our secret love child, unknown to either of our spouses; and that I should let him know of this occasion via the formal notes through which we would communicate after he left Atlanta for further fame and points north and west. When I wrote him, I addressed him by his full name—Dear James Dickey—and gave my name on my return address as Mrs. Paul E. Daniell Jr., indicating my lower status as suburban housewife.

Blessedly, our encounters didn't take. But still in the grips of my romantic ideals, I wrote, "I do believe in the good purpose of fate, and the possibility of . . . fulfillment within a human life. Is that foolish of me? If there is any kind of happiness, it has to be on this side of consciousness, and I want so much to know all the pure, good, delightful things, be everything I can be, and ignore all the rest." Apparently I still imagined him to be the repository of all the above. And as long as I wrote in the masked way of which he approved—of nature and animals and the female as muse—he was supportive, slathering me with flattery, saying I would be a greater poet than he ever was. "The deer love to be hunted," he said, boldly hinting at his inherent cruelty toward

women. Not knowing my very toughness—indeed, our similari-
ties—would become my protection from him, his kind, he told
me I would have made a good pioneer woman.

But I was beginning to see the signs: in a prescient dream, he
leaned over me, wearing a big cowboy hat, and stole a line from
one of my poems and put it into his. Not long after, I opened the
Atlantic Monthly to see the title of my poem in progress, "Angel
Stud," in the middle of his long poem, "May Day Sermon."

"They're just shrill hysterical women who write about their
menstrual blood and throwing their abortions in a gutter," he
said, crudely dismissing the new women poets, among them
Anne Sexton and Sylvia Plath, when I told him how much I liked
their work. And when I began to write in a new, more direct way
myself, our paths diverged. "The woman has never truly been
known in poetry—she either says too much or too little," he had
said to me; and at that moment, I determined to become the first
woman poet who would say exactly what was right of women's
experience—still thinking to please him and my male mentors.
But now I began to wonder: who was Dickey—or any man—to
say what was true about women's experience?

"Though there is truth . . . in his remark, it is yet another quote
by a man on the writing of women, and part of the slippery,
almost inflexible, male-directed self image that the woman must
break down within herself before she can even begin to write. . . .
simply (adding) to the existing heaps of saccharine that concern
themselves with clouds, things made of silver, 'love,' and babies
who never defecate. . . .," I wrote in an unpublished paper, "The
Woman as Writer," in the mid-sixties.

As the years passed, Dickey went away and came back, each
time drinking more double martinis at lunch—and his ideas,
along with the big prizes he was winning for his poetry, became

more far fetched: he would have run for president if . . . or he could have played football for the NFL if. . . . My role was still to listen, to be enthralled; to participate in the scenarios he loved to see played out, such as having his secretary Brenda, who obviously had a crush on him, and me at the same drunken lunch. But it was a role I was finding impossible to play. His sexism had come to feel like a caricature, a predictable set of behaviors. I had been immunized, my backbone strengthened by my new feminism.

I was also ashamed of my part in Jim's treatment of his first wife, Maxine. At first, as his lover, I had felt superior; she looked as harsh, as insensitive as I had imagined—the cause I was sure of the poor man's infidelities. But I had been embarrassed, even in those pre-feminist days, by the dismissive way he had talked to her when I, and the rest of our little writing group, had visited their Atlanta house (Jim had published one book then.) "Brang me a drank, Baby," he said to her as though she were a waitress. "What do you think this is? A bar?" she snapped back before disappearing into the kitchen. I was shocked—I would never have spoken to my husband that way, and he wasn't even a Famous Southern Poet. The next day, he called. "Yuh left one a yore lil' white gloves hyah," he said fondly, "little" being one of those diminutives Southern men like to use with their women, and it seemed gallant to me, his younger paramour. But a splinter of doubt was already making its way deep into my brain.

I recalled with a pang the time when, a couple of years later, the Dickeys had come to a party at my house; how his and Maxine's sons—Christopher, pubescent, and Kevin, a little younger—had looked vaguely depressed; perhaps with the angst of kids being dragged around by their parents; but perhaps—and this was what bothered me—with discomfort at being taken to meet yet another of their father's mistresses? (Christopher, it

would turn out, would escape his dysfunctional home in the same way I had, via a teenage marriage.)

And there was a lingering anger on my and my sister poets' behalf. I saw Dickey's attacks on these women as attacks on freedom itself. For everywhere I went to read, I met other women who had been put down by male professors and poets, when they told their truths, wrote directly out of their real lives. And for a while, I saw such a South and its men as destroyers, even murderers, an image I had used throughout my first collection of poems, *A Sexual Tour of the Deep South.*

But the anger wasn't just for my sisters in poetry; it was for my mother and myself. In 1976, as I began writing *Fatal Flowers: On Sin, Sex and Suicide in the Deep South,* my story of my mother's life and death, and my own life as a Southern woman, I realized afresh that Dickey and men like him—would have approved Mother's repression, the "if you can't say anything nice, don't say it at all" attitude that had led to her suicide, and would have disapproved of any efforts she had made toward freeing herself. ("The only reason anyone puts someone on a pedestal," my Savannah therapist told me; "is to knock her off." Psychoanalyst Leslie Sanders described a similar theory: "A man would rather lose the woman than have his image of her changed.")

"You've got to control your anger!" my feminist editor said during a visit to Savannah from New York, looking at the yellow second sheets, the pages I had written about the Famous Southern Poet (as I called him in the book), strewn around my writing table in the front room of my little Victorian flat.

By the time of the book's publication in 1980, I felt that I had done so, letting irony do the work of conveying my rage. Still, the Semi-Famous Southern Poet, a Dickey protegee who also knew how to seduce, deceive, dissemble—skills learned at his master's

feet?—castigated me for "telling;" indeed, it was the woman who was supposed to beg the man not to tell, not to reveal her shame. The Madonna-Whore complex, the idea behind *The Stepford Wives,* was alive and well, and it was women's duty to keep its purveyors comfortable, at whatever price. That I had told the truth about how Southern men sometimes behave—thus bringing that behavior out into the open for other women to see, was unacceptable—because without women's shame and collusion, such behavior could just become impossible?

By the time Jim Dickey and I read on the same program at Georgia State University, he had become a part of my past. His crassness, his reputation with women, was by then well-known (my literary agent, a born and bred New Yorker, had been on an elevator with him, where he had said to her, a stranger, that she looked like she needed "a good fuck"). His keeper at Georgia State had handed him, already inebriated, into the chair next to me, thinking perhaps that I, a woman, might soothe and caretake him. And for a few minutes he looked deep into my eyes, or tried to, murmuring lines like, "Ah honor the past. . . . Do yuh know whut ah mean—ah honor the past. . . ." And when he drunkenly mocked me during my reading, I was barely bothered. I had no feeling left for him, I thought. For he had already become a cartoon in my mind. Or as Martin Amis wrote in his memoir, *Experience,* "a joke is an epitaph to a feeling."

I had a post-Dickey relationship with the Semi-Famous Southern Poet, who knew just how to apply some of the same "gut wrenches." And at last, I had learned—after numbers of affairs—to avoid such men altogether.

Still, I would occasionally have a stab of recognition, such as when watching the scene in the movie, *Surviving Piscasso,* in which I would suddenly know where I had seen the same sneer,

the same cruel, yet pleased glint, like a cat playing with its prey: on the face of James Dickey. Yes, I was lucky, I would tell myself again.

But as I was about to learn, other women had not been so fortunate.

When James Dickey died in 1997, thirty years after our affair, I was surprised to find him entering my dreams again—once, descending a flight of stairs in fluffy pink bedroom shoes. Now, a soft gel light, a diffuser fell over all, and, in the way of time, I began to recall the good—what I had learned from him as a poet, how I had loved his early poetry. He came to me in these dreams either as sad, disabled by his illnesses; or as a spirit guide in the realm of poetry. "Rosemary—where is my Rosemary?" a friend cited him as imploring at a last booksigning in Atlanta and I was pleased.

When *Summer of Deliverance,* Christopher's account of life with his father, was published, the book lay beside my bed, unread, for two years. I had read the reviews, the excerpt in the *New Yorker,* and that old anger had risen again: it appeared that Christopher and others blamed Deborah, Jim's second wife, for trying to "kill him" during his last years. Though I didn't know Deborah, and though she had telephoned me—both of them on the line, drunk and ranting—the idea that a woman would be blamed for Dickey's decline, when he had inflicted so much damage on other women, including his first wife Maxine, seemed to me to be ludicrous. This, I thought, would be like a female lion killing the old lion who has killed so many of her female kittens through the years.

At a booksigning after his death, Joyce Pair, editor and originator of the *James Dickey Newsletter,* came up to speak to me of her fondness for Deborah, to say how anyone would be driven crazy by living with Jim. Then her expression changed. "How

was he on a scale of one to ten?" she asked, her look letting me know what she meant. "Three," I said promptly, diffusing memories of a fifties-type guy who apparently knew nothing of the existence of the clitoris, or a woman's ability to experience pleasure (I hadn't known back then either, not that I would have dared to object, to question); that despite his way with words, the Famous Southern Poet's actual performance had been just that— a performance. And then there was the flash of the party at which he propositioned both me and a handsome male poet, his polymorphous perversity surfacing; or the time, when, seeing how little he could affect me anymore, his cruelty had surfaced so clearly, so like a shark's, inflicting pain with his teeth, that I had vowed never to be alone in a room with him again. (Later, in Henry Hart's *James Dickey: The World as a Lie,* I would read something Dickey had written in a notebook in the fifties: "I sometimes think [that] the only way to teach a woman the essence + particularities of love is to take her first to bed with a jar of [V]aseline + strap and work on her with both. . . .")

By 1999, I had been leading Zona Rosa, creative writing workshops for women, helping them tell their truths, their stories, for eighteen years. And during a workshop in Columbia, South Carolina—ironically, Dickey's home for the last years of his life, and a town where I had never even tried to give a reading while he was alive, knowing that there, he reigned supreme, a White God—I was about to be introduced to Dickey's women, the women who had stood by him, and loved him no matter what.

"Jane thinks Dickey can do no wrong—she hated Christopher's book," a friend warned about the woman who would be hosting the event. She and Jane had been students of Dickey's at the University of South Carolina in the early seventies; she was a blonde, and in class, he had always called her Little Yellow Bird—

because he couldn't remember her name? "Though the way he came in drunk was pretty pathetic."

"It was the bicentennial year, the year of Carter's inauguration, and early in the semester, he went to Washington to present the inaugural poem. He told us around that time that Maxine was dying of cirrhosis of the liver—'hyah she is, dyin', and she just can't quit drankin'.' Soon after that, she came to class with him, looking awful. She sat in a little desk on the front row. Dickey had on gray double knit pants—why did he wear such ugly pants?!—and she whispered to him that they were unzipped.

"Before long, he told us she had died. And before the semester was over, he told us he was marrying Deborah (who was also in the class). 'Ah just want to tell yuh ah love this class! Ah love yuh all!' " she said, echoing his melodramatic tones.

"It was weird. The university was thick with sexism; the only way a woman could get any attention was by attaching herself to one of the male 'stars'. Dickey was charismatic, and honed in on the ones who were vulnerable. But I was shocked that he would remarry so soon—the thing with Deborah was definitely a Monica Lewinsky thing."

Jane, a pleasant, serious-looking woman with pale, pearl-like skin, and prematurely silver hair, now an administrator at the school where she and Little Yellow Bird had gone to classes with Jim, described visiting Dickey in the hospital very near the time of his death: "He asked me what the worst thing I had ever done was . . . 'Had I ever been in jail.' . . . 'How many men I had fucked.' . . . I said, 'Mr. Dickey, I may be a flirt, but I've never been promiscuous—I'm a married woman with children!' "

As she spoke, I had the eery feeling, the déjà vu, that I would have again and again while talking with others of Dickey's devotees: as

they quoted the Great Poet, it was almost as though I'd been there, had heard his very words and saw the cruel, almost cat-like curiosity, the desire to bring down his prey. "He was always nice to me," she went on. Many women have a tenderness about them, an empathy for even the worst of men; and Jane struck me as being especially compassionate. She explained that she did know two women, Lynn and Paula, however, whose lives had been greatly affected by him; ironically, both were living on disability, both were alcoholics, she had known both well since their student days. "He asked me why I wasted so much time on Lynn"—Lynn had long had major mental health and addiction problems, and Jane had spent a great deal of time caretaking her, giving her friendship, encouragement, and money in between her bouts of hospitalization; "and I said, 'Mr. Dickey, how would you feel if you were sick and no one cared about you?'" Jane also described Paula Goff, a woman who had devoted herself, often to her own detriment, to James Dickey, his life and ambitions, during the last twenty-nine years of his life.

As Jane and I drive into the white-picket-fenced trailer park in West Columbia, then park beside number eighty-eight, the plan is that we will visit with Paula Goff for a while, then take her to Red Lobster—her choice—for lunch. Jane says that, because of her drinking and booze-induced epilepsy, Paula lives on disability, and has little money herself for such treats.

When Paula greets us, she stands large and imposing, but also looks friendly—like a Saint Bernard eager for company. Her long graying dark hair, parted in the middle, hangs around her broad face in uneven lengths; beneath her chin sprout some gray and black strands.

Inside the mobile home, the venetian blinds are drawn; despite the delicious spring noon out-of-doors, any light inside is artifi-

cial. Papers, clippings, literary magazines lay everywhere—on the floors, the couch, the ironing board; she has set out one of my books along with other artifacts, "for effect," she says. I remember reading how Jim kept books stacked everywhere, and typewriters, with pages of manuscripts in various states of completion, setting at the ready in every room in his house in Columbia. Had Paula copied him in his messiness, his collecting of things? "I learned it from the best," she admits, grinning.

On the far wall is a photo, she and Jim—their faces shrouded by tree limbs, giving them a far away, mystical look. In the picture, she looks radiant. Leading us into her "office" she points out another photo of Jim—this one more of a studio shot—and the typewriter she says he gave her so she would be typing on one identical to his own when typing his manuscripts.

Not long before, the University of South Carolina had persuaded her to give them the valuable papers—the original manuscripts and notes and letters—that Dickey had given her through the years; for these treasures, they were paying her sixty-five dollars a month: "That's the most I can receive without losing any of my SSI," she explained, obviously not having considered that they might have paid her enough that she wouldn't need the SSI at all! "My sister handles my check each month, and as soon as I get some money, I take a cab to Chuck's liquor store up at Mulbury Plaza."

"I had heard of the wild man before I met him," she says. She had heard the talk about him at the university, where she was a grad student, and had seen an interview with him, and another with his wife, Maxine, in the *State* in 1968, when they had first arrived in town; in the pictures, he is young, blond, movie-star handsome. His poem, "The String," about a surviving brother teaching his own son how to make cat's cradles that he imagines his dead brother to have made before he was born, was printed

on the same page; it was the first of James Dickey's poems that she had read.

But there was more to it than that: Paula believes in signs, in prescient dreams, and she tells me that, even before they met, she had dreamed of the Unknown Man, tall and fair, "who said a shocking thing to me;" that she had then met him in life, and that "he said that same shocking thing."

"'I could fuck you all night,' he told me, right in front of Maxine, who was in the room where I was sitting at his feet."

Paula had grown up in Olympia, a mill village section south of Columbia, and as a teenager, worked at Dodd's Variety Store. Like me, she had gotten married at sixteen; and had had three children by age twenty-one. At the time of their meeting, Paula, thirty, was married, the mother of three children, and a junior at the university, already showing an academic bent and literary promise of her own. Indeed, there is much evidence of her talent and achievement B.D., or Before Dickey. Yet soon she would be typing his manuscripts year after year, her own poems going unwritten and/or unpublished.

For the next seven years, she took Dickey's classes. "And for seven years, I was his grad student assistant—it was the fastest way to get to him. We were connected in three ways—he was my teacher, my lover, and we worked together."

When Jim lost his driver's license because of booze, Maxine would drive him up the hill for Paula to pick him up. "Well, turd, I guess you got what you wanted," Maxine told her.

"Once, when he was staying at the Ritz Carlton in New York, he called and asked me to come," Paula says. I arrived at 4:00 A.M., and there were these gold telephones on pedestals in the lobby. 'We don't allow that here,' a concierge said to me as I started to call Jim in his room. During the trip up on the plane, I was so excited

I had begun hemmorhaging. I had on a green corduroy coat, dark blue slacks, and a polka dot blouse, and the back of my coat and my slacks were soaked with blood. The next day, Dickey went out and got me some clothes and pads." They then went to a coffee shop where Dickey said to a cop sitting at the counter, "You do a good job." "So I said to a hooker who was sitting there: 'You do a good job, too.' He liked to role-play—on a plane, he would talk like a truck driver and want me to talk like his waitress-wife.

"Sometimes he called me his mill girl; other times, his soul-mate, his pure-hearted puella," she says, her face glowing. As in the words of songwriter Randy Newman, Jim Dickey had obvi-ously given her "a reason to live."

Eventually, because of Dickey, her husband Corbett threw her out of the house, keeping the children. "Then a maniac shot him in the head in a neighborhood bar." Paula, who says she loved her hus-band, too, says she saw signs, that he would die: "I dreamed myself turning a corner, and my hair turned white. I told my class"—she was teaching an honors class with a curriculum she had designed herself, even though she hadn't yet received her M.A.—"'I'm going to turn an overwhelming corner in November.' And 'Jaco's Corners' was the name of the bar where Corbett got shot."

Dickey, his meglomania leading him to assume that he would automatically be a suspect, waylaid Jane at the university: "Yuh have to call Paula! Tuh tell 'er ah didn't do it!" But he kept saying "Ah did it psychologically,"—wanting to lay claim, I wondered, to an act of passion, of violence, the extremes to which he was obvi-ously attracted?

"I hated him for marrying Deborah," Paula goes on, still vehe-ment. A year before Maxine Dickey died and despite that they were both married, he had asked for her hand in marriage. "He proposed to me over and over," she says; "People can die of a bro-ken heart and my heart was broken when he married Deborah."

Later, she and Deborah became friendly. But Deborah also pulled her hair out, and stuck a sliver of glass through her finger. "He'd never marry you. You're not pretty enough," she shouted at Paula that night. Besides she had three children. And what was Jim doing while this was going on? "Just sitting there, watching." Like Picasso, continuing to paint as Dora Maar and Marie Therese pulled hair and clawed?

At times, Deborah would fire drivers so Paula couldn't get to work at Dickey's home office. Sometimes she would get so upset that she'd call the police to have Paula removed from the house. Then when Jim needed a manuscript typed, she would call Paula again, rehiring her, only to fire her once more when the work was done. Often, because Jim complained that he had no money, and despite that she was poor, Paula would agree to do the work for free. Like Sonya Tolstoy, copying and recopying her husband's manuscripts, she toiled on and on. "When I typed letters for him, I put my initials at the bottom," she said proudly of her contribution to *Crux,* a collection of his letters.

While Paula was typing the 1300-page *Alnilam*—a novel that, like a *New Yorker* reviewer said of *The English Patient,* was "so well written as to be unreadable"—Jim was having bad headaches. When he finished writing, and Paula was finished typing, Deborah took him to the hospital, where he was diagnosed as having a cerebral hematoma (he would tell Paula and others that Deborah had hit him over the head with a heavy object). Then she fired Paula again.

"We called the room where we worked the Cave of Making—it was full of books and papers, and Jim and I liked it that way. One day when Jim was in London, Deborah told me to clean it up, that we had to throw things away. She was mad because a journalist from *People* had come, and I'd taken him into the room and he'd seen it that way. We were standing in the den by the couch, and I had a seizure, and she called 911. So I didn't have to do it."

Later when he had a different secretary, Deborah said, 'She cleaned up the office, and I didn't even have to tell her to.'"

"Then Deborah said we had to start working in his office at school"—I wondered why it had taken her so long, since according to Deborah, Paula and Dickey were drunkenly falling all over each other practically under her nose. "Deborah was jealous of our close relationship"—and she was telepathic. She would call and say to get out of his office, that she was coming with a knife to chase me out of the building."

When Deborah was finally hospitalized for her much-publicized addiction—the *State* cited her arrest in a Columbia crack house—Paula would take things to her at the state hospital at Jim's request. "I met a patient, a Native American, on the walkway, who raised his hand and said 'How.' I raised my hand and said 'How' back. Jim thought this was the funniest thing."

Towards the end of Jim's life, after he and Deborah had separated, Paula bought groceries for him with her food stamps, "seven-layer salad, Stouffer's stuffed peppers, linguini with white clam sauce, and vichyssoise—I learned to make that because he liked it." But, as oblivious as always to her situation, he never offered to repay her. By then Paula had suffered heart attacks in addition to having seizures, and had gone on disability. But she emptied his urine bottle, helped him into bed, read aloud to him—*The Painted Bird*—and kept him company. "I would stay until midnight, then I had to drive home through a bad neighborhood in my broken-down car. If he gave me gas money, he would fold the bill up like an airplane and I had to catch it." Despite her loyalty—or because of it, since mean-spirited people almost always choose the vulnerable on whom to vent their anger—he was cruel to her till the end. After watching *A Few Good Men*

together, he dressed her down, telling her, as Jack Nicholson says to Tom Cruise in the movie, "You can't handle the truth."

This time she didn't come back. "That was on May 12, and he died in November." But she did forgive. "I have the handkerchief with my tears, the one I took to the memorial service." Jim had told her what he wanted her to do at his funeral: "He wanted me to rush up the aisle and throw myself onto his coffin." But she hadn't been allowed at the funeral or the burial, which was by invitation only.

By now, we've left the trailer, and Jane has driven us to the Red Lobster, where we sit in a booth. As we talk our food comes, and Paula, with a child-like pleasure, pronounces her lobster tail "fluffy." "Jane told me I couldn't drink today, but I had a couple of drinks this morning before you picked me up," she says confidentially while Jane is in the ladies room.

After a few more comments about signs, and the number thirteen—"Volcano on Hokobe is erupting right now, and Mt. Rainier is about to erupt"—Paula looks at me slyly. "Do you know what he said about you?" she says; "That you were a suburban wife and mother when he met you, and when he got through with you, you were the whore of Babylon."

It takes one to know one, as we say in the South. And since he had been even more brutal—and as personal—in his attacks on other women writers, I felt I was in good company. Indeed, the only women poets I had known him to praise were the more innocuous ones—the ones unlikely to rock the boat of male dominance by word or deed.

"But he was always interested in your poetry—interested when he saw anything by or about you," Paula says, as though I might have been offended.

That afternoon in Columbia at the South Carolina Festival of Books, I read the section on my relationship with Dickey aloud from *Fatal Flowers* for the first time since the book had been published almost twenty years before. Paula sat in the audience, looking pleased and vindicated—a star by association.

Yet Jane's view was different: "What you read about from *Fatal Flowers* were the same things she told us this afternoon," Jane said that evening over drinks in a Columbia restaurant: "He chewed women up and spit them out. And he kept Paula from having a life. In fact, meeting Jim Dickey was the worst thing that could have happened to her!"

Now that I was interested in Dickey again, I began reading the spate of books that had emerged after his death. While noting the errors in even the small section of Henry Hart's *James Dickey: The World as a Lie,* in which I was cited, I wondered how many other inaccuracies there were in the book (according to Hart's book, Jim referred to me as the Judith Exner of his life, reminding me afresh of how hard it must have been to be done in by a woman, when he was the one used to doing the doing in).

Perusing *Crux,* a collection of Jim's letters, I was shocked at his blatant, yet offhand sexism in writing to his male peers and colleagues about such women as Adrienne Rich, Carolyn Kizer (the Pulitzer Prize winning poet who had published my first poems), and his casual condescension toward Anne Sexton and Diane Wakoski, both poets of reputation.

When I opened the issue of the *James Dickey Newsletter* promised by Joyce Pair—I saw what amounted to hagriography: one paper defended Dickey's ommision of women in his brutal saga and last novel, *To the White Sea;* another excused his personal attacks on Anne Sexton and her poetry as being based on a set of

deeply held tenets about what poetry should be. Both, amazing examples of sleeping with the enemy, were authored by women.

Then there was Mary Cantwell's memoir, *Speaking with Strangers,* published in 1998. Having grown up around Southern bad boys and their ways, it was hard for me to believe that Ms. Cantwell, the consummate New Yorker—magazine editor and author, and long-time resident of Greenwich Village—had taken James Dickey so seriously, for so long, despite years of his drunken behavior, and her more savvy friends and colleagues warning her off. But, as Brother Dave Gardner said about us dumb Southerners selling water to those smart Yankees, maybe it takes a smart Yankee to be truly naive.

The book, apparently written as Cantwell was dying, is prefaced by a Graham Greene quote: "If one cannot close a book of memories on the death bed, any conclusion must be arbitrary." In it, Cantwell calls Dickey the Balding Man, and describes how hurt she was when he had married Deborah, shortly after Maxine's death; his hurried trip to New York; and his insistence that she proclaim her love for him over again. (Apparently Jim had discovered the joys of proposing, keeping a woman's hopes up, since Paula was back in South Carolina, hoping, too.) Cantwell heard about his remarriage, she wrote, from friends who had read about it in the papers, reminding me of another well-known Southern author who asked his wife for a divorce via fax. And again, I thought of Picasso, with his string of slave-brides: Olga, Marie Therese, Dora Maar, Françoise, Jacqueline....

Cantwell passed away in 2000 at age sixty-nine, two years after her book was published, and three years after Jim Dickey's demise. I couldn't help but wonder: as she lay dying, had she considered her years of devotion to Jim Dickey a wasteland in her life—or, like Paula Goff—the one thing that had given her life meaning?

I had saved Chris Dickey's book, *Summer of Deliverance,* until last, knowing that it held emotions that might engage my own. And when I finally held it in my hands, it felt hot, feverish, loaded with the kind of information only to be had from truth tellers. That Chris had loved and hated his father, and that he had to travel to the other side of the world, indeed, to put himself in harm's way, to escape his poisonous influence, there was no doubt. As I read, Maxine—in her submission to booze, to Jim and his cruel nicknames—became a tragic figure, another woman lost to a man's cruelty and genius. I again felt the chill I had felt at watching Anthony Hopkins playing Picasso, as if in the presence of evil.

But I had to laugh when I read of Jim's fear for his life at Deborah's hands. He was loyal to her—but was his loyalty a reflection of the truth that some men are only truly engaged by a woman who treats them badly? And had Deborah simply followed in Maxine's footsteps, even unto her own near-self-immolation? Jim's laissez-faire acceptance of violence, of craziness, of female masochism, may have meant that she had little reason to recover as long as they were together. I recalled once trying to tell him about a serious problem in my own life, only to quickly realize that, in stepping out of my role of devotee and Jim-worshiper—I was boring him. Whatever Deborah's problems were, living with Jim Dickey could in no way have helped them. And since I had addiction in my own family, and knew how attention-grabbing, how all-consuming, that situation can be, I had a small moment of amusement, thinking of Jim Dickey, the Great White Hunter who had run roughshod over so many women—trying to hold *that* tiger by its tail.

"'You can do anything, but just don't cut that hair!'" the chunky, red-going-gray haired woman exclaims as we approach.

"What is this? Beauty advice?" I ask, puzzled. Jane has picked what she hopes will be a "good" day for us to visit Lynn Cansler in the project-like red brick duplex where she lives. She had been released from the hospital after one of her many stays only the week before. But the woman who greets us on the concrete porch outside her door is ebullient.

It will be well into our talk before Lynn explains that her greeting—"just don't cut that hair"—had been Dickey's first and recurrent words to her. Indeed, the photos Jane will show me later that night will be of a gorgeous young woman with long bright hair, falling in deep voluptuous curves.

As Lynn leads us inside and through the tiny kitchen into a tiny sitting room, we step over and around debris. As at Paula's trailer, the space is chaotic, filled with all manner of things.

"Lynn is a talented visual artist," Jane says for my benefit, plucking up and handing me a gourd Lynn has painted in vibrant colors, swirling designs; "I have these growing in my yard, so I suggested to Lynn that she paint them." As Jane will later explain, Lynn can't keep the place straight or clean, and not just because of her illness: "She grew up well-to-do, and never learned to clean or cook." But at the moment, it's hard to imagine this forty-nine-year-old woman, looking done in by life, sitting in shorts at a cluttered dinette table that almost fills the room—living in luxury, or even in ordinary comfort.

It's August, late afternoon, and the heat is overwhelming—apparently, there's no a.c.—but Lynn says she must smoke: "I'm so nervous." For my and Jane's sake, she leaves the door ajar—which in no way alleviates the sense of being in a small smoke-filled oven.

Though Lynn had told Jane that she didn't want to talk about Dickey, he seems to be the only thing she *does* want to talk about. "I read his poems when I was twenty-one, and I thought, My God,

here's somebody who writes like me and gets away with it! And our interests were the same—nature, angels, and higher forces."

She had already attended the Ringling School of Art, the Columbus School of Art and Design in Ohio, and St. Andrews Presbyterian College in North Carolina. She and her mother traveled to Columbia so that she could try to get into Dickey's class. But first they went to Jim's house on Leila's Court in Columbia in order to meet him. "'Come on in,' he said. Then, 'Baby, just don't cut that hair!' He was sitting in a gold chair."

Lynn, like Paula, is a believer in signs. "Jim could be psychically dangerous, on one level of non-karma. But not to an avatar—a natural born healer. Paula is an avatar—Paula and I have similar dreams—so she was safe. That's the only kind of woman who's safe around him."

"Jim Dickey, an alcoholic?!" Lynn snorts in disbelief when I tell her that Paula had said Dickey was not an alcoholic. I'm getting used to her way of saying the opposite of what she means. "'Drinking is a voluntary form of insanity,'" she says, quoting Seneca, then another source: "'No alcoholic wants to stop; he just wants the side effects to stop.'"

"We had a father-daughter relationship, a reverse relationship from what he had with other women—he was a man who had to have a woman. And what would I want with an old fart almost thirty years older than me anyway? One time, when he wasn't there, I went in and started teaching his class. 'Who are you to teach James Dickey's class?' somebody said, and I said, 'I'm his daughter'!

"Once when I came into class, saying I was going to have my sex change, he said, 'That's okay, baby—just don't cut that hair!'" Later, because of his words, she had gone into his class with her head shaved, wearing a World War II army helmet. "'You're trouble, Red,' he would say. One time he asked Deborah to bring

me four signed chapbooks of his poems. 'Take these to Lynn,' he said; 'Then maybe she won't cut my balls off!'"

For a while she and Deborah had been pals. "Deborah was kind and nice at first—but she cut the cord." Lynn had sent gifts to the Dickey's daughter, Bronwen—bird feathers, the materials for a dream catcher, wrapped in a rabbit's skin; all things that were signs of the natural world. Jane had already told me that Deborah had gone hot and cold with Lynn, depending on whether she needed drugs; that, at times, Deborah had taken Lynn's prescription drugs. Then Jim Dickey decided he wanted to keep Deborah away from her drinking and drugging buddies, including Lynn. "I had nothing else to offer him, and he was keeping Deborah away from her friends."

"But I would hear things—about how she was downtown, wearing a mink coat, looking for her fix, and how Jim took her to get her drugs. And once when we were walking out of an NA meeting together, she was talking about another man she was sleeping with."

Over the years, Lynn has had a number of jobs, one as a successful reporter and illustrator for the *Greenville News*—Jane hands me a sheaf of delicate black and white drawings on pages of newsprint; she had been fired when her illness had begun surfacing again.

Lynn goes into another room, comes back with a picture of a handsome silver-haired man. "And a retired chaplain at Duke University took me to England with him 'to help with his book.'" At her tone, I flashed a young beautiful Lynn—her red locks flowing—and the widower who would take her abroad.

Now she's on a roll: "And once I was even a prostitute. I was in Vegas and wanted more vodka. So I took an old man up to my room, and he left me seventy dollars."

Between 1970 and 1990 Lynn moved from Columbia a number of times—to Texas, to Asheville, to Greenville, to Arizona. "And now my sister has exiled me here," she says, speaking of the one family member who still communicates with her, and who is the payee for her disability check.

That Lynn's life has been marked by grief and loss, and the repeated indignities often suffered by the mentally ill, is clear. She has been pregnant twice: "Once I had an abortion: I murdered my baby." Pain marking her face, she says she was illegally sterilized—"without my knowing it"—in Hall, one of the many mental hospitals she had frequented. For years she had raged, wanting to sue; but Jane had talked her out of it.

According to Lynn, poet and philanthropist Carolyn Kizer saved her life one winter in Washington, D.C., when Lynn was there looking for a job. Lynn had met Carolyn through Dickey, and called Carolyn's apartment, leaving a message saying she was staying at a Y, and describing her intention of committing suicide by freezing to death. Carolyn called every Y in Washington, searching for her, Lynn says, then had taken Lynn into her apartment. " 'Just stop fucking around and paint,' she told me." The seventies were marked by a romanticization of madness, R.D. Laing and all that; and Carolyn apparently believed in Lynn's brilliance: "She consulted Dr. Silver at Duke University, in Paranormal Studies, to see whether I was psychic or psychotic."

But Carolyn's feminine and feminist support was apparently not enough: "He'll destroy her!" Lynn overheard Carolyn saying of her relationship with Jim Dickcy. "A psychic-healer saw a photo of him, and said, 'Stay away from him—he'll drive you crazy!' And sometimes I wonder what kind of hold he had on me. He could drive me to damage myself. . . ."

But, in fact, Lynn feels more hurt by Chris Dickey's account of

her visit to the hospital right before Jim Dickey's death than anything Jim ever did. She hands me a page torn from Chris's book, heavily inscribed with black ink.

In it, Chris describes Jim's last stay in the hospital as a time during which people started to hang around, including "a . . . middle-aged woman . . . another incidental lunatic sycophant who wanted to embrace and kill him." Chris goes on to write that despite his father's former delight in madness as inspiration, he could no longer withstand it, "coming back in the form of one tawdry little woman . . ."

Here, Lynn had printed SLANDER . . . TAWDRY INDI-CATES JEWELRY. After Chris completes the sentence by describing her as someone with an empty life, looking for his father to fill it, she had scrawled, OUTRAGEOUS!! WAS LOYAL TO THIS TEACHER WHO WAS A FATHER FIG-URE TO ME . . . NO SYCOPHANT WOULD TELL HIM . . . THAT I ACTUALLY PREFERRED JAMIE (TO?) ANDREW WYETH, she had scribbled around the margin of the page as though in a white-hot rage.

In Chris's book, Dickey tells her to get out of his room, and Chris next cites a phone conversation he taped, taking notes to give to the police in case they needed to make a case. In it Lynn described her hurt at being cast out of Dickey's room: "I was completely out of my mind and I said, 'I ought to go back up there and shoot the old bastard!' He was so cruel."

In the book, Dickey dies shortly after Lynn's aborted visit. "Chris wrote it like I killed him, that he hated me. But what he didn't know was that Jim and I talked on the phone later that night. We talked about James Agee, and he said to come see him when he got out of the hospital. And he didn't understand that the reason I went was that I called Jim's house, and his secretary,

Meg Richards, told me that he was in the hospital and that any-
body who cared about him should go see him now."

By now I have read Chris's book, and I agree that his account
seems like overkill. Too, I recall another section in which he
describes some of the women in his father's life as "grimly plain;
and one of them, one of his favorites, was plainly ugly," and how
I had wondered if a bit of the father's sexism—and ready cru-
elty—had rubbed off onto the son. Or had it just been Chris's
way of further dealing with his own hurt and rage?

Now Jane has gone outside because of the cigarette smoke;
Lynn is talking about *Revolt in the Desert,* T.E. Lawrence's syn-
opsis of *The Seven Pillars of Wisdom,* and we've moved into the
tiny kitchen where strange things set atop other strange things—
I note the tops to the stove burners have been removed; on the
table I see her notebook, stuffed with notes, journal entries,
poems. And pill bottles.

"The right thing to do if you're completely manic depressive is
to commit suicide," she says. She's been off and on psychotropic
medications since she was twenty. Now she's on 3000 milligrams
Tegretol, 8 milligrams Adivan, 4 milligrams Klonopin daily; she's
also been on Depakote, Xyprexa, Thorazine. "At the hospital,
they give me benzos (benzodiazipins), then I get better, and they
take 'em away. Then I drink, I go crazy, and get locked up again.

"I took a knife and chopped it open," she says when she sees
me looking at the white scars crisscrossing the inside of her arm,
and I ask about the deep angry red cuts on her forearms; "I've
been doing it since I was a teenager. I just put rubbing alcohol
onto it, and then I can go to sleep."

"Does the writing help?" I ask, indicating the thick notebook
on the table. The tragedy is that this woman, once beautiful, was
also beneath it all, brilliant.

"It's not all over yet!—Haven't you heard of late bloomers?!" she protests when I ask how she feels about not having been able to fully realize her talents. As in the Kris Kristofferson lyric, "Freedom is just another word for nothing left to lose." And Lynn has lost everything—but her spirit.

"And I wouldn't have missed James Dickey for the world. He was awfully kind to me." As with Paula, our conversation is turning into a song, a revolving paen to her mentor, and I think how little true kindness she must have known if James Dickey had become her touchstone. Now she's talking about the stars and the Moon, Mars and Venus, and Dickey's great mystic poetry. "I'm still influenced by him. I still have that ghostly hand behind me. . . ."

By the time I leave, Lynn has pressed her copy of Chris Dickey's book into my hands, along with the torn-out inscribed page, plus two of Chris's other books, along with the painted gourd "I'll sell the books to you for five dollars," she says. Wishing I had more, I hand her fifteen dollars.

"This is more a story of mental illness and the toll it takes, than about James Dickey," Jane comments as we drove into the hot Columbia night; "But then, he was the focus. She was obsessed."

The second time I visit Paula, with Little Yellow Bird, a photographer, Paula's long straight hair is matted with blood. She cheerfully says she had fallen in the kitchen, then poses with one hand reverently on Dickey's picture, beside the desk with the typewriter he had given her.

Before we leave, she says she will read us a poem from her unpublished collection, *Washing My Hands*. With the blinds drawn as before, the television blaring two feet away, she stands as though at a podium, her voice rising dramatically when she comes to the lines in which she quotes Dickey: "'I'm talking

about the world!'" she booms, describing what Dickey had promised her as they sat over Bloody Marys during a tryst in a hotel restaurant in New Orleans. Again, it was almost as though I was hearing Dickey's urgent voice, telling his lies, again.

She gives me a copy of the manuscript between red cover pages; her own copy is on red paper throughout, "for blood," she says. As I flip through the pages, I see a poem titled, "Eating Dirt." She wants the photo of them together, his arm around her shoulders, the leaves and branches romantically softening their dopey-in-love expressions, to be on the cover "when it's published," she adds.

The phone rings—it's Lynn, wanting to know if she's given me the poems. Before Yellow Bird and I leave, she asks for a ride to Chuck's liquor store. "I always have to drink when I talk about Dickey—because that's what we used to do," she says, her words as poignant as the lyrics to a country-western song. "It was my ambition that did me in—that, and love." And that night in Savannah, at home in my own bed again, I dreamed that voice: "I'm talking about the world! . . . I'm talking about the world! . . ."

Writing among Gentlemen. What was it about male writers— Dickey, Hemingway, Mailer—that made them turn to such extremes of male behavior? Was it because they considered the act of writing—passive, done sitting at a desk in most cases, using material rising out of the right—or intuitive part of the brain— basically effeminate: that they felt the need to counteract it with extremes in order to feel like a man?

For whatever reason, James Dickey had felt driven to create an ugly myth about himself. He was a genius—and he was a genius of lies, of manipulativeness, of poetry, of self-creation. The

Jaguar, the cowboy hat, the bow and razor-tipped arrows—were we women also among the things that reinforced his image? Instead, he had succeeded only in creating, in the eyes of some, a cartoon of what it means to be a man.

Rakes usually repeat themselves, using predictable lines, and Dickey was no exception. In a letter, poet Rosemary Prosen describes a week-long trip to Los Angeles with him in 1976: "Mostly I listened to him talk, talk, talk. And drink, drink, drink. And flirt, flirt, flirt . . . I went on full alert one evening when he collapsed into a kind of epileptic fit, foaming at the mouth, and moaning about winning the Nobel Prize some day. . . . He proposed marriage; that is, he began to ask questions about my personal life. . . . 'Well . . . he muttered, you don't love me.' I did not reply. I was relieved when the week ended. . . . I was happy to get home. . . ." She went on to say they had never had sex. Indeed, the women who were safe, who never felt hurt by him were the ones—she, Jane, Joyce Pair—who had never slept with him: in obedience to the tenets of the Madonna-Whore complex, he was often "the perfect gentleman" with these "good girls."

Joyce Pair and Little Yellow Bird argued that he was simply a product of his times—a non-argument, I thought, looking back on the many changes women have made, their sacrifices toward truth, since the sixties and advent of the women's movement.

In the way of a man seeing through another man's behavior, Jane's husband couldn't tolerate him. Nor could the husband of his secretary at the university, or Bob Lescher, ex-husband of Mary Cantwell, who, ironically, had once been Dickey's editor for *The Deliverer,* later to be titled *Deliverance.*

When *Parade* guru Marilyn vos Savant was asked by a reader whether she believed there were evil people or only evil acts, she

replied that she believed that there were evil people, just as she believed there were good people—that it wouldn't make sense to say merely that there were people who performed good acts. Yet there do seem to be people who, like "the little girl with the little curl right in the middle of her forehead," are either "very, very bad, or very, very horrid"—and James Dickey appears to have been one of these."

In his book, *The Soul's Code: In Search of Character and Calling*, Jungian James Hillman describes the way the artist often creates a mythology around him or herself in order to protect and preserve that acorn of creativity deep within. That Dickey was fond of Oscar Wilde's quote, "Nothing succeeds like excess," was apropos. Salvador Dali once jumped down a flight of steps, breaking both ankles, in order to make a point. In his extremes, Dickey was like that, too.

"James Dickey's middle years were lived . . . on the small but fervently observed stage that academics and other famished readers reserve for the Great Man (and only lately, the Great and Equally Reckless Woman)," Reynolds Price wrote in "Bookend" in *The New York Times Book Review* after Dickey's death; "Most of the people whom Jim's debauches troubled were adults who had after all volunteered with open eyes to stand in his path. . . ."

I didn't fully agree. For some, being involved with Jim, was more like being a kitten caught before the threshing machine, a hungry monster that ate up one's gifts and talents in order to feed itself. Or, as Jane said of Jim's relationship with Paula Goff, "he chewed her up and spit her out."

As I wrote up my notes—as I became immersed in James Dickey again—I felt like I had an infection; mysogyny, delusion, even evil, festering inside my brain.

And again, I felt lucky: had I been as vulnerable as Paula Goff and Lynn Cansler—both were tender-hearted to a fault, with fault-lines that made them especially subject to the kind of attention that Jim Dickey was so good at dishing out—would I too have ended up used up, on disability, an alcoholic or worse?

Someone wrote that there's a splinter of ice at the heart of every artist. Jim had his, and I probably have mine. Indeed, it was my toughness—the very thing Jim had liked least about me—that had saved me. My sin was that though I had initially been attracted by his genuis, I had become more interested in my own life and work—in my truths—than in his. And that was revolution, rebellion, in Jim Dickey's eyes.

But now, for the second time in my life, Dickey-fever had subsided, the poison was leaving my body, and I was myself again.

"At least, he was entertaining," Little Yellow Bird says of her semester with Dickey. And if in talking with some of the women in his life, I had the feeling of a woman used up, he was used up in the end, too.

Chris Dickey seems to feel that his father was shaped, even done in, by the demands of an insatiable public. Among pages and pages of pain, Chris Dickey presents Dickey's tender side as a young father, and his final, fatherly love during his last illness. Toward the end, Chris appears to have had the relationship with his father he had long wanted. And however difficult Jim's relationship with Deborah may have been, it does seem to have tenderized him by the end. Indeed, I understood both Deborah's past rage toward Jim, and her continuing love for him. In recent conversations, I sensed a whole person, a woman, now clean and sober, who had lived through demons of her own, and had come

out stronger for it. A year after Dickey's death, she had called to say that she liked the memorial piece I had written on him for the *Atlanta Magazine.* Just before another call from her, I dreamed that she came to Zona Rosa, my creative writing group for women—she had expressed an interest, but hadn't shown up—and that I had read a tribute to him in her honor. ("But get rid of that gourd—it might have a spell on it," she, a devout Catholic, advised of Lynn's gift to me.)

When I was back in Savannah, I received a note from Lynn describing why she hadn't gotten around to reading the book I had sent: "There's been some trouble here . . . (but) thanks for your insights on the manic dep(ression) problem. . . .

I had sent Paula a copy of a collection of my poems, *Fort Bragg & Other Points South,* and after reading my poem, "Sewing Lessons," she wrote me, telling me how alike we were, recounting at length her love of home ec., of sewing, of pink waffle pique and dotted swiss; indeed, it appeared that we had made almost the same garments, including a dress "with scallops at the neck, sleeves and hem. . . ."

"I wore this thin, light-blue dotted-swiss nearly strapless dress for a parade in Irmo, South Carolina. . . . (riding with) a small piano on the back of a truck, with me playing, and the children surrounding me and singing. . . . It was a Highlight of my life. . . .

"I never told J.D. about the Irmo Parade. . . . I did tell him lots of stories, however, and he told me alot, too. I was lucky to have thirty years with him—one way or another. . . ."

And at times, I would feel myself even craving his crass directness, his far-fetched embroideries. "It makes you wish Dickey was still here, doesn't it?" I said to my sister Anne as we left a pleasant but mild poetry reading at an Atlanta college. As any artist knows, there can be no creation without destruction. When

Dickey spoke of poetry, which he clearly loved above all else, he spoke truth. He loved, too, to seek out the mystery layered beneath reality, to put it into words and rhythms.

If only he could have kept it to that. And to a bit of that outrageousness, too.

2000

The Feminine Frustration

"Most of us don't talk about it;
we just keep it inside day after day."
— A Computer Data Specialist
"When a man speaks, it's heard more."
— A Domestic Worker
"You never hear boys say they wish they were girls."
— A Fifth-grader
"I've found that no matter how nice it sounds, it's
degrading to be put onto a pedestal."
— A Housewife
"I now know what it is to be black."
— An Attorney

The comments were made by Atlanta females, referring to the frustrations of being female in what they believe is a male-oriented, male-dominated culture. In Atlanta, feminist groups proliferate, from NOW (National Organization for Women) to the women's liberation groups and small, almost spontaneous "rap" (talk) groups, such as one whose members range from ages twenty-three to seventy.

Weeks ago, along with International Women's Day, feminists gathered outside the state capitol to affirm their alliance with women everywhere. They heard their local leader demand

twenty-four-hour-a-day child-care centers; free, safe, and legalized abortions, and equal work for equal pay. Weeks after, at the national convention of NOW, Betty Friedan, author of *The Feminine Mystique* (a 1,500,000 seller published in 1963 and probably the first shot of the women's new revolution) voiced a suggestion originally made by Atlantan Louise Watley, that on August 26 millions of women "cover their typewriters, unplug their switchboards, put down their mops and sit back until employers guarantee that all jobs, including those at the top, be open to women." Mrs. Friedan added that women should also "sacrifice a night of love to make the political meaning (of feminism) clear." It is this meaning that some Atlanta women, like their national counterparts, intend to emphasize. Despite their hallowed right as Southern belles to chivalrous treatment by males, they are incensed. Increasingly, the scent of magnolia blossoms fails to mask the acrid odor of their anger. They proclaim loudly and clearly that they are oppressed.

Whether it is myth or reality, some Atlanta women feel that the attempt to keep them in a back seat position begins during childhood (from the time they are first taught to play with dolls rather than Tinker Toys) and that the force the feminists call "educational tracking"—the direction of women toward less demanding work in light of cultural concepts of the woman's "place" grows stronger the more ambitious the young woman.

"Absolutely, there is something working within our society to keep women out of its center," says a Georgia Tech associate professor of English in her forties. "Women who try to buck it begin to question whether they are real women. It took me forever to get my Ph.D. because I didn't take it seriously. I was interested in being attractive to men, and according to the myth, the women who competed openly were unattractive bluestockings. It's cul-

turally formulated that women who are happy in their personal life need nothing else, and it takes a hell of a strong woman to buck it!"

Career-minded women entering colleges find countless obstacles and blatant discouragement. At Emory, a graduate student declared "there is vocally stated discrimination against the entry of women into the graduate schools. One criterion for admission is the possibility of completion of the degree. A married woman must attach a statement to her application affirming that her husband supports her work. Of course, a male married student need attach no such statement by his spouse!" Says another Emory woman, "When my husband and I both applied to the same graduate school, I had better grades and was more qualified, on paper. Yet it was suggested that I drop out of school to support him; and when we both applied for a fellowship, he received one. I did not . . . we are now being divorced."

A chemist who carried a double major in biology and chemistry during her undergraduate studies says that Emory didn't want her to major in science. "It was obvious there was something wrong. There were only four girls in a class of about 100 men." According to the Religious Life department paper, there are quotas on admission for women to undergraduate and graduate programs. Yet Dr. Evangeline Papageorge, Executive Associate Dean of the Emory School of Medicine, emphasizes it has no quota for the admission of women. But "We try to make certain that (an applicant) is not a young thing who just wants to marry and say 'Goodbye, medical school!'" Dr. Papageorge maintains that the small number of girls in the school is because not as many women apply as men. "They are rarely encouraged by their families to do so," she says.

Many women who might have considered becoming physi-

cians, had they been men, turn to nursing, fulfilling the accepted
idea that appropriate work for a female is as a "helper." Such a
concession to the culture doesn't always work out happily. "In
nursing school, we were taught only what we needed to know to
do the job," declares a young woman, first in her class at
Piedmont Nursing School. "As though he were training an ani-
mal, the instructor would say, 'This is all you need to know.' A
doctor/teacher repeatedly said, 'Don't ask me why; just believe!'
Or, 'I'm trying to make this simple; I don't want to go over your
heads.' This made classes very dull. And the worst thing was that
most of the girls were glad!" The Women's Liberation Group at
Emory works to counteract such attitudes. "We try to reach the
undergrads—with leaflets, with demonstrations—before they are
totally brainwashed into marrying young, thus stifling any cre-
ative development," says a member.

The U.S. Labor Department reports that, in the professions,
women comprise only seven per cent of the physicians, eight per
cent of the scientists, three per cent of the lawyers and one per
cent of the engineers. Concerning women in management, the
Harvard Business Review reports that the barriers are so great,
"there is scarcely anything to study." And according to a recent
Playboy article, (itself the subject of a feminist controversy),
"Thirty-one million women work—but a third of them are secre-
taries and clerical workers and over a fifth are service workers
(waitresses, domestics, and the like); only small numbers of male
workers are in either category." June Wakeford, Atlanta Regional
Director of the Labor Department's Women's Bureau, believes
so few women enter the professions because there are not
enough peer types to orient young girls. Wakeford, a lawyer,
escaped the feminine prototype because the attitude within her
family was one of free competition. Wakeford first became aware

of the dearth of women in her field when she noticed that none of the lawyers she encountered were women. "I'm no genius, so there was no reason for me to think I was there because I'm exceptional."

Even if a girl hurdles the obstacles of educational tracking, and although the Civil Rights Act of 1964 proclaims that "it shall be unlawful . . . to fail or refuse to hire any individual because of . . . sex," she might still find distasteful days ahead. One problem may be in finding a job which uses her hard-earned knowledge. A psychology graduate recently applied for a job with a large Atlanta company. Male interviewers talked with male applicants, a woman interviewed *her*. All available jobs turned out to be clerical. A girl who worked as an insurance adjustor in another city applied for a similar position here and was told repeatedly that it wouldn't do to hire a woman. Insurance adjustors often travel together and the wives of the men wouldn't like it. She replied angrily, "What of airline pilots and stewardesses?" A woman with a degree in television and radio from the University of Georgia says that she applied for an opening as a disc jockey for a classical music program at an Atlanta radio station. "I wasn't even asked my qualifications!" she declares. "The director of the station just said, 'I wouldn't think of hiring a woman!'"

Women with academic aspirations often hope the university complexes will be less discriminatory. Not so. A man who applied for a teaching position with a local college was told, "It's a good thing you're not a woman; we prefer men." And though the Georgia Tech alumni magazine recently ran a special issue on "Women in a Man's World," the women portrayed—from an aerospace engineer through the college president's wife to an authority on botulism—were all called by their first names and defined largely in terms of their marital status and home decorat-

ing plans, "a kind of adult mascot system," complained a feminist reader.

A 1969 Ph.D. claims that there *is* less discrimination in the academic world. But she also says, "When I applied for a teaching job, one department chairman asked me how many children I have and if I plan to have more. I wanted to reply to him that I am less likely to become pregnant than many men in his department are to die. Pregnancy is ninety per cent preventable at this point, while the death rate for people ages fifty through sixty-five is twice as high for men as for women. I felt he had no right to ask the question!" (Women often hesitate to voice their anger to interviewers for fear of further discrimination due to "bitchiness.") A young girl who was interviewed for a secretarial job at a local university was questioned about her sex life by the personnel head. The widespread touchiness of some Atlanta women regarding hiring practices was evident at a recent meeting of NOW, when members enjoyed the fantasy of a recently married man being queried as to whether "You think you can combine your career with marriage?" or, "Do you have pre-school children?"

The most painful cases of discrimination in hiring involve women who have sacrificed to gain an education only to find that sexism threatens to keep them from practicing in their field. A June 1970 honors graduate of Emory Law School cites a series of harrowing interviews. "In my search for a job, I have probably interviewed in every large law firm in Atlanta, many medium-sized ones, and some small ones—totaling about twenty-five. At a large firm, I spent two days being interviewed by thirty firm members. I received a one-sentence letter of rejection. When I called to ask why, I was told by the head of the hiring committee that 'the men didn't want to give up the informality of their meet-

ings.' Another top firm invited me for an interview and turned me down; the reason given was that 'they had never heard of my college' (Montclair College, New Jersey). In another case I was told upon entering the interview that the firm did a great deal of litigation, and that the interviewer had never seen a competent woman in the courtroom. 'How many have *you* seen in the courtroom,' I asked. He replied, 'Not many.' I said his view 'sounded like self-fulfilling prophecy.' 'That's probably true,' he said. 'I've never believed Jews were good at litigation either!'"

"Single women in the field are told they might marry and have children," she added. "Consequently, they are passed over. But since I am already married and have children, many interviewers have admitted to me the real reason—simply that *I am a woman.* No rational argument can move their irrational bigotry. Education in no way does away with prejudice. I have always been idealistic, optimistic—but I'm not any more. I now know what it is to be black." Her whole family is despondent over the situation. "I gave up teaching because of my love of law and all of us sacrificed so I could go to law school. For all these years, I scheduled my classes to coincide with my children's school hours, kept house and cared for them in the afternoons. Now I can't find work in this city."

According to Wakeford, of the Women's Bureau, the problem of discrimination in hiring women for management or professional positions is ideological. "We are seen as members of a group and not as individuals. The image of the bright-young-man-on-the-way-up is part of our society. Who in hiring positions will go against that when they can get brownie points by choosing the guys? Men like to say women are not as qualified, but the truth is a gal only needs the same tender loving care, the same training as a guy." She suggests that men envision a country

where the president, most senators and representatives, the governors and most heads of business are women. "Then a man might realize the sense a woman has of a tremendous power structure that is dominated almost entirely by men. Then he might understand the frustration of a bright, ambitious young woman in the face of it."

"But how can a man run a profitable business if he has to pay male salaries?" queries a business head, "Men won't work for as little as women." "That's the same argument the plantation owners used about freeing the slaves," counters a feminist sarcastically. Indeed, the problem is not just getting a job, but obtaining a fair salary to go with it. "Women should be used when possible in the Resident Manager capacities because with them you can buy more talent and dedication for less money than with men," stated a management consultant at an Apartment Owners and Managers Association conference. He added that the women "should not be too young or sexy or too old and decrepit."

Often, *women* discriminate, fulfilling the movement charge that "women are their own worst enemy." These range from secretaries who insist on male bosses and physicians, through educated women whose well-bred hackles rise at the terms "women's liberation," to women who employ only other women. A woman who has experienced discrimination herself, and who now heads her own all-woman firm, counters with the argument cited by a man—that economic conditions prevent her from hiring men. But she adds that she also prefers women on her staff because "women are better under pressure than men. They get plenty of practice for they usually run a house in addition to their jobs. They go home and do all the cleaning up while their guy watches TV."

Still, job-holding women feel that the hard core discrimination

comes from men, and that they will be reluctant to give it up. "The doctors don't like the nurses who work under them to receive special training, to get titles and new responsibilities," declares a nurse. "They prefer the chasm—the master-slave relationship." Movement terminology labels this attitude "male chauvinism," or "sexism" (as in "racism"), and considers it *the* basis of oppression of women in our society. Feminists say "the woman's place is in the home" is still the attitude of most men. "The redneck approach is that a gal should be kept barefoot and pregnant," declares Wakeford.

Though *Atlanta Journal* staff writer Billie Childers advises that women should "sue until the businessman's head swims in his martini," many women still fear being outspoken or aggressive. "I feel very touchy on the matter," declares a woman with a new Ph.D. "I'm afraid to say anything because of the possibility of being discriminated against in looking for a job." Indeed, similar apprehensions were voiced by many women who repeatedly asked that their names and those of their companies not be used because of "repercussions." Indeed, in a recent Kiplinger "Letter to Businessmen," recipients were advised to "look out for the militant women . . . take their campaign seriously. . . . For employers in particular, a warning . . . equal employment rights are guaranteed by law . . . the thing to note is that women are getting aggressive about their rights."

Regardless of their rights under the law, women feel that some forms of sexism are subtle and impossible to legislate. A woman taxi driver declares, "Sure, we're discriminated against by male drivers; they pick up our calls all the time. They think we get more tips *because* we're women." Her statement refers partly to what liberation movement women call the objectification of women—the treatment of women as objects, primarily sexual.

"At the hospital, the doctors feel privileged to touch us any-where," complains an attractive nurse, "with kisses, pats, hugs. And you just don't object. You could be unfriendly, but would find yourself working in a very inhospitable atmosphere."

Of course, only women work as Bunnies and topless dancers. (A NOW member, queried about how she'd like to see a man working as a Bunny, said, "If he's got the equipment, tell him to go ahead.")

A teenage girl models lingerie at lunch for businessmen who buy for their wives. "I feel like a slab of beef, and I've lost my respect for 'respectable' men." Many men seem to feel that women hold such jobs by choice. But an organizer of working class women says when she worked as a waitress, most of her fellow workers were women who were heads of households, forced to work at minimum wages. "In addition," she says, "(the restaurant) had the power to lay us off, or insist that we work any number of hours per week." Saying she was fired for soliciting for International Women's Day and for attempting to unionize the women, she added that "so often, women dependent upon this kind of menial job for the substandard existence of themselves and their children must sit all day at Grady to get aid for a sick child, and risk losing the job, or neglect the child's illness to keep the job. Often, they lose the job anyway."

"Men are given leave of absence from jobs to go to war to kill people," charged Betty Friedan in a speech recently, "while women are often forbidden leave in order to give life."

Women who are heads of households because of death, divorce, or desertion suffer the most. Housework, child care, dress—all are more difficult. "At a private day nursery, I was charged $90 a month for the care of my two year old son," says a young divorced nurse, who receives neither alimony nor child support. "Now I leave him

at a nursery provided by the hospital; my salary is $160 every two weeks, and $30 is taken out of each check to pay for it. I have to pay whether he is sick or not. I don't know what would happen if I got sick, or got in debt; it would be the end."

Related to child care are the problems of birth control and abortions. "A doctor on the board of a hospital here advised me to go to Johns Hopkins for an abortion," says another nurse, the sole support of her three year old child. "I was completely ignored when I arrived there and made my request. I got so desperate I tried to do it myself with Q-tips and a catheter and a mirror tied to one foot. Finally, the doctor found an abortionist who came to my apartment and did it for me." For such women, there are other problems related to the culturally-ordained role of the female. "My daughter begs me to attend PTA," said a divorcee, who works fulltime and moonlights as a free-lance writer. "Though I hate it, she worries about being discriminated against by her teacher if her mother—her female parent—doesn't attend. It's what mothers are expected to do."

For women who work, the complications of women's dress, perpetuated by the image of woman-as-sexual-object, or one of special beauty, becomes an additional burden. Hours spent shopping, polishing one's nails, washing stockings, or setting one's hair on uncomfortable rollers can cut into a day considerably. But whatever the limitations of her budget, her time or her desires, the working woman is expected to look as chic and pretty as her prototype in the pages of *Glamour*. Perceptive women often attempt to simplify, to resist. Even the most competent woman executive often finds false eyelashes and sexy dress as effective in dealing with her male colleagues as her best ideas. "When I go to work, I dress to knock their eyes out," says one. "I've found that it makes as much impression as good work, and

insures that they [men] listen when I talk. But by doing this, I have lost much respect for them and their value system. It is as degrading to them as to me."

If women who are breadwinners, or who simply desire careers, are afflicted with so many problems because of their sex, what of women who still adhere to the traditional male (and especially Southern) image of them as "something special—to be treated with kid gloves, belonging mostly in the home," as a businessman puts it? Because of her election to remain outside the workaday world, is she less oppressed by the effects of sexism?

The wife of a northside Atlanta attorney and the mother of three children, makes a statement that illustrates the contradictions and conflicts inherent in her mode of living. "I'm typical, I guess. I drive a station wagon, but I don't like suburban life. I feel strongly about myself as a person who is both learning and aging at the same time.

"I find myself envious of men, period. I like men and admire them more than women because of their freedom. For instance, I chose not to go on tour with a local theatre group because I felt it might demean me in the eyes of my young son. With my infant daughter, I have a new life to take care of, but I'm still searching for my own. As soon as she's older, I want to escape, almost to the point of wanting to lead a double life. Right now, I live off the fantasy of what her life might be as a young woman; I will recommend that she develop whatever potential she has. This is no life for a person. I have a hard time accepting what has to be done—all the dirty work. But some days I feel superior because I render to my children what no man can. Other days, when things are bad, I feel no person should be submissive to another. Still, we don't want a society in which masculinity is reduced—the caveman thing will still be popular in 1984." With all her displeasure at her situation, she believes that "women must be less so men can be more."

"Middle class white women are oppressed whether they know it or not," says Louise Watley, a black woman who is an outspoken leader in NOW. "In keeping up with the Joneses, in trying to give a good party, in thinking about whether or not to have an affair, or wondering if their husband is. Why else do they take tranquilizers and drink so much?" She noted an old saying in the black community, "Nobody's free but the black woman and the white man." Black women, because of long experience in a matriarchal culture, seem to handle responsibility and complicated roles with more equanimity than their white sisters. ("At faculty get-togethers, you always ask a black woman who is a faculty wife what she does," says a woman who taught English at Spelman. "All of them do something, usually in a professional capacity.") Black women feel they are already more liberated as women than their white counterparts. They have long acted as heads of households and their men are as accustomed to leaning as being leaned upon. Black women feel that white women have much to learn from them about independence. At a recent Georgia State University symposium on "Upward Mobility," Bunny Jackson, wife of Atlanta's Vice Mayor, entitled her talk, "In Defense of Homemaking," but was applauded by the women when she said, "The way to make a home is to get out of it."

Though some women's lib members believe marriage is out of date ("I don't want to be anybody's property and I don't want anybody to be mine," says one), many live with men in situations that range from collective to conventional.

Loosely organized in 1968, members recently set up a study group in which they study such questions as "Are women really biologically inferior?" "Are we oppressed?" "Who benefits by our oppression?" and "Why did previous feminist movements fail?" The study group is related to the aim of "consciousness

raising"—the heightening of awareness of one's situation as a woman. And though the group energetically joins NOW to support issues involving job discrimination, birth control, abortion and child care, the differentiating quality of the group seems to be its radical—and militant—single-mindedness. "Many women are beginning to think a revolution might be necessary," confesses one. "Though our goal is simply to liberate women, we will do whatever is necessary to achieve that end."

Yet, ironically, it is often women who have "made it" who discredit the movement and the notion of discrimination.

"I'm feminine, yes, but not a feminist," asserts Marjorie Thurmond, partner in an all-woman law firm. "Though I've handled cases involving everything from corporations to murder, I've never experienced discrimination from the courts, judges, or clients." She believes that being a woman is often used as an excuse for lack of desire or willingness to work.

The feminists say the attitude of such women is similar to that of blacks who have made it. They say, in essence, "You haven't made it because you're not good enough. I am and I have." They are separatists who ignore the suffering of other women.

There are other women, too, who feel the movement is unjustified, or at least untimely. "Sure I know there's oppression," says a housewife. "The other day my maid had to wait all day at Grady Hospital for medical care, while I was waiting to go to Saks. But I'm still naive enough to believe you can overcome discrimination alone—by individual effort." ("How do you convince a middle class woman who has a Rich's card and drives a Mustang that she's oppressed?" asks an Emory women's liberation member. "How can we confront her with the knowledge of what it is to be independent and responsible, rather than a parasite?")

Atlanta painter Katherine Mitchell believes, "This thing with

men is really a kind of misunderstanding that has evolved from man being the hunter and woman the child bearer. It's not the same as racism for there is no real antagonism. If men *are* oppressors, they truly like those whom they oppress." Echoing the basic sentiment of women who object to the movement, she adds, "The best thing women can do for women is to distinguish themselves as individuals."

O. Henry Harsch, an Atlanta psychotherapist disagrees. "The liberation movement is entirely justified," he says. "In my practice, I see many women who are depressed but don't know why. What they assume are the problems of life are really the problems of their second-class citizenry." Yet he ominously predicts a change, if it comes, will be difficult. But the major problem will be that "a large majority of the oppressees agree with their oppressors." He predicts the movement will be headed by angry, aggressive women who will turn men off by their methods.

Others envision, like a rainbow in a dark sky, a utopian age when the relations between the sexes will be enhanced because of woman's new ability to relate to her man as a whole person. "The more a person can be, the more he or she can enjoy another," says Dr. Harsch. Some hope for the day when men can be "househusbands," or perhaps work only twenty hours a week, sharing with their wives the chores of home and children; and when women can exercise a healthy aggressiveness that permits a man the luxury of an occasional restful passivity.

"I, for one, would like my wife to bring in more of the family income," enthuses Dr. Harsch. "And if women's liberation has its way, she won't mind at all."

1970

Mesas to Magnolias:
A Southern Woman in the West

Before visiting Wyoming last spring for a reading tour, I had nightmares: I knew I would be driving throughout the desolate state alone in a rental car. Though I had visited a couple of years before by plane, I recalled looking down during what felt like riding a bronc through the air currents. The landscape I had seen beneath me had looked as barren and cratered as the surface of the moon.

I had remembered writing the first draft of a poem, "Living on Rape Time," in my room in what I thought of as the Cheyenne Hawaiian Hilton because of its pastel resort architecture and Western stores and cowboy bars. Eating dinner alone in the motel dining room, I had realized that the men at the table next to mine were speaking of me, my physical attributes, loudly and openly. Awash with my first full awareness of the paranoia I continually carried with me when traveling alone, I had rushed to my room to record the images that were bombarding me.

I thought, too, of the five days I had spent at the Virginian Hotel in Medicine Bow, where I had been deposited after a two hour drive past nothing but mountains in "white-out" and antelope humped against barbed wire. ("They've never learned to jump fences—just stack up against 'em and die when they run out of grass," my driver told me). From what looked like a two story structure from a Western movie set, across the highway from a railroad track and nothing much else, I was to be driven for each

of five days to schools in the area ("the area," I soon learned, consisted of anything up to 150 miles).

During my stay, I had quickly eaten an early dinner of whatever variation of beans the cafe cook had prepared that day, then retired to my red velour papered room to dream of azaleas, of my daughters in Atlanta and once, of my mother, dressed in a cream satin blouse, smelling of gardenia perfume, but bandaged stiffly across her chest where a breast had been removed.

I had woken sobbing, filled with presentiment, but had been afraid to go into the hallway to use the only telephone. I had been terrified that the sun-and-wind burned miners who were the only other guests at the hotel, and who filled the bar adjoining the cafe each night with drunken shouts, would become aware that I was there alone.

I had felt like a captive in a room in the old quarter in Tangier. How did Western women deal with it? On my previous trip, though buffered by my male hosts, I had had hints of a female strength and resiliency that fascinated me. There had been the unofficial state poet laureate, a woman in her sixties who drank her bourbon neat and who still bore on her cheeks the broken capillaries that were the marks of the time she was trapped in a wagon in a blizzard as a child.

I had heard stories of the ranch women who spent six months of each year a hundred miles from a drugstore or doctor, with only a short wave radio for communication with the outside world. And everywhere I had seen faces—of women in cowboy bars, as lined as those of the men; of Indian women, walking a half foot behind their men, of miners' wives stepping outside their trailers in pink hair rollers, babies over forearms—that seemed to contain secrets of survival that I wanted for myself.

Still struggling to exorcise the remnants of self-contempt and

passivity left by a Deep Southern upbringing, I wondered how they dealt with a landscape even more inexorably dominating, a culture more blatantly male chauvinistic.

If these women had developed special survival skills, what had been the price to themselves and their daughters? (I had long since realized that the necessity of development of such skills had left me with deficits in personality and energy that might have been spent on self, in a less difficult culture.)

Did they, like me, find themselves eventually becoming addicted to the very conditions that made survival skills necessary? What happened to the women who didn't quite make it—what was the Western woman's equivalent of the Southern woman's "nervous breakdown"?

And were relationships between the sexes like what I thought of in the South as "Southern Comfort"—a kind of sticky-sweet sentimentality masking the punch of violence, a flavor intensified by accentuated differences? It was not accident, I suspected, that the Rocky Mountain West was the one other area of the country where the music indigenous to Nashville and Macon, with its sexist-sentimental lyrics (which can still reduce me involuntarily to tears), is as popular.

This time, as I drove past mesas, buttes, and oil rigs plunging enormous insect heads rhythmically into the earth, I determined I would find the answers.

It was in Gillette that I met the first of the women from whom I would learn during the next two weeks. A brunette Dolly Parton—dressed in cowboy boots and jodhpurs, dark curls cascading down her back in spite of her thirty-eight years—Claire appeared in the back of the classroom where I stood reading poems to fifth graders. She had heard of me, she said, and asked if I'd like to have lunch.

During the next forty-eight hours, I became, with her, part of what is know as the "Gillette Syndrome" (apparently a non-dif-ferentiation between night and day, with much of the time spent in bars, or recuperating to go to bars; ". . . and the blood *really* flows on Saturday night!"

I met her ex-husband, still her lover, who talked about money and mineral rights as though they were the words to a country song—and his one refrain, aside from allusions to our looks or his sexual prowess.

I was "set up" with her college friend, a rancher-lawyer-bar owner who picked me up in his red pickup, drove me around alter-nately talking over CB radio and looking down my blouse; told me that I wrote that "women's lib" book because I'd never found an adequate man; and fed me French fried Rocky Mountain oysters, describing to me as I ate (or tried to eat them) how he himself cas-trated calves on the ranch: "There we just throw 'em on the fire like hot dogs!"

When he suddenly stood up to leave for Denver with his "pod'ner" to interview for strippers, he said to me, "I'll be down to Lar'me to meet you next week."

"Don't count on it," Claire whispered from my other side.

Together, Claire and I cruised bars, danced with miners and cowboys, and weighed propositions; until in the middle of the second—or was it the third?—night, she stood up as abruptly as had the rancher, and announced she had to go.

Where? "To South Dakota, to see my race horses; it's only a four or five hour drive." As we walked out to the parking lot together, Claire stopped to talk baby talk to two snarling dogs in the back of a pickup ("Aren't they cute, guarding the truck like that?") while I thought shudderingly of infinite space and black-

ness, the Rocky Mountains, and the roads like rough roller coasters that had brought me into Gillette.

The next morning, through the throbbing of my dehydrated brain, I heard the phone ring. "Hi!" said Claire brightly. "Some dude left an orange jacket over in my room at the Ramada Inn. Pick it up for me, will you? I'll get back to you next week in Laramie."

Claire was the first I met of a breed of women who appeared to thrive in their brutal environment like flowering cactus in the desert. There was Morgan, a stocky, halo-haired woman in her mid-twenties who worked as a laborer in the oil fields (and who complimented me on my guts: "You drove here alone on *that* road—it's one of the worst in the state!")

In a bar, I mat La Rue, a jolly, waitressy-looking blonde, thirty pounds overweight, who had been widowed three times and left wealthy on the proceeds. ("Gillette men work themselves to death so they can leave their widows rich," the rancher told me proudly.)

And I heard of the failures of survival. The isolated ranch women often simply rode off into the snow (or less destructively, with a ranch hand). This happened so often that the poet laureate told me over bourbon and the usual bloody meat in a "supper club" in Casper that she felt she could accurately predict the phenomenon in other women.

She pointed out across the room a taut, weathered-looking woman in denim ranch clothes, whose eyes, indeed, held the desperate vacancy, the unfocused quality, that I recalled from weeks before my mother's first breakdown. "But there's nothing you can do—you can't tell them," she added; it was as though the failures in adjustments were acts of nature. (Casper is said to be the windiest spot in the nation; local mythology says this leads to the

comparably high suicide rate: "The winds drive people crazy here.")

The miners' wives turned out to be engaged in a merry-go-round of shift-change love affairs, with frequent divorces and remarriages designed to break the monotony of their trailer-and-child bound existences. "My new daddy used to be your daddy," I heard a fourth grader say conversationally in one of the trailer towns I visited. Apparently, stimulation for these women could rarely be found outside a lover with a shift difference from one's (present) husband.

Everywhere, there were the ubiquitous women, heavy of the thigh and teased yellow hair, who appeared to have embraced totally the Western-and-Southern male's notion of women as either on the pedestal or off it.

That legalized prostitution recently became a part of the West again (in Nevada) logically reflects the hard-bitten pragmatism about the use of one's sexuality that is the resort of women to whom other avenues, even tenderness, seem blocked. Indeed, I wondered if Claire was in love with her ex-husband, or his idea of himself as a future millionaire. "At my age," she confided practically, "I only want to get really involved with men who are rich."

Claire's attitudes seemed characteristic of Western women. Though her ex-husband's intermittent trips to a pay phone to make calls to other women brought tears to her lovely mascaraed eyes, she wasn't sure the relationship was practical. Madge, an elegantly slender ranch wife (I later saw the pants suit she wore in the Sears and Roebuck catalog, one of the more expensive items listed), was mother of four and mistress of both town and ranch houses. She no longer loved her rancher-husband, she confessed, but would remain married to him in order to insure her children's inheritance of the ranch.

The lonely toughness of these women reminded me of my own crazily over-developed defenses. Yet just as mine seem (most of the time) perfectly rational and necessary to me as a woman and artist in the South, their realism and practicality seemed demanded of them by both the harsh physical environment (with winter temperatures often falling to forty degrees below zero), literal isolation, and the chauvinistic culture created by mammary, mama, and money obsessed Western men. On a ranch or in a mining town, there is no place for the kind of magnolia-delicate hysteria so highly developed in the South; black maids and mammies don't exist here and never have.

It was this that I perceived as the major difference between me and my Western sisters. Their survival was literal, physical; that of women in other parts of the country tends to be psychological, even their mechanisms of manipulation.

Though a Southern August can feel like living in a tank full of hot water, the fetidness that accompanies lushness can't compare with the wind off the Rockies and distances of hundreds of snowbound miles. Walking across a mesa outside Powell, looking, with a friend for fossils (or fish—the area was once the bottom of a sea); gazing out across a space that looks endless, uninhabitable, if harshly beautiful, I found it hard to believe that the Western migration had ever taken place—though I *did* expect cowboys and Indians to come galloping from one of the distant chasms at any moment!

Some women, like Morgan, had migrated west *because* of the possibility of a pioneering life, of testing themselves against the elements of sexism. Morgan had been photographed by a playful friend out at a rig, seated beside a fellow worker who read *Playboy* as she held *Playgirl.*

But in spite of a "we're in this together" kind of camaraderie,

relations between the sexes are as intense and based on differences as they had been in rural Georgia, when I had walked to high school each day in ballet shoes, disregarding that their delicacy required a new pair every month.

Yet dancing (or "stomping") at the Brass Boot in Cody, I recalled the chauvinism of the Billy Carters, James Dickeys, and Greg Allmans of my world as effete, subtle compared to that of Western men. In Savannah, a city said to be as beautiful as a woman, it's difficult to tell—among the antique-and-Conrad-Aiken-loving upper middle class—whether a man is a heterosexual or homosexual.

In the West, open homosexuality, *especially* lesbianism, seemed an impossible alternative. When I attempted to speak of it to the rancher, I was quickly squelched. Anything other than straight sex is still "sick" here, though he also told me, "Sex is our fun—we just don't believe in that 'love' stuff." The Devil's Tower, a 1280 foot phallic jet of rock, spewed up from the earth fifty million years ago in the northeastern part of the state, still seems an appropriate symbol of the culture.

It's said that everyone in Wyoming knows one another; and as the poet laureate and I sat in the Casper supper club, she waved to a man who she said was running for governor on family "oil money." As he turned a perfect profile, black hair slicked back thirties style, he looked to me like a character out of Scott Fitzgerald, an Eastern oasis in a roomful of cowboys.

In a few minutes, he came over to our table; and hearing that I was from Georgia, faked a Southern accent to begin a story about how, as a Yale undergraduate, he had spent summers with his roommate in Savannah, "loadin' sugah at Dixie Crystals all day, and dancin' with the deb-u-tahnts all nite."

But I sensed that beneath, he was still too close to the rancher

and Liver Eatin' Johnson to have acquired the kind of prep school charm and cruelty of well-off Southern men (though his permanented wife—waiting stoically at their table—*did* exude the kind of passivity I was used to seeing in Atlanta matrons.) He remained a part of the environment that made it necessary for Claire, Madge, and the fifth grade girl who proudly wore earrings made from the rattles of a snake her daddy had killed out on the rig, to adapt.

As a Southern woman in the West, I felt comfortable—too comfortable. It was easy for me to slide backwards into the butter-wouldn't-melt-in-my-mouth attitudes in which I had been schooled (unsuccessfully, my mother felt) since the age of two. It was easier still for me to give up for a while my usual pattern of paying for my own drinks and dinner.

More frighteningly, I found myself in touch with my own potential for violence. I, who shuddered at the traps my stepfather set out for moles on his farm in North Carolina, found myself wishing I had time to stick around for the June bloodbath that is the one day of the year on each ranch when the calves are simultaneously castrated, dehorned, and branded. I *wanted* to be a part of rodeo days in Cody, when guns are said to go off at random.

On my first trip to the state, I had found shocking the preponderance of whips and spurs, and the size of the branding irons, in the Wyoming State Museum in Cheyenne. I had been appalled at the emphasis on cowboy culture, and the de-emphasis of that of the Native American. Now, I found myself in the thrall of the Western mystique, bloody steaks, sexism and all—and recognized how smoothly I had been prepared for it by the major Southern violences I had barely noticed, so busy had I been struggling with its violences to my own autonomy.

Western women, I found *seemed* less passive; but as every Southern woman knows, her passivity is partly pose. Their

strengths, like those of my sisters in the South, had developed both in spite of and because of their environment.

Flying back toward Denver to meet my Braniff flight for Atlanta, I no longer even noticed the buck of the Western Airlines plane. Instead, I consoled a man from Atlanta on his first plane ride. (He had come west on a Greyhound bus, he told me, and was never coming back, much less going up in a plane again.)

As our plane swung through the endless blue-white that the Wyoming Chamber of Commerce accurately calls the Big Sky, I felt as endangered and exhilarated as though I had been on a white water raft trip down the Snake River, or sky diving for the first time. I was no longer terrified of driving several hundred desolate miles alone, or even checking into a hotel full of miners by myself.

At nine, "My Friend Flicka," written by Mary O'Hara on a ranch outside Cheyenne (had she been trying to avoid snow-bound neurosis?) had been my major influence; at eleven, I had written in my five year diary my ambition of becoming a mother of six who wrote novels while cakes baked in the oven. In Wyoming, I felt my pubescent fantasies suddenly revived—that all I would have to do to fulfill them would be to buy a cowboy hat and take riding lessons.

Our shared sisterhood seemed understood by the middle-aged ranch woman who came up to me after my reading of poems crammed with images of Southern feminine frustration: removing a jade ring from her finger, she silently placed it on mine.

1977

In Search of the Macho Man

It started one Saturday morning in June in Savannah. Watching an ocean liner move as slowly as sorghum syrup down the Savannah River, my friend Madge and I sat sipping Bloody Marys. A visual artist, Madge was broke and looking for a job. "I heard of one you might like, too," she teased. "It's on an oil rig a hundred miles out. They want women aboard to help 'civilize' the men." Despite more than a decade's difference in our ages—my forty-three to her thirty—Madge and I shared a taste for cream-filled Dunkin' Donuts, frosted nail polish, and a certain kind of girl talk. We both laughed self-consciously, visions of sugar plums—or the male equivalent—dancing in our heads.

An out-of-work writer, I idly wondered whether a gig on the rig might not recoup my nonexistent bank account and get me away from my frustrating boyfriends, who had recently included a staid-but-married philosophy professor, a painter who had dropped so much acid that he didn't care anymore, and a vegetarian who had been celibate for eight months. More than outer space, quantum mechanics, or the phenomenon of Billy Carter, men puzzled me. The rig might be a good place to find out what *they*—that ever-mysterious Other—were like in their simplest, most primitive form.

And I knew that at heart I was still the Southern girl who grew up necking in the backseats of Chevys while Hank Williams

played on the car radio; a woman hopelessly imprinted with a taste for cowboy boots and Stetsons, beards, and pickup trucks. Why, my favorite daydreams were of working on the Alaskan pipeline, or as a dance-hall girl in the old West.

Despite my fantasies of biceps bulging beneath tight T-shirts and rock-hard asses cupped by shrunken Levi's, I still didn't imagine that within a week I would actually be one of the first women aboard an offshore oil rig I'll call the *Venus,* working as a steward—maid—to seventy-five men at the far end of the spectrum of macho.

Yet by Wednesday, we were descending by helicopter to the oil rig deck. "Do you think it'll be like Club Med?" Madge whispered as we walked through what looked like a crowd of cloned Marlboro Men. From the disapproving look of the man leading us, I didn't think so. Over coffee in the galley the chief steward described our duties. We would work from eight in the morning till eight at night, with thirty minutes for lunch. Besides cleaning the bulkhead—the interior wall that looked like a baby had smeared it with black grease instead of feces—until it was pristine, we were daily to make eighty bunks. We would sweep, dust, mop and straighten each cabin beginning, *first thing,* with the cabins of the big shots: the tool pusher, tour pusher, company man, and ship's captain. Next, we would clean the baths between the better cabins, clean the latrines, sweep, mop and wax the companionways—halls—on each deck, then clean the rec room and tool pusher's office. In our *spare* time, we were to consult the chalkboard in the galley for wake-up times; the bosses, he said coyly, *liked* a cup of coffee in bed, and it was *good* to find out *how* they liked it. Oh yes, and polish the brass that beautified the doorstep of every cabin and latrine. There was *nothing* as distasteful as mossy brass, didn't we agree?

Glancing at Madge, I saw that she, too, looked delicately faint. The rest of the day became a blur of scrubbing that grease from the bulkhead and breaking each of my carefully Revloned fingernails.

Ironically, it was a situation for which my Southern upbringing had prepared me. Within a week—as though all my years of ardent feminism had never happened—I had reverted to the docile, honey-dripping, man-pleasing ways at which I had been so adept as a fifteen year-old cheerleader. A dozen times a day, Madge and I battled for space before the one tiny, broken mirror in our cabin, reapplying mascara and lip gloss. Because they were cooler, we told ourselves, we wore flowered cotton skirts and low-necked blouses; bare feet and painted toenails. The only thing I lacked in life was a flower to stick into my sweat-tendriled red hair.

Soon, living in what could only be called close quarters with sprawling, drawling, brawling men—ex-rangers, rodeo riders, cowboys and barroom buddies—I began to believe I really was that dance-hall girl in the saloon, and I began to get in touch, for the first time, with the Power of Sheer Lust.

In theory, of course, I had always believed it as much my right to fuck oil riggers and truck drivers as that of my white-collar male peers to bed waitresses and secretaries. But in practice, I—like most women—prided myself on choosing lovers for such "finer" qualities as sensitivity, intelligence, aesthetic refinement, and that catchall seventies' virtue, awareness. This was probably why I had ended up, pre-rig, with so many hormone-deficient boyfriends.

On the *Venus,* surrounded by men with whom I believed it impossible to have a "relationship," I was learning that sweat was definitely an aphrodisiac: Eating black-eyed peas beside a man in filthy Levi's, his arms smeared with black grease, now turned me

on as much as sharing caviar with a Richard Gere-type in an Yves St. Laurent suit. Yes, these were Real Men who put first things— like sex, country music, sex, pickup trucks, sex, good bourbon, sex, cockfighting—first. I noted how *they* noted everything about me, every moment of every day. "Ya-HOO!" yelled three riggers at once amid a burst of spontaneous applause as I emerged from the walk-in freezer with a frosty Coke and hard nipples.

A curly-haired blond hulk with a chipped front tooth and muscles like logs bulging through his torn black T-shirt, Bobby pushed himself back in his seat across from me at the galley table and chewed on a steak bone. "Thank Gawd I'm gittin' off this thang!" he said across—or was it to?—the bottles of A-1, Hunt's, and Louisiana Hot Sauce. "Been on here three weeks now," he added, carving the steak shreds from between his molars.

"What do you plan to do first?" I asked in my best social-worker voice. It was a tone I had found drove the men mad—undoubtedly it reminded them of mama—and, at the same time, kept them at bay.

"Whut do yuh thank?! I'm goin' into Savannah to git me some!"

"Do you know anyone there?" I interrogated brightly, recalling the way he had looked at my tits when I had come out of the freezer.

"Nope!"

"Well, how do you know you'll be able to—uh—'git some'?"

He looked at me as though I were infinitely stupid. "I'll jes' *git some,* that's all!"

Here was a man who was sexually confident, yet definitely in need, I thought as he casually changed—or seemed to change— the subject: "I'm gonna be fishin' up off the deck later on. Why doncha come on up 'n set a while?"

After Madge and I swabbed down the galley, I showered and changed into a flowered skirt and blouse and coral-colored bikini panties. When I arrived on deck the wind blew my skirt up to crotch level; holding it down a la Marilyn I walked across the heliport toward Bobby. Staring at my thighs, he offered me his chair and leaned against the rail. As the moon rose and waves washed the decks of the supply boat below, he thrilled me with tales of his sad life as a ranger, a paratrooper, a sniper in 'Nam; as a bronc-bustin', rodeo-ridin' cowboy in South Flarda; of his marriage to a bad wo-man and the loss of his child. "I lost it all to thuh love of a lady," he said mournfully. His words tugged at my heart strings like the lyrics to a Willie Nelson song, rousing my tenderer instincts and at the same time fusing a direct line to my cunt. He was sensitive, I told myself. The thighs bulging like tree trunks from his khaki cutoffs had nothing—at least not *every-thing*—to do with it.

When he opened a nearby hatch and climbed down the ladder, I descended after him, holding his outstretched hand and pretending not to notice as he looked up my skirt at my coral panties. While he pulled me toward the radio man's cabin—the radio man, smoking a joint, smirked and left the room—I wondered what sex with Bobby would be like. Would he be the macho man of my dreams, more effective in every way than my male peers? I didn't have time to think about it. "I saw you with thet purty red hair 'n I knew I had to have yuh," he slobbered into my neck, tearing my blouse, skirt and bikinis down in one motion. "'N I jes' *love* suckin' pussy, girl," he added, pushing me into the bottom bunk with one hand and unzipping his cutoffs with the other. Crouching beside me, he forced my thighs open for what seemed like a minute of lapping by an overenthusiastic German shepherd, then five minutes of fucking that alternately felt as

though I was being pounded by skin-covered rocks or smushed by a 10-ton tractor.

"How'd yuh lak it, girl?" he asked proudly.

"It was—breathtaking," I replied honestly.

"Wall, guess we better be gittin' on back," he said, lifting my hair to inspect the bruise I could feel developing at the side of my throat. When I got up to dress, I noted with chagrin the blood and-come flowering on the radio man's sheets.

Something had happened, and I knew it wasn't orgasm. So it must have been that Other Thing. "I think I'm in love," I told Madge back in our cabin. She sat naked in our one chair, her painted toenails poised on the edge of my bunk; we were stuffing chunks of cake with white icing into our mouths and washing them down with straight Black Jack "What? With that hunk?" she snorted. From Minnesota, she had a clear Northern vision denied me as a Southern woman. "Hey," she added, "he must be something in the sack—I mean, bunk—to make you say that after giving you that gross hickey!"

"Well, he's sweet," I defended, ignoring her implication that maybe—just maybe—his spectacular build had something to do with my feelings.

Indeed, Bobby reminded me of Ferdinand the Bull, or the second-grade boyfriend I had had in the fifth. Unlike some of the screwed-up urban men I knew, I doubted that he would ever choose jogging or transcendental meditation over fucking, or insist I wear black stockings and garter belt sans panties on dates for which he arrived three hours late, already too drunk to get it up. No, I suspected, as long as I had two breasts, and two legs I was willing to open at his command, he would be as euphoric as Ferdinand in a pasture with ten cows.

Sure enough, I kept him happy by going down on him, his

massive back against his cabin door (yes, he *did* like sucking—me, of him), and by letting him fuck me during seconds stolen from my endless mopping (once leaving a tampon in a C-deck wastebasket to be emptied by an incredulous Madge). He'd flop sweatily on top of me in the middle of the night, despite Madge's irritated comments from the top bunk.

Reverting to my Southern mama's teachings about the male ego, I tried not to use words like "extraneous" and "credibility." Never mind that Bobby didn't know what "incompatible" meant ("Mah wife said it meant we didn't git along too good"). I was *tired* of talking to men about their post-divorce traumas, their mid-life crises, and the positive powers of est. When Bobby swaggered past me and grabbed my ass, grinning and sweating in his torn jeans, I really understood for the first time what men see in the kind of two-digit-IQ females who the rest of us women scorn as "only sex objects."

And he wasn't really *that* dumb, I told myself, probably using the same kind of reasoning men use. It was just a different *kind* of intelligence. Despite our disparate life-styles, I began to imagine that he could be trained in the arts of graceful living, equality of the sexes, and even open relationships. "I'm not gonna hold yuh to not doin' it with anybody else," he said as he bent me backwards in a spine-rending kiss. With the naiveté of a *Psychology Today* liberal, I believed him. It didn't seem too important when I let J.T.-the-tour pusher—the craggy, sixtyish, night boss—tug me into his bunk when I woke him with a cup of black coffee. I admired his still-powerful nude torso, his macho tales of oil-field fights and South American whorehouses. Besides, I had been mopping all day and wanted to lie down. "I kin make thangs easy out here fur yuh, gal," he said persuasively, adding the bit of pull necessary to make me melt onto the mattress beside him. When it

turned out that he liked foreplay—at least, he-to-me—even less than Bobby, I told myself it was a generation gap, a notion reinforced when he told me that his sweet lil' wife of thirty years "never *touched* me down there with 'er mouth." But I wasn't a wife, was I? In J.T.'s view, though, my status as oil-field trash made it unnecessary for *him* to please *me*. The whole thing was over in less-than-satisfying minutes.

"One year, I wuz in so many fights that I changed jobs nineteen times. When I wuz made driller, I wuz only nineteen, the wildest 'un in South Texas, 'n the girl I marrid wuz the purtiest. Fur thuh longest, I didn't even try to kiss 'er. Fin'lly one night I said, 'I'm gonna kiss yuh, gal, 'n if you try to stop me, I'm gonna slap yuh.' So she let me kiss 'er 'n other thangs, too. . . .

"Thuh first year we wuz marrid, I kept on goin' out with oil-field trash. I laked to drive 'em wild, gettin' 'em hot, than laughin' in their faces, known' I wuzn't goin' to go out on my wife. I *never* let *her* look at me or touch me down there. I still don't lak to see a nekkid wo-man—I wont 'er to wear a lil' baby-doll pajama or sumpthin'. . . The purtiest thang I *ever* seen is a mare with 'er colt, or a cow with 'er calf. . . . I guest I hated wimmen in a way . . ."

As he talked, Bill-the-tool pusher spit tobacco juice over the rail into the sea. We were sitting on a couch he had ordered two roustabouts, like slaves in old Rome, to bring up to the deck for us when I said I wanted to look at the ocean after supper. Bill had begun coming up to me two dozen times a day to make some out-of context comment about my qualities as a cleaning woman; it had taken me a while to realize that, rusty from thirty years on oil rigs and nearly as many of monogamous marriage, he was flirting.

Bill's jeans were tight over his ass, his work shirt stretched across labor-broadened shoulders, his eyes were a hard, clear blue, projecting a gaze respected by every man on the rig. Now

they followed me with a look of infatuation, but it was not just sex he wanted. Bill followed his own rules, and one of his rules forbade fucking on the rig. When he said he was thinking of moving to a rig in Peru and taking me with him, I was puzzled. Why didn't he just make a pass, since everyone on the rig already assumed he was sleeping with me? "Nope. It's all 'er nuthin'," he said firmly. I felt flattered but uncomfortable: As a Southern woman brought up to indulge daddy, I found his fatherly approach incestuously sexy. I wondered aloud how he would feel if he knew how I really lived. "I don't keer whut you done before," he said with grave simplicity. "That's between you and yore God. Lots of wimmen are lak ten-cent novels," he went on, "but you—you're lak' a book a man could read forever."

On the last night of my shift—the July temperature 102 degrees, the air conditioning broken again—Bill commanded two roustabouts to carry a mattress up to the pilothouse where I might sleep more comfortably. He laid his big hand on my thigh, uncovering where my legs crossed beneath my cotton skirt. "No man has ever wonid you in yore life as much as I do. But I cain't stay up here with you."

But where does that leave my desire to get laid? I wondered crossly as I rode the elevator back down to B-deck. Walking past the open door of Otis-the-welder's cabin, I saw him toweling his homegrown extra-large torso. "What you doin'?" I asked. In minutes, we were in the bottom bunk, my painted toenails sticking through the inadequate curtains, sliding around like crazy beneath a centerfold of a girl who looked ready for a gynecological exam. Otis adored all the nuances neglected by Bobby, J.T., and probably—I projected—Bill. Despite going barefoot in Alabama till fifteen, he was at least cognizant of the clit.

Back in our cabin, Madge was lying on her bunk, dipping soda crackers into a can of Hershey's chocolate syrup ripped off from

the galley. "You look like the cat that swallowed the canary—or something," she smirked. "Who was it this time?"

"Did you know Otis is possibly the best lay on this rig?" I asked.

"But what about Bobby? Isn't he the one you're in *love* with? And J.T.? And Bill?"

I mentioned J.T.'s Madonna-Whore split, Bill's preference for mares and colts, and the fact that Otis was being transferred before long to a rig at the South Pole. Then I asked her seriously, "What do you *really* think about these guys, anyway?"

"Well," she said, a stream of chocolate dribbling down her chin, "they're just like any others, I guess."

"But don't you think that—despite their lack of . . . uh . . . subtlety—they're *high-energy, passionate, adventurous?* Just like the pioneers who settled the West?"

"Nope," she yawned, dabbing at her chin with a Kleenex. "They're just like all the rest."

Back in Savannah for two weeks, I joined Madge in trips to Dunkin' Donuts and river-front bars, and in showing over and over—till our "outside" friends began to gag—slides of the drill-rig floor, the lifeboats, the galley, and of us sitting in the laps of our muscular-and-tattooed new pals. One ex-lover—an accountant with a taste for garter belts—particularly disapproved of my fondness for the riggers: "I guess *their* pricks are always sticking straight up," he said sarcastically.

In a few days Bobby phoned, alternating between phrases like "I love you," "Did yuh do it with anybody else?" and "You're muh woman 'n I'm comin' up there." Before I knew it, he was throwing his Bowie knife at the roses in my wallpaper, enthusing about what a good gun rack my French armoire would make, and lying around naked in my four-poster bed. I was running to the liquor store for more Chivas (riggers are big spenders) or standing over a hot stove in July, boiling up crabs or gumbo.

Off the rig, Bobby was something else. For one thing, he was drunker. For another, with none of his energy absorbed by twelve-hour shifts on the rig, he was as overpowering as hurricane David. Each day since his arrival, he had faithfully phoned his sweet lil' mama down in Flarda. "Come on, girl," he now commanded out of the ozone, "we're goin' down there!" Fifteen minutes later, he stood impatiently beside my Fiat as I lugged over a cooler of Heineken and an inflatable beach float. That night, he grinned and tugged me toward the bed where he lay drinking Maddog 20-20 in the cheap motel halfway to Tampa. How could he possibly want sex, I wondered? He'd stopped every hundred miles for a blow job.

Bobby's mama's mouth was prim as she dished out the field peas at the dinette in their mobile home: We weren't married, and instead of being a good local girl, I was oil-field trash. Big Bobby, Bobby's daddy, looked like the daddy of all South Florida rednecks. The boys were drinking Pabst, and I wanted one too, but I knew that since I was female that wouldn't do. Determined to be submissive, I drank sweetened iced tea and looked at baby pictures of Bobby for two hours while he and Big Bobby went off to shoot their guns.

The next day, his lil' mama got the Greyhound to visit her sister in Eufala, and Bobby and I went out to look at Ford pickups. Later, when we stopped at a supermarket, he instructed me to go inside and buy Pabst and chicken gizzards "while I jes' set out here 'n look at thuh pussy."

Back in Savannah, we put the slats back in my four-poster bed and I packed Bobby's bag for his gig on the rig. "I'm gonna keep *this*"—he shoved me back on the tangled sheets, pushed up my nightgown and clipped a pubic curl with his pocket knife—"in mah billfold to sniff on."

I had only a week more to recuperate before my second shift on the *Venus*.

When I arrived with an azalea in my hair, Bobby pushed me against the wall and kissed me, but he wore a scowl. "Thuh word's out Bill'll fire me if he finds out. Ev'rybody says he's after you, 'n they're sayin' a *lot* of other thangs, too," he growled, enumerating a list of reputed fuckees that amazed even me. In addition to scrubbing and mopping twelve hours a day, I now had to reassure Bobby by going down on him five times a day instead of three. Bill insisted I eat every meal with him, and spend my evenings with him on the deck. As the boss's girl, all I got was the right to take a nap each afternoon when, as likely as not, I would find Bobby, all 220 pounds of him, sacked out in my bunk awaiting the matinee he now considered his due. And with the force of a semi hurtling down the straightaway between Macon and Savannah, J.T. and Otis forged ahead in their belief that since they had had it once, my body was theirs forever. I was finding out that the sexual freedom I took for granted as a single woman could become cause for chaos in the closed world of the rig.

Unlike my consciousness-in-flux, the riggers' minds were untormented. When Bill sent a new woman "back to thuh house" —fired her—for sleeping with the company man while the man stayed on, he couldn't understand my anger. "Whut's it to you? She's not yore special friend or anythang." As I tried to explain sexism and situational ethics he looked as puzzled as though I had been speaking Chinese. After all, a woman's place was in the mobile home or the whorehouse, wasn't it? I was learning that despite the tremulous look that crossed his face at the sound of the word "Texas," or at John Denver singing "Country Roads," his sensitivity didn't extend to women, blacks, or Jews.

The following morning, folding a T-shirt that read, "Hondas were created to keep niggers off Harleys," I wondered what else

would anger me that day. I was beginning to feel like I was living amid a chorus of randy Randy Newmans constantly singing "Good Old Boys," but instead of enjoying their attentions, I felt like slapping them off like mosquitoes. I was turning into a shrew with seventy-five husbands, a blue-collar wife who yelled at the men whenever they walked over my freshly mopped floors. "Don't you have any work to do?" I lashed out at Bill when he interrupted my scrubbing for the twentieth time in one day. "If you wanted us out here for companionship, you should've hired geisha girls!"

When Bobby told me that he wanted me to quit "cause I cain't stand 'em lookin' at yuh 'n knowin' whut they're thankin'," I agreed with relief. Back on dry land, I drove straight to my apartment and phoned in my resignation. Then I lay down in my four-poster bed for several days to sort out my brains.

Bobby called regularly over the short-wave radio to say maudlin things that I knew could be heard over the entire rig. When his shift ended, he phoned from Tampa: "I've been thankin' 'n thankin' 'n I jes' cain' stand it that you did it with J.T."

"But Bobby, you *said*—"

"Another thang," he slurred, "all them books 'n thangs at yore house. I know whut you really thank—that I'm a dummy or a chauvinist or sumpthin'. . . .

"Bobby, I *never* said that—"

"Why, you don't even know *how* to be a good Southern wo-man," he went on drunkenly. "A good Southern wo-man would've slapped mah face when I said all them thangs about doin' it with dawgs, or other people. And a good Southern wo-man sure as *hail* never would've took me to a fag bar where I ended up in a threesome with a queer. . . .

"But Bobby, *you* were the one who asked him to go home with us—"

"Must be 'cause you're frum Etlanta, 'n there's so many Yankees up there," he concluded , clicking down the receiver.

I didn't care. My rose-printed wallpaper, French armoire,and I were safe. I had o.d.'ed on macho men.

Is there life after macho men?

After a few months, Madge called from Galveston, where the *Venus* had moved. "Bobby told Bill that you slept with J.T., and Bill had to be kept from killing J.T. . . . It sounded like the words to a song I hadn't heard lately. "Bobby's getting married to a twenty-one-year-old virgin; they're moving into a new mobile home. And oh, yes, Bill's leaving his wife and taking the new girl to Peru with him."

"Another thing," she went on. "We women feel like we're living in a nunnery these days.We've found out that with these guys, we *have* to stay on that pedestal." She chuckled. "But they sure do remember those *wild* days when *you* were here!"

That night I went out to dinner with an urban attorney whose articulateness seemed like a relief—till I found out he was more interested in talking than in going to bed. Maybe it was because of him that I later found myself in a down-home redneck roadhouse with a tiny dance floor, a live country-western band, and probably more cowboy hats per square yard than anywhere outside Gilley's. As I slow-danced with a bearded hunk, he pulled me tight in a bear's embrace.

"You're so purty," he crooned. "Ah'm a ranger up in White County. Lookin' fur me a wife. Kin you cook?"

1982

Secrets, Shackles, and Shame

"I'm haunted by this terrible feeling, this nightmare, that I'll never get away from Jack," Ginny Foat said in *Life* magazine in May 1983. As I read, her words leaped forth like neon; I felt that rush, almost physical, that for me signals identification. In fact, I had bought the magazine—not one I usually read—solely because of this piece.

My sister, Anne, and I had just been shopping at a glossy Atlanta mall. On her queen-sized bed between us lay a tumble of pink and mauve pantyhose for me and a lacy violet nightgown for her, plus our bounty from Walden's. Now, we sat back against the pillows, sampling the books that, along with a certain kind of lingerie and perfume, were our mutual passion.

"Here, read this," I said, referring to the now well-known and overworked facts: that Ginny Foat, a former coordinator of the National Organization for Women (NOW) in California and in 1982 a contender for the national vice-presidency of the organization, had been charged with murder on the basis of a statement made in 1977 by her former husband, John ("Jack") Sidote, regarding events that took place in 1965; and that though the charge had been dropped in one state, Nevada, she was now to be brought to trial in Louisiana, where the alleged murder had taken place. "Another good woman dragged down by a bad man," I said. "She couldn't possibly be guilty and have achieved what she has!"

"Oh, I don't know. Maybe there's more to it than that," Anne said casually a few minutes later, tossing the piece back to me, My younger sister is more pragmatic, less idealistic, than I. Which is why she still lives with her now-prosperous first husband in an elegant Atlanta suburb, spending her free time skiing at Snowmass and going to exercise class, while I've been divorced three times, live in a small apartment in the miniature city of Savannah, and entertain myself, when not behind my typewriter, by dancing at the local gay bar or cooking up potluck suppers with other down-and-out friends. By the time Anne and I went into her kitchen to start dinner, Ginny Foat had burrowed into my mind in a way that made me know already that for me, she symbolized something beyond the obvious.

For despite Anne's warier view, my identification with Foat was immediate, and as I learned more about her, would become, for a time, stronger. We were close in age, she forty-two to my forty-seven, both products of the fifties and early sixties. We had each grown up in sexist, traditional settings: she, as an Italian-Catholic in the small town of New York; I, in a small Georgia town so dominated by the presence of a stern Bible-Belt God that dancing was not even mentioned, much less allowed, at the local high school. In a photo that accompanied a piece by Teresa Carpenter in the *Village Voice,* I noted that while Foat's brows had been plucked in the thin style favored by my mother, she had worn, as a teen-ager, the same kind of ponytail I had had at that age—and had a body that, like mine, suggested a precocious sexuality.

Like Ginny Foat. I had swung, in my sexual life, from proper yet boring mates, the men my mother and grandmother called "good husband material," to the wild—often bad—guys to whom I was really attracted. "J.T. Owens can shake worster than Elvis," a girl sitting near me had carved on her desk during high school.

I, too, had preferred the boys with the black ducktails, the sensuous lips, the irreverent glances—a genre I thought of as the Boy on the Black Motorcycle—to those destined to become accountants or commanders in the navy.

Like Foat's, my life, too, had been scarred by relationships with men with problems. My father had been an alcoholic who had sexually and otherwise abused me; I had escaped him via marriage to a no-good good ole boy of nineteen who—till I fled with my two-year-old son three years later—had battered me as well. And, like Foat after Sidote, I'd had two other marriages to milder men (and in my case, two more children); but by then, I had been so marked by the violence (and excitement) of these early relationships that I had little taste for traditional men or a traditional lifestyle. Thus, like her, I had been ripe for feminism, for counterculture values when they appeared.

Yet the changes I had made had cost, inducing a recurrent case of the emotional bends, a kind of free-floating guilt at having disowned the past, my class, and especially the patriarchy-inside-me that I imagined Foat, with her transitions in lifestyle and politics, to have experienced. I was certain, the more I read about her, that Foat was being punished by a patriarchal society for "stepping out of place," becoming a feminist. In fact, in my own lowest moments, I was still trailed by someone I thought of as the Man in the Black Raincoat, who was really the Boy on the Black Motorcycle turned older, malevolent. My crime? Not being a good enough daughter, wife, mother; even thinking my own thoughts, following my own head. Were these the crimes of which Ginny Foat was guilty as well?

When I first heard of Foat, I was busily finishing a book, more than two years in the writing, through which I hoped to resolve some of these conflicts. It was definitely not a good time to start a

new project. But back home in Savannah, I learned the names of Foat's New Orleans-based attorneys, and wrote to her, enclosing a copy of my autobiographical book.

In a few weeks her literary agent, Peter Skolnik, called: he was looking for a writer to do *the* book on Ginny Foat; would I be interested? As we talked, he made clear that Foat insisted on total control over the story, its conclusions. I wasn't interested in doing an "as told to" or "with" book, I told him: I wanted to do something comprehensive, an exploration of women's dependency problems, their problems with abusive men. "Well, don't make up your mind without meeting her," he said, and I agreed: I would fly to New Orleans at my own expense—secretly hoping that Foat would change her mind, accede to the kind of book I wanted to do.

In New Orleans, I met with Foat and her companion, California lawyer Kay Tsenin, twice—once in the lounge of the Pontchartrain Hotel, where white wine was three dollars a glass; again, during a hectic trip to the airport where they drove me because it was the only additional time they could take out of their pre-trial preparations. My impression of Foat, plainly dressed in polyester pants and blouse, a sweater over her shoulders, was that of a bland woman already exhausted by her coming ordeal. Yet despite her fatigue, she was smiling, shaking hands with well-wishers in the lounge, airport, almost as though she was running for office. During the few minutes before my flight, I described the kind of book I would like to do, and pressed into her hands a gift of a collection of my poems, *A Sexual Tour of the Deep South.* "Can I have the envelope you brought it in?" she asked, quickly sliding it back inside the brown paper after I had inscribed it. Her motion reminded me of something, and then I recalled what it was: when the book had been

published in 1975, my ladylike mother, afraid that it was "improper," had asked that I bring her a copy in a brown paper sack. It was a gesture that should have hinted to me that perhaps Ginny Foat and I weren't as much alike as I thought.

When Skolnik and I talked again a few days later, he reiterated Foat's wish for a book over which she would have total control; I, my inability to write it under those conditions. In the interim, I had learned through the literary grapevine that the book had been offered to at least a couple of other writers, on what verged on bizarre terms: the stipulation that the writer could be fired at will, and rather than the usual fifty-fifty contract for collaboration, an unequal distribution of the profits with the contract in Foat's favor; also that because a movie sale had already been made to ABC, it was imperative that Skolnik find an author. "We can't have another *Fatal Vision!*" he said now, referring to the recently published book by Joe McGinniss on Jeffrey MacDonald, the Green Beret doctor convicted of murdering his wife and two children. McGinniss had begun the work believing in his innocence, then had become, during the writing and the trial, persuaded of his guilt.

Still convinced of our mutual concerns, I wrote Foat a note saying that I was sorry we wouldn't be working together on the book, but hoped she had found a writer for her purposes ("a ghost writer," I had suggested to Skolnik); and that I still intended to attend the trial, perhaps write of her. I called an attorney friend to get me out of the jury duty I had just, ironically, been called to in Savannah, and made plans to fly back to New Orleans.

The night before the trial began, I defended Foat to my friends.

"She won't get out of this scot-free!" said my conservative pal,

Madge, with whom I was staying. Since we had once shared the close quarters of a cabin on an offshore oil rig where we both had worked, I knew her well enough not to be surprised by her attitude.

"Madge, for God's sake—she hasn't been convicted of anything yet!" I argued anyway.

"But it says here that she hit a man over the head with a tire iron," she went on, misreading the New Orleans *Times-Picayune.*

"Was *charged with,* not *did,*" I protested.

"All I know is what my folks would think," she persisted, referring to her Midwestern parents: "that she's been married four times, so she could have done this, too."

"But Madge," I cried. "I've been married *three* times; you don't think I'd commit murder, do you?"

"Well, they must have had *some* reason to think she did it," she said stubbornly. At that moment, her boyfriend, Steve, came in to add his two cents worth: "She *will* be found guilty," he said with an almost bristling conviction.

"Oh, I'm glad I'm going out, to get away from this!" I said. But an hour later, at the F & M bar, I was into the same thing again: "Personally, I'd like to see 'er fry," a sensuous-lipped, Southern-voiced movie reviewer was saying to me after I had been introduced as a writer at the trial; then he went on to confess that he was in the process of being divorced from a "libber like Foat—'n ev'ry mornin' I wake up hopin' I'll git a phone call sayin' she's been hit by a truck!"

My brain was beginning to recoil at the hostility with which Foat's story was met. That night, I protectively dreamed of her, a dark-haired little girl again, eating spaghetti and meatballs in her mother's cozy Italian kitchen. Or was it me in my grandmother's

Georgia farmhouse, sitting near the fireplace, spooning up chicken 'n' dumplings?

The next morning, I automatically sat down in a pew on the defense side of the small courtroom. Already, its space recalled for me situations of shame: the Baptist church I had attended as a teenager, the preacher yelling images of hellfire and damnation, repayment for my secret sexual thoughts; as all around me sat the provincial neighbors who were my jurors; the sanctuary where I had twice been a nonvirginal, and thus impure, bride; the funeral where I had not felt proper love or sorrow; and even the university lecture hall where I had flashed on being shot as I read from the angry poems that rejected my early imprints. And once more, I was filled with grief for Foat for having to live out my worst nightmares, for being brought here to trial for her sexual sins.

Impatiently I blocked out the state's opening, then listened enthralled as defense attorney John Reed poetically recapitulated Foat's tragic life. Abortion rights, which I had been told she had worked for, had not been mentioned at all during the selection of the largely Catholic jury, but because Foat's stomach pooched a bit through her straight skirts in the not-unattractive way of many women our age who have had children, I had wondered whether she had ever given birth. Now, Reed poignantly spoke of her failed early marriage and (explaining the pooch) the child she had borne out of wedlock; her romance with, and abuse by, the monster who was Sidote; and finally Sidote's threat that if she left him, he would see her "rot behind bars" as he had.

As Reed spoke, my empathy welled to his words. In the ladies' room, where I went, shaken, during the recess, I saw Kay standing guard, heard Foat crying softly, saw her pumps on the floor in

the stall next to mine. Back in the hallway, I saw an elegant black man, erect in a silky three-piece suit, his striking blue-green eyes staring ahead as though in a trance, being led toward the elevator, in handcuffs. "The best and the beautiful," I thought, recalling the women with whom I had conducted writing workshops in prisons in Wyoming and Georgia. His proud stance while in shackles seemed symbolic of what could happen to Ginny Foat, to me, or to anyone outside the mainstream.

During that day and the next, as the state called various witnesses, I waited impatiently for the one who had caused my identification with her in the first place. When at last John Sidote was called to the stand, I remembered my father's easy charm, the fact that he had his own band in which he played saxophone in the style of Guy Lombardo at the University of Georgia. And I wondered whether Sidote, like Daddy, would have retained, at forty-five, despite his destructive and destroyed life, a modicum of that charisma.

What I didn't realize was that Sidote would even look a good deal like my Valentino-dark father. When he walked up the aisle with the cocky stride undoubtedly useful to a short man in prison, I saw that his eyes were as dark as Foat's, that he was approximately the same height, and that he must have once been a swell-looking guy. His forehead was deeply lined and marked by a broad horizontal scar, his remaining dark hair slicked back. He wore a mustache, a navy suit, striped tie, and the anguished gaze of a romantic in pain. "He looks like all my male cousins!" exclaimed one of the press corps, a woman from an Italian family. As he gave his address as the Jefferson Parish jail, I was awash again in the ambivalence I had felt toward Daddy when he had been down and out; when I, a young mother, had dutifully taken bags of groceries to him in his skid-row room, but because of his drunkenness and the revulsion

his maudlin fondling caused in me, had found it hard to spend more than a few minutes with him.

"If he's lying, he sure is a good actor!" said a spectator, echoing my thoughts after a day and a half of testimony during which Sidote had described his passionate "physical attraction to Virginia," their sleazy life on the lam, and finally—sobbing—the murder of Moises Chayo. Yet, while dramatic, these confessions were not surprising. What *was*—in view of the fact of Foat's projected book, her movie sale—was defense attorney Robert Glass' accusation during his cross-examination that Sidote had given interviews to "women" reporters from the *Village Voice* and *Rolling Stone,* and to Liz Trotta of CBS, and had negotiated to sell his story to *Penthouse.* "And didn't you say, 'This story is explosive enough, deep enough, passionate enough to make a best seller!'" Glass shouted, pointing his finger like an evangelist while making good use of a Charlton Heston profile. "And you *had* to testify—it's the only way you could sell your book!" Glass concluded triumphantly. "You beat her for five years, didn't you? You beat her before you left New York. You beat her in Florida, in New Orleans, in Nevada, in California, didn't you?!!" the attorney ranted in the rhythms of a Bible-Belt preacher. "I may have *hit* her, but I never *beat* her," Sidote answered, drawing laughter from the courtroom. "You pushed a Scrabble board over her head, didn't you?" "Yes—a piece of cardboard!" "That night she left, you almost killed her, didn't you?" "How could she be dying? She left on a plane that night!"

By the time Sidote had been made to admit, time after time, to his other crimes, his incurable alcoholism, his seven-year slide into total degradation, I was beginning to feel queasy. That night, back at Madge's apartment, Steve's dog raised his leg, displaying a glistening red penis, and I felt nauseous at the sight of his male-

ness. Nor did I want to go with them to the Quarter to the Greek bar to watch virile sailors dance with one another. The culture had provided an executioner for me in the person of the Man in the Black Raincoat. And the Man in the Black Raincoat looked just like my father who looked just like Jack Sidote who looked just like my lover; when the man I lived with called me that night from Savannah, I didn't want to talk.

That Sunday, during a recess from the trial, Madge, Steve, and I picnicked in the old Metaire cemetery, walking among the above-ground tombs, the lifesize statuary, the oaks dripping Spanish moss. "It would make a good movie set, wouldn't it?" Steve said, his voice echoing through the mausoleum filled with dying blossoms from the All Saints' Day just past; "Maybe one about Marie Laveau, the voodoo queen." As I picked a flower that looked like a large flushed vulva, I thought about Foat, the state's implication, in its opening, that she had been a Lorelei, a vamp who had persuaded the gullible Sidote to leave his wife, child, good job to become the instrument of Moises Chayo's doom. "Dear Daddy," I read on the recently crayoned note attached to flowers at the tomb of one Rosario Schilleci, 1925–82: "I love you Give me a sign you are happy I need to know to survive." As Madge and Steve called their pets for the drive back to the Garden District, the cat evaded us, running from bush to bush, her hair standing on end—apparently, as possessed as I had become.

On Monday morning, I put on my raspberry dress, the purple boots again. "You're taking *those?*" my lover had asked, watching me pack. True, they weren't exactly sedate attire, but wearing them had cheered me during the tragicomedy that was the trial. The word was out that Foat would testify that day, and when I

arrived, the spectators were already crowding the door of the small courtroom.

As I sat down, I noticed that the front rows of the other side of the room were largely filled with Foat's partisans—women who, with their monochromatic faces, short, back-combed hair, and three-piece suits or slacks, all looked to me like they were vying for a vice-presidency at Shell Oil. As I chatted with a detective for the state who was sitting in front of me, I asked about the elegant black man I had seen led away in handcuffs the week before. "Oh yeah, that was Simmons," he said. "He'd just been convicted of killing his girlfriend's two children, two and five. He hit 'em in the stomach so hard their livers ruptured." So much for my identification with the underclass: my delusion had been as romantic, and misled, as had been Mailer's about Jack Abbott. And was I as deluded in identifying with Foat? "If you don't play by the rules, they'll get you, or at least make life uncomfortable. I'm a living example," said a woman named Laura Foreman, who had been secretively scribbling all the previous week. "I know what that lady's been through," she went on, confiding that she had once been the subject of a journalistic scandal that had put her in the public eye and caused her to resign from *The New York Times.*

"The divorce was terrible. Ninety people on one side of the family—no divorces," Foat's mother, Virginia Galluzzo, said proudly when she was called to testify just after Foat's sister, Emilia. The seventy-two year-old woman, with her cap of short gray hair (or was it a neat little wig?), her navy jacket-dress, and large white button earrings, was exactly the sweet-faced little Italian-mother I had dreamed of. "I asked her not to go [with Sidote], I wanted to keep her home after her annulment from Danny [Foat's first husband], she took it so bad. . . . Her father struck her. He said, 'You've got to stay here.'" She went on:

"When Ginny came home from Sidote she had bruises . . . [Jack] had given her a good beating!" As Foat's mother spoke, I wondered what, in her view, constituted a "good" beating.

By the time John Reed called Foat to the stand, Sidote's credibility had been decimated, his violence established. Dr. Thomas M. Smith, expert witness on alcoholism, had agreed with the Glass defense that an alcoholic might commit murder, then, out of long-standing resentment, falsely accuse the wife who had left him: "It's consistent if a person has been drinking many years and has a diagnosis of alcoholism." (It is also consistent that the alcoholic might *not* be lying, as he confirmed to Assistant District Attorney Gordon Konrad under cross-examination.) Dr. Jack Levitt, a retired psychiatrist called by the defense, had evaluated Sidote when he had been in Chino prison in California following his conviction for shooting a young Samoan outside the bar that he and Foat ran, the No Regrets. When the state prosecutors had objected to Levitt's diagnosis being used as testimony, Judge Burns had ruled in their favor, but the elderly Dr. Levitt had freely given out interviews in the corridor. "Sidote was a schizoid personality with a schizophrenic episode at the time of the incident," he said, "and could have gotten into more trouble." More violence? "Yes."

Now the courtroom waited breathlessly for Foat's firsthand account of that violence. "What was the year 1965 like?" Reed asked gently. "Horrible—shameful—terrifying," she sobbed, her face in her hands. "Have you ever told anyone publicly about this?" "No, I never told anyone *privately* about it," she said, eyes downcast. "Can you tell the jury?" "I don't know, I'm so ashamed," she cried, revealing the mortification that would be the theme of her testimony. "My drink was waiting at the end of the bar. . . .[Jack] sang 'There Will Never Be Another You.'. . . He was the star of the Villa Lipani. And I was his girlfriend. I was his star," she said tremulously.

"When I told my father I was going [with Jack] . . . he hit me and told me I was acting like a whore."

I recalled a similar scene with my father, how resentful I had been. But there was no time for righteous indignation; we were next battered, incident by incident, with details of Foat's battering. During that afternoon and part of the next day, the courtroom was given saturation therapy, leaving viewers convinced not only of Sidote's craziness but of Foat's infinite capacity for victimization. For five years, she testified, Sidote had bossed, beat, shoved, punched, and choked her. And he had complemented his abuse with tales of mutilation: drawing a line around her breasts with a finger, he told her how he had cut off a whore's, how much longer it would take to sever her larger ones. When he had bounced drunks at the Ponderosa he had taken them out back, where he had stuck a knife in their kidneys to "drain off the alcohol," then dumped their bodies into garbage cans, he told her. When they lived in Hermosa Beach, California, he bragged of killing a wino, of cutting off his "thing."

Yet this was the man she loved; good helpmate, she gave him all the money she earned, even her tip jar. "It was my fault . . . he was under so much stress—I had to figure out ways to make it easier for him," she said, explaining why she didn't leave.

And of course there had been what she considered sexual abuse: "'I've always wanted to do that to you'," she quoted him as saying just after accusing her, as she dressed for work, of "'going out all painted up like that because you're gonna'"—pause, tears— "'Suck somebody's cock!'" As Foat spoke—or whimpered—she regressed into the "wou'nts" and "cou'nts" of New Paltz, and frequently the same rhythms, even phrases, Reed had used during his "extemporaneous" address. It was hard to tell whether she was simply a bad actress, or an actress with bad lines.

While Mrs. Galluzzo listened to the turgid details of her daughter's life with Sidote—details she allegedly had never heard before John Reed's opening statement—she wore a pleasant, faintly anxious expression on her round face. During a recess, she had told a little story about Foat to the crowd gathered in the corridor: that as a little girl Foat had wanted to climb a mountain near where they lived, but had been told that it was on someone else's property; "If you'll climb the mountain with me, I'll take you home for spaghetti and meatballs," she had told the property-owner's child. The tale, illustrating Foat's tenaciousness, was familiar, for I, too, had been brought up to persevere—yet in the cause of containment, female propriety, rather than the uses of autonomy. When I had finally escaped my brutal young first husband—bruised, yet with my baby and my life—my mother had tearfully pleaded with me to go back because "mar-riage is sacred."

And there had been a mild pride in Mrs. Galluzzo's voice, too, when she had testified of Foat's answer to why she did not leave Sidote, come back East while he was in Chino: "'No, I have to stay here . . . help him through this'"; and to the fact that "till just a few days ago," Mrs. Galluzzo had never known about the baby that Foat had driven alone many miles from home to bear out of wedlock, then had given up for adoption. Was this, in her view, what it was to be a woman? And was Foat more her mother's daughter than I had imagined? Or was that a mirage as well?

"Isn't she the sweetest thing?" an older woman, obviously a partisan, had said during a break. A nun told me that she and her Sisters were there in support of Foat, that Foat and Mrs. Galluzzo had attended a prayer meeting at their convent. One day, I had complimented Foat on a rose-colored blouse that did, indeed, light up her olive coloring. "I don't know *why* I'm smoking so much," she said to me on another day in passing. Yet, during the

first week of the trial, the original picture I had had of Foat had not grown much clearer.

I was developing an impression, but it was not the one I had expected: the spark of righteous, even healthy, rage I had anticipated had never appeared during the trial at all. Rather than a phoenix, I was seeing an amoeba, a chameleon, an amorphous figure who left me wondering who the real woman was. In fact, the discrepancy that was bothering me most was the discrepancy that was Ginny Foat.

That night, I went home to Madge's apartment numbed, as though I had been subjected to an all-day slide show of illustrations from *Hustler* magazine. The next day, as Assistant District Attorney Konrad tried to wrest the focus of the trial away from Sidote's battering of Foat to her alleged involvement in the murder, he appeared cruel, as though he was further torturing an already bleeding creature. But my capacity to respond to violence had been reduced, and my identification with Foat, despite our shared early experiences, had begun to smudge. "What do you have to do to dredge up memories—what do you have to do to do it now?" John Reed asked, nudging his client back into her role as victim. "Make myself naked in front of everyone," she cried. "Have you ever talked to *any*one about them?" "No," she answered, reminding me of secrets, shackles, and shame. But it was too easy to dismiss the situation as just another caused by a vengeful, drunken, angry man, even though Sidote's credibility, in my view, had been destroyed. My own emotions had been changing from day to day: the whole thing was sliding around in my brain like mental nausea. Foat's total victimization was almost too torturous to contemplate, yet I had become uncomfortably ambivalent about her.

When the clerk read the verdict, "Not guilty," the women vying

for a vice-presidency of Shell Oil were suddenly jumping up and down and clapping, Foat was crying and hugging her fans, and several of the women jurors were coming down to have her autograph the cloth napkins on which they already had the signatures of each of their associates. Even though I was no longer a true believer, I felt compelled to go down to the front, just as I had as a teenager at the Baptist church.

At the press conference two hours later, surrounded by TV cameras, microphones, the Foat of the trial no longer existed: it was as though she had swiftly had brain surgery, another self poured into the shell that was Foat. Though she still echoed Reed's phrasing—as when she said, "I was prosecuted for my marriages, my ability to love"—this Foat was charismatic, forceful; "I've wanted to go into politics, run for office—now, since my life is an open book, I have less to fear from the opposition. . . . And yes, I will do a book," she said, naming Laura Foreman as her author, revealing the ambition and assertiveness she had kept concealed during the trial. A few days later, the movie sale to ABC, negotiated well before the trial, would be announced in the press.

"Do you think she did it?" a New York essayist asked me subversively over the phone the next morning. Unlike the California journalist who had sat beside me, overlooking every point made by the prosecution while applauding each one made in Foat's favor, we still weren't sure, though we had heard more than the jury. But both of us were certain of one thing: that by the end of the trial, we felt that we had been battered for five years—that we had been persecuted ad nauseam by Foat's persecution.

Why was I still disturbed as I flew back to Savannah? Was it something as simple as that unfortunate human tendency to blame the

victim– or even pique because we had not come to an agreement on the book? As I examined myself, neither rang true. I had been genuinely sickened by the idea that a woman had had to answer for being abused—that she had been brought to trial, in a sense, by her abuser. Standing in a supermarket line a few weeks later, I flipped through a tabloid to see a headline, "Nun Quits Convent in Order to Marry Murderer." To hear Foat and her lawyers tell it, she, too, had simply been a saint who stooped to consort with a sinner. But throughout the trial, I had waited for a moment of healthy rage—of authenticity—which had not been forthcoming. As the days had gone on, I had first been troubled by the fact that Foat had remained so long with a man who, according to her own testimony, had not only abused her but had done so grotesquely. Later, I had anguished over the possibilities that she could have voluntarily collaborated in the robbery and murder of Moises Chayo, or that she had been malleable enough to be battered into doing so. Now, Foat had been found not guilty, but I had mentally debated another equally unsettling possibility: that she had a capacity for concealment, expediency, and amorphousness that was overriding, and went beyond the demands of the trial.

For this and other reasons, my original identification had smeared. Because we were both feminists, had had similar early experiences, I had mistakenly assumed that we were more alike than we were. True, the Bible-Belt preachers of the deep South had fanned the flames of my teen-age sexual and gender guilt as surely as the patriarchal priests of New Paltz had hers. I, too, had played the Good Woman to a Bad Man—reading the Bible each night to my young husband, devouring books by Bishop Fulton J. Sheen (perhaps read by Foat, a Catholic, as well) on how to be a longer-suffering wife, despite abuse that had been almost as extreme as

that she had described. But there, apparently, the similarity had ended. At nineteen, I was a high-school dropout with no money, a two-year-old son, and a mother recently hospitalized for the problems that would eventually lead to her suicide; in a community at least as rigid as New Paltz, I had escaped my abuse through the aid of a kindly grandmother much like Mrs. Galluzzo. And there were other differences as well. My mother, garden-club-proper, other-directed to the point of madness, had been as shame-filled as Foat. Thus I had long been more frightened of repression than expression. "Do what you want, but don't tell it" is a Southern credo I had fought—some would say too successfully—for my whole life; more than marriages, money, convenience, authenticity had been what I wanted most. And while the Man in the Black Raincoat had, indeed, trailed behind me like a piece of toilet paper stuck to a high heel for most of my life, the division of the human race into saints (women) and monsters (some men) no longer worked for me. I know, for instance, that many of the more put-upon women of my childhood had concealed broad stripes of aggression beneath their skirts; that the alcoholic or abusive men I had known had been among some of the most anguished—sick, rather than evil; also, and most importantly, that with every lover I had ever chosen, there had been a collusion of sorts. In fact, it had only been by owning the disowned parts of myself—my own impulses toward sex and aggression, yes, even my repressed love for my abusive father— that I had been able to reduce the Man in the Black Raincoat back down to the Boy on the Black Motorcycle.

Back in Savannah, I heard Ginny Foat say on *Donahue* that she "hoped for cirrhosis of the liver" for John Sidote; and that the book proposal for her life story, written by Laura Foreman, had

been sold to Random House for $150,000. I wondered if it would be an honest account or the hagiography Foat and Skolnik had originally appeared to want. Since it seemed to me that it was the secrets that were the shackles and the shame, I hoped, for Foat's sake and the sake of her followers, it would be the former.

When she returned my call requesting an interview a few months after the trial, Foat told me that besides working on her book, she was now forming Legal Advocates for Women. Its purpose, she explained, will be educating women on all aspects of the system, and providing resources, including defense funds. She seemed less interested in discussing the psychological ramifications of her experience. "It just thrills me to see myself billed as Ginny Foat, Political and Feminist Activist, rather than the defendant in a murder trial!" she said in conclusion.

"I *still* don't know whether she's a cipher, a victim—or just another good woman martyred to a bad man," I said to Anne on the phone some time later.

"But I do know one thing—she's a woman who knows how to make good use of her situation." "Well, I could have told you *that*," Anne said without interest, then went on to what, to her, was more imperative: "There's a fancy new lingerie shop open at the mall. So when are you coming to Atlanta so we can buy nightgowns 'n' stuff?"

1984

How to Be a Belle without Traveling South of the Mason-Dixon Line: Or Some Things I Learned from My Southern Mother, a Costa Rican Hooker, and a Few Others

"I wouldn't have expected anything less of you," said a recently transplanted Southern friend, glancing at my ankles appreciatively. We had just met at a New York bar on a particularly cold, windy night, and I had confessed to wearing heels rather than boots despite the weather.

"I hate to go out to dinner with Southern women—they always flirt with the waiter," complained my literary agent as we ordered in a Greenwich Village trattoria. It took me a minute to realize she was talking about me, the way I had smiled at the man pouring the wine.

And on a Minneapolis talk show during a book tour, I found myself rising to the defense of my Southern wiles when the no-nonsense woman co-host—doubtless agitated by her male cohort's flirtatious comments on my Tea Rose perfume, my pink dress—crossly accused me of being manipulative.

"I think we have a sickness in our family," mused my sister, Anne, looking at the array of Maybelline in my bathroom. We were raised by a mother who—we were told over and over—had been "the prettiest girl in Atlanta," who "could have had any boy she wanted," and grew up in a family in which man appeal—or How to Fight a Duel Over, or at the Very Least, Send Flowers To—was the terminal degree. Thus while serious women in other parts of the country were discounting sexual in favor of fis-

cal, academic, and athletic savvy, we carried a double load, forging ahead in our frivolous ways as well.

Indeed, as a woman who has been boy crazy since fifth grade, who had the reputation of having more dates than any girl who attended my rural Georgia high school, and who later, after a third divorce, became for a time a bona fide sex addict, what makes a man find a woman sexy is a subject I've studied as long and as avidly as Jane Gooddall studied chimps. During the past decade, my research has taken me aboard an offshore oil rig (where I worked as one of four women among seventy-five hunks), to a "Soldier of Fortune" convention and the boom towns of the still- wild West. Most recently, I visited a hotel-cum-brothel in San Jose, Costa Rica, where prostitution is legal.

Everywhere I went, I asked the men what they found sexy, and the answers I got were both predictable, and as varied as the colors in a kaliedoscope. "They don't give a damn about panty lines or Underalls," enthused Don, a thirty-six-year-old psychologist from Miami, his arm around Esmeralda, one of the "girls" at the Park Hotel; "They're proud to be women, by God!" And yes, I had to agree—the women to whom he referred *did* seem to favor sheer fabrics, the wrong color lingerie.

"A woman who asks what a man finds sexy," cleverly answered several others. "One with a dark, soulful look. Like my mother," confided David, a forty-year-old playwright. "A woman with a round bottom and a round top," answered Bill, a well-built—and easy-to-please—roughneck. "Healthy, earthy. And she has to have *hair*," declared Aldan, a twenty-four-year-old construction worker. "A good smell; about twenty-five percent of them have a smell I don't like—and I'm not talking perfume. But I like all the rest," said forty-two-year-old newspaper man Hank-the-Hunk, explaining his local reputation as a ladies man. "I wouldn't want

her to have bad breath, so it's good if she brushes her teeth a lot,"
said John, a twenty-four-year-old MBA graduate who looks a lot
like Pierce Brosnan: "Oh, and I don't like a woman to wear those
big belts that hang down like gun holsters, or moldy things with
holes in them. As long as she's clean, all she needs are some nice
clothes, a little makeup. . . .

"When you first become aware of them at, say, thirteen, it's
budding breasts. Then, at age eighteen, it's *big* breasts; at twenty-
one, consent, and at twenty-five, consent with variations; "But
after a while you finally learn that almost everyone has all the
usual things—ten fingers, ten toes, two breasts, a vagina—then it
has to be something else."

"Carol," chorused several men friends, mentioning a brown-
haired free-lance illustrator with a plain-but-pretty freckled face, a
less-than spectacular figure, when I asked for an example.
"Because of the way she dresses, I guess," mumbled one when I
pressed for details. "I don't know—it's just the way she smiles,"
puzzled another. "I first noticed her when she wore a see-through
top to the theater, then sobbed loudly all the way through Jacques
Brel," said the playwright. I recalled the time I had introduced her
to Zane, my red-haired live-in lover: lying back on my couch, she
had languidly raised her cigarette for a light, then, as he had bent
over with one, had run her fingertips over his tattooed biceps,
murmuring, "I wish I had me a big, red tomcat like that. . . ."

Yes, there had always been something unpredictable, even out-
rageous, about Carol. When I visited her to ask her about what
made her sexy, she was wearing the same unflattering Indian-print
shirt, crumpled denim skirt in which I had seen her last. As we
talked, she picked ticks off her Labrador Retriever, then showed
me her new .38, holding it at arm's length, taking aim as she
spoke: "It must be because I grew up with five brothers and don't

mind talking dirty," she said, acknowledging, like Nancy Friday in her book, *Men in Love,* that many men never outgrow the scatological stage. "Another thing, I always make a man feel like he's the only one on earth, even if he's the third one that week," she said, describing what must be the ultimate in Southern good manners. "Or even that night," she added, laying the gun down.

The point is that there's something inherently sexy about every woman. Among my other friends, actress Liz has cheek-and-hip bones a man could get cut on, an energy, on stage and off, that mesmerizes. Mimi runs an antique clothing store and emphasizes what *could* be called an overripe hourglass figure with the curvaceous forties' fashions she loves. With her dark eyes with the dark circles beneath them accented by heavy black bangs, she has exactly the soulful look the playwright seeks. Janeene, an introverted editor, cultivates a languid aloofness, lounging around her all-peach apartment looking as though she's made of feathers and old lace while the phone rings and rings. Sarah, in her fifties, has her hallmark waist-length brown hair that she wears in a chignon during the day, lets down for a lucky few at night. My sister, Anne, dark-haired and slim-hipped, used to complain of her unruly locks, worry that her boyish figure made her less than feminine; today her bold black bob, her sinuous slink, often makes her the most striking woman in the room. Madge, who worked with me on the oil rig, was once plump, straight-haired, and pale; six months later, she was skinny, had a blond frizz, a dazzling smile, and an entourage.

Now that we've established that being sexy—even sinfully, lethally, so—is within all our reaches, let's set up some ground rules:

Go where the men are. Go, if you can, where you have to bat

them off like mosquitoes. There's nothing that makes a woman sexier than being surrounded by them. If you've been in a girl's school or a nunnery, get out for a while. If you've been in New York too long, you might consider moving to an oil rig town in Louisiana, or better yet, Alaska. Or you might land a job as a sportscaster, then fight for your right to go into the locker room.

Not much good has been written about singles bars, yet they are full of men who long to be met. Don't be afraid of going there, if only to experience being in a crowd of men. Better yet, frequent a neighborhood pub where everybody knows your name. Then if someone new and cute comes in, the bartender can introduce you.

Personal ads are good, too. Begin yours with something like, "Extravagantly beautiful and sexy." Than have a party and invite the fifty or sixty men from whom you get answers. Men like crowd scenes as well as scarcity—it gives the poor a chance to compete. And oh, yes, have cards printed, something that says *you*—mine has a red rose in one corner, with my name in red italics. (No, this is *not* the same as carrying a condom in your purse, though nowadays, that's more than okay, too.)

Just remember the rule of thumb: that surrounded by men, we become sexier by sheer contrast. For example, most of them have hard flat chests, many of us have soft convex ones. They have whiskers; hopefully we don't.

Remind yourself how much they need us. It's been written that men romanticize sex, while women romanticize men. "Don't you know men think of sex—and therefore, women—every five to ten minutes?" Hank-the-Hunk asked seriously. Even Sartre, old and blind, wrote to a friend that "I can hardly work, I'm so distracted by thoughts of women. . . ." At a cowboy bar in Wyoming where the men vastly outnumbered the women, they stared at my friends and me like starving children pressing noses to a shop

window in a Dickens novel, then stumbled all over themselves asking us to two-step. The walls above the oil riggers' bunks were inevitably decorated with the centerfolds at which they nightly worshiped, shrines to the power of the Mons.

But despite all that airbrushed stuff they expose themselves to when they're lonely, men are not as perfectionistic as you think. So whatever your real or imagined defects, there are always some who like *your* type. The oil riggers, for example, were all men on whom any efforts toward anorexia would have been wasted. Indeed in some circles curves have never been out; the women at the Park Hotel in Costa Rica almost all had slightly rounded tummies from the babies they bore before eighteen; yet one connoisseur called them the most beautiful women in the world outside Bangkok, and the place was full of nice-looking gringos who had traveled thousands of miles to meet them. "She's got perfect legs—feet on one end, a pussy on the other," states a very male joke. "The worst I ever had was wonderful," goes yet another bit of chivalry.

So if you don't already know it, write it down a hundred times a day till you do: *men need us.* Then when you run up against some passive-aggressive neurasthenic who in the past might have sent you into a tailspin, you can simply blame it on his childhood and move on, tossing your hair like Kathleen Turner, while visualizing yourself surrounded by a dozen even better-looking guys, all demanding the aforementioned cards like tickets to a Mets game.

Reject the ones who would reject you. There's nothing worse for a woman's joie de vivre—and therefore her sexiness—than feeling rejected. Thus, smart girls learn to sort the interested from the disinterested in advance. I once had a friend who marveled at my ability to go into a singles bar, leave with the man of my choice. Yet my secret was simple: before making a move, I visu-

ally cased the room, learning via eye contact who was likely to choose me back.

In high school, I, too, cried my eyes out over the elusive guy, all the while ignoring that shy boy who would later become a commander in the Navy. Hopefully, we outgrow this aberration. But unfortunately, a few of us continue the self-defeating habit of falling for men who aren't even candidates, from gay ballet dancers to groupie-drowned rock stars to the New Man at his insensitive and self-sufficient worst.

Why beat your pretty brains out and lose confidence to boot, over some resistant, arrogant guy when there are so many other, nicer ones around? Of course that may mean giving up a bit of *your* perfectionism, that part of you that whispers, "But he has funny hair," or "I don't like his shoes." Think about it for a minute: we don't like them to judge *us* that way, do we?

Still, its essential to look as good as you can. Men are basically visual, olfactory and tactile creatures, and all those shorthand signs of sexiness—a fresh flower in your hair, a silk shirt unbuttoned down to *there,* a slight smile on your glossy lips, a slit skirt worn with those aforementioned stockings and a garter belt— well, they *work.* Men like to see women in things they would never wear themselves—say, a feather boa, or four-inch heels. And never underestimate the power of pink. In high school, I had a fail-proof angora sweater that I wore to school on Thursday if I didn't yet have a date for Friday. And a touch of frou frou, even sleaze—very dangling earrings, a fake fur jacket dyed pink, an ankle bracelet spelling out your name in rhinestones—is rarely out of place. Today, I have a collection of man-tested things—rose satin mules, black-seamed hose, rayon blouses that look as though they came from Frederick's of Hollywood—to judiciously mix on occasion with more reasonable threads.

But don't *over*estimate the power of these things, or forget the appeal of tight jeans, an outdoorsy look. Until the Lesson of the Ugly Blue Maid Shoes, I assumed my attractiveness depended on my footwear. Then I wore flat blue rubber jobs from Kresge's basement out to my job on the oil rig, where, sweat washing away my Maybelline, I still found myself surrounded by hunks saying things like, "I'd marry yo' dawg to git to you, honey." Since, I've learned that even Dolly Parton, who once vowed never to be seen in anything but heels, works out in tennis shoes, and some women even manage to meet and seduce men while wearing high-topped Reeboks.

One last note on the subject of appearance: "Always take your knee-highs off before your slacks," fifty-year-old Sarah advises of dating at midlife (though in truth, most men would prefer that knee-highs had never been invented at all. Or as my lover Zane, one of the multitudes who entertain stocking-and-garter-belt fantasies, professes, "Panty hose have just gotta be a Communist plot!")

But don't forget the other senses. Men secretly adore all those things they have been brought up to disdain for themselves, like homecooked meals, cut flowers, and a voice with a giggle in it. When a man calls and asks what you're doing, don't be embarrassed to say, whether it's something as mundane as cooking up a pot of homemade vegetable soup, or just doing your nails: in either case, the image of you making life more aesthetic has been created. Always keep something sweet and childlike—fudge or cookies—in the freezer to serve him with milk or with drinks (my own favorite combination is Jack Daniels Black Label with chunky chocolate chip cookies), thus effectively reminding him of Mother, the greatest sex symbol yet invented.

And of course, *touch* him: pick lint off his coat, lay your hand on his wrist, tweak his cheek like a sexy aunt. "I like women who

touch me because it's a signal that she's less likely to reject me later," explained the playwright. The rule of thumb here: you can get away with more than you think. The prostitutes at the Park Hotel in San Jose greeted their favorite customers with a kiss, a disarming "I luuuve you!" then put their arms around the men at the bar, nuzzling their necks, fondling their nipples from behind. One night as one sexy lady and I sat at a local pub in my home-town of Savannah, a man friend joined us. Before I had even fin-ished introducing them, a look of delight crossed his face: I learned later, that she was already, well, *touching* him beneath the table. For months, he exclaimed to me how attractive she was. Zane claims that the night we met, I took his hand as we talked, placed it on my bare thigh (it was summer, I wore a slit skirt). I don't remember it—but he sure does.

Which leads us to warmth, even kindness. You'd be surprised how many good-looking hunks think their ears are too big. "I was too shy to ask a girl for a date, despite being a football star," Zane told me; "then later, I found out that all the girls thought I was a snob." *I like you* is a powerful message that carries no obligation. "It's cruel and inhuman that we're not allowed conjugal visits!" cried Esmeralda via our translator as we walked through La Reforma Prison in San Jose. I was there to interview mercenar-ies, she simply gave consolation: as we walked past the impris-oned men, they stretched out their arms toward us as imploringly as homeless tomcats at a pound.

Men are often hungry for conversation, so start it up anyway that you can: tell him your first career was as a cheerleader (many a man's favorite fantasy), then that you went on to become a nun for a while (yes, some of them dream about leaping over the wall, too). Dare to be saucy, cheeky. Tell him he turns you to moosh—even if it's a fib, you've definitely set up some friendly vibrations, not to speak of creating some interesting mental images.

A man who worked with the homeless in New York with Sister Theresa and the Sisters of Mercy said that at first he didn't know how to talk to those people: "But then I learned from watching the sisters that you can talk to anyone about anything—it doesn't have to be anything special." And good—and not-so-good—looking guys aren't exempt from a need for this kind of friendliness.

"I speak to the highest that is in you," goes an old Navajo saying, and despite all that stuff about common interests, I've found that men *do* like to speak of matters close to their hearts. Among my favorite queries are "What means most to you in life?" and "What would you be doing right now if you could do anything in the world you wished?" What*ever* a man answers, it's sure to be more interesting than sports scores!

So when a man extends himself—opens a door, calls with an invitation, buys you a drink or makes you dinner—say *thank you:* it's only civilized. Indeed, graciousness works as well as it does elsewhere, and men, like other creatures, crave time, attention, and contact.

Tap into the positive power of elusiveness. Next comes the tricky part: you've given him the signals—now, being sexy requires that you step back a bit. "Let him chase you till you catch him," goes an old Southern saying. Men want to fall in love, and will, if we let them. "You're better at stringing a man along than any woman I know," said one of my stringees admiringly, speaking of my skill at a sport still popular down my way, the tinge of regret, even promise, with which I customarily demurred. Psychologists have recently "discovered" what my grandmother knew all along: that uncertainty, even anxiety, is an aphrodesiac. And as hard as it may be for a woman to believe, men expect, even at times, seem to enjoy, turn-downs.

Yet while being elusive may sound coy, even a bit manipulative, it really just means having a clearly-defined self, a set of values and

priorities around which we shape our decisions: that there is more to us than sitting beside a telephone, waiting for a man to call. For despite nurture versus nature, sensitivity training and all that, men are still hunters to whom there is nothing more appealing than being the first choice of a woman who has other options: whether other men, or putting in more time at her word processor.

Nowadays, resistance need not be sexual: "New women are elusive for different reasons," says Carol; "A lot of women my age have been let down by traditional standards of love and marriage. They're out there working and seeing how men really act. They don't want to put up with that, or with being somebody's maid. It'll take quite a guy to nail me down—someone who appreciates me for my strengths, rather than my weaknesses," she adds firmly.

So instead of always being available, conforming yourself to his needs, show a little spunk. Think Colette and her mother. Think Scarlett O'Hara. Think Shug Avery in *The Color Purple*.

And most importantly, keep in mind the purpose of all this, which is FUN. As a therapist friend explained, our ability to be playful, to enjoy primary activities like sex, comes out of the child rather than the adult or parent part of our psyches. Like dancing, like dressing up, sexiness ideally feels good, and makes those around us feel good, too.

Indeed, probably the worst thing that can happen to you from following the above rules is that you might have to unplug your phone for a while, or take a trip to Europe while you decide among your beaus.

For until something better is invented, fuschia nail polish and vamping it up will never go out of style.

1985

The Scandal That Shook Savannah

"Southerners always had the wisdom to realize that form is as important as content. In moments of crisis or confusion, form can literally keep you alive until you figure things out," wrote Rita Mae Brown in *Southern Discomfort*. She might have been speaking of debonair Jim Williams, fifty-five, of Savannah, Georgia. When Williams shot his twenty-two-year-old companion in 1981, he was a wealthy leader of local society. The dead man, his sometime lover Danny Hansford, had a reputation around town for wildness. Despite Williams' plea of self-defense—"We had gone to a particularly violent drive-in movie, and Danny had smoked a lot of marijuana cigarettes"—he was convicted of the murder twice and is now out of jail after a state supreme court reversal, pending a possible third trial. Nowadays, former party-goer Williams sometimes dines alone at an elegant restaurant named Elizabeth, or drives his green Jaguar around the streets of Savannah, a still handsome man with a sardonic expression and a stiff upper lip.

While Savannahians sip Jack Daniel's or Scotch on the rocks of a late afternoon, a number of versions of the now near-legendary event are bandied about. Despite this city's pastel beauty, it also has a dark underside. Within its hothouse atmosphere, the present runs concurrently with the past; events that happened decades before are discussed as though they happened yesterday,

including a number of scenes of sex and violence extreme enough to rival any dreamed up by Tennessee Williams.

Poet Conrad Aiken heard his father shoot his mother, and then himself, in the bedroom of one of the city's beautiful historic town houses when the poet was eleven. During the twenties, a young man from a wealthy family was said to be dating the singer-girlfriend of a local bootlegger; one night, someone rang the doorbell of the family mansion and, when the door was opened, threw into the hallway proof the young man had been castrated— a story allegedly kept out of the local newspapers, yet passed down decade after decade. During recent years, there have been a number of flamboyant murder cases, of which Jim Williams' is only the latest.

After the second trial, Williams ran his lucrative antiques business by phone from the Chatham County Jail, aided by assistant Barry Thomas. "One woman said that she overheard in a beauty parlor that Jim had been let out of jail to have a party; others said he was ordering in lunches from Mrs. Wilkes' Boarding House," says Thomas, referring to a well-known Savannah eatery. "But none of that was true. In fact, he only left jail once during the twenty months—to attend his father's funeral. It was a gray day, and it was raining."

In order to understand the interest of Savannahians in such minutiae, one must first understand the character of the city itself. Designed around twenty-one landscaped squares, the historic district, and its adjacent Victorian district, comprise a city within a city. In this section of tightly cobbled streets, overhanging Spanish moss and, in season, masses of oleander and azaleas, people of varied incomes live side by side in elegantly austere eighteenth-century and frilly Victorian nineteenth-century houses. On special occasions, one might see children dancing in the squares beneath a

brightly ribboned Maypole, or grown men dressed in full Confederate regalia, served by uniformed blacks while lunching inside a gazebo. There is a remarkable sense of intimacy, a sense, almost, as one woman put it, "of living in one big house."

Indeed, the city is permeated by a remarkable and insular chauvinism. In a piece in the *New Yorker* on the kidnapping and murder of young George Mercer IV, grandnephew of songwriter Johnny Mercer, writer Calvin Trillin described the city as one of the few places in the country where the word *blueblood* is still taken seriously.

Yet Savannah is also the kind of town where drunken, irreverent fun and thumbing one's nose at propriety are still permissable, even popular. It is said that the first thing one is asked in Atlanta is, "What do you do?"; in Charleston, "Who were your ancestors?"; and in Savannah, "What would you like to drink?" The Chatham Clinic for Addictions was founded in 1956, when it was discovered that roughly half of the patients in an Atlanta clinic were from the Savannah area. "It was one long cocktail party," says a former debutante of her seventeen-year Savannah marriage. The city's St. Patrick's Day celebration—the second largest in the nation, drawing as many as 300,000 participants— begins with Bloody Mary parties at 8:30 A.M., and is a three-day, all-out bash at which just about anything goes. Never mind that the good times often mask racism, substance abuse, corruption and vice. The true crime in Savannah is taking anything—except the word *blueblood* or the city's own history—too seriously.

"Savannah has always been incredibly tolerant of sin," agrees Albert Scardino, 1984 Pulitzer Prize winner in editorial writing. A former editor of the controversial and now-defunct local weekly, the *Georgia Gazette,* Scardino is now a reporter for *The New York Times.* "And they say, 'Don't ever let the facts clutter up

your view of things.' While I was growing up, there were several rather notorious murders involving people of status. But the standard rule was that you couldn't get a jury to convict."

If every story in Savannah has not just two sides, but at least twenty, Jim Williams, convicted of the same murder twice, was the subject of many of them even before his indictment.

Williams grew up in Gordon, a small mid-Georgia town, where he played the organ at the Baptist church. Later, after building up a lucrative business that began with collecting country church antiques, Williams gave an organ to the church. "I just know that boy couldn't kill anybody," people there still say. His parents were divorced when Williams was a young adult. His father, a barber, remarried and moved to a trailer within view of the family home; his mother, Blanche, put Jim and his sister, Dorothy, through college by working as a secretary at the local kaolin mines. Blanche, who is said to bake a mean caramel layer cake, had high standards for her children: Dorothy went on to get a Ph.D. in philosophy, and Jim studied interior design at the Ringling School of Art and Design in Sarasota, Florida.

"Twenty-five years ago, when James Arthur Williams arrived in the historic seaport of Savannah, Georgia, he expected to stay for only a short time," began a 1976 piece on his Bull Street mansion, Mercer House, in *Architectural Digest.* "Much in life, however, is accidental—perhaps even fated." "Back then, he only owned one suit, on which he paid fifty cents a week," says old friend Jack Kieffer. "But he always made a nice appearance, wearing a fresh shirt and tie every day." Williams occasionally ate on credit at Southern Kitchen and worked at Klug's, a furniture and decorating store.

His real wealth began with the sale of Cabbage Island, which he purchased for $5000 and then sold for $662,000, when it was

discovered to be the site of phosphate. ("Jim asked for the money in cash," says a friend. "There's a photo of him naked, smoking a cigar, lying in $100 bills.") But in a town where few let careers interfere with the cocktail hour, Williams labored hard, and still does. He works with his hands, waits "till the sun sets" to begin drinking and retains the frugality of an earlier time: "He would come downstairs to the shop and change the light bulbs from sixty to twenty-five watts," says a former employee.

During the early fifties, he and others put small down payments on old houses, renovated them and sold them at equally small profits. The city now has the largest historically preserved urban area in the country; Williams, who for a time served as president to the local museum, the Telfair Academy of Arts and Sciences, has owned about fifty homes in the district, including Armstrong House, one of the most imposing mansions in Savannah. In 1969, he spent $55,000 to buy Mercer House, where he has lived ever since; almost ten years later, Jacqueline Onassis, traveling through the Savannah seaport by private yacht, visited the house and is said to have wished to buy it and everything in it. The house was also the setting for the advertising campaign for Esteé Lauder's Private Collection. The house now includes floor tiles from England and an upstairs pipe-organ room, decorated with a pair of Russian chandeliers and with a mauve ceiling hand-painted with flowers, butterflies and clouds.

Along the way to wealth and artistic integrity, Williams also worked hard socially. For eleven years, he gave annual Christmas parties to which invitations were coveted. "The parties were wonderful," says Barry Thomas, who helped Williams prepare for them. "People who were dull on the street would just glitter. You'd eat off the Duchess of Marlborough's china service and use Queen Alexandra's flatware. Candles were lit, silver was every-where. The women wore all their jewelry, the men black tie and

tux. The house glowed, and people were ascending and descending the staircase. It was just heaven." Williams, his mother and sister formed a receiving line at the door to greet guests.

"He's 'Jimmy' or 'James Arthur' in Gordon, Georgia; 'Jim Williams the notorious' here in Savannah; and 'Mr. Williams the rich American' at the Ritz in London," says an associate. "And when he talks about the British royal family, you'd think he was talking about his own!" Williams says a favorite recent book was *Matriarch,* Anne Edwards' biography of Queen Mary. Among his friends is the daughter of the Duke of Argyll, Lady Jeanne Campbell.

If Williams is a man who enjoyed others' respect, he apparently also enjoyed their envy. "He would walk as a guest into the [prestigious and private] Oglethorpe Club with a handsome man on one arm, a knockout blonde on the other," says a friend. "It was as though he were saying to the other men there—men who had gotten married, worked hard, had kids—that he could have material possessions *and* beautiful people of both sexes." ("My heterosexuality is my best-kept secret," Williams says.) "He was a glamorous, good-looking guy with tons of money," the same friend adds. "They were eaten up with envy. You could see it in their faces."

Indeed, Williams managed to offend as well as impress. For one thing, he delighted in cutting people from his list of guests, as noted in the pages of the *Georgia Gazette:* "I change the party list every year. I delete names and add names. My 'off list' is an inch and a half thick," he is quoted as saying "with a sly laugh." Others objected to the parties themselves: "They were too crass, too much like a circus," says an observer of the scene. ("But only to those who weren't invited," says Williams in answer to such criticism.)

And though Williams held another, private party for men only, some resented the fact that only a couple of token gays were invited

to the more prestigious event. "He would have a party for friends, many of whom were much less successful than he, using the occasion to show off his expensive possessions," says an acquaintance.

Then there was the Nazi-flag incident: during the filming of a Lincoln-era movie for CBS TV on Monterey Square in front of Williams' house, he hung a Nazi banner from a street-level window to disrupt the shooting. "Incidentally," says Williams, "it was just one of the many flags in my collection." Barry Thomas, who was there that day, says that Williams—angered by the disruption of life in the square and the filmmakers' failure to honor his request that they donate one thousand dollars to some charity—would have hung out *any* flag that would have ruined the filming. "And you can't have Union soldiers marching before a Nazi flag!" says Thomas.

Temple Mickve Israel, the third-oldest practicing Reform congregation in the country, stands across the square, and Savannah's Jewish community is an old and illustrious one. The next day, Williams, who owns part of Hitler's silver flatware, was censured in the *Savannah News Press,* and he received a letter from the synagogue demanding to know why he had a Nazi banner in his possession. "When I visited his place during a house tour some years ago, I was appalled," says a local woman. "There was Nazi stuff all over the place—he hadn't even bothered to put it up." But Jack Kieffer says, "Nazi daggers and swords are simply the finest ever produced. Jim was interested in history, and if you see them as works of art, they're very collectible items today. Prices have skyrocketed." Barry Thomas concurs: "The pure macho of the design is wonderful!"

Nevertheless, there was a bad feeling toward Williams in the community even before he shot Danny Hansford on May 2nd, 1981, with one of the several German Lugers lying around the

house. In view of Hansford's history of violence and substance abuse, Williams' claim of self-defense sounded reasonable enough. "Jim was going to Europe and had a lot of cash in the house. He planned to take Danny with him to help out—he [Jim] has hypoglycemia—but when Danny said he wanted to take marijuana along, Jim told him he couldn't go," says Williams' attorney, Sonny Seiler, explaining why Hansford became so enraged that night. But District Attorney Spencer Lawton cites a cigarette burn on the corner of the desk where Williams had been sitting, implying that perhaps Williams became angry when Danny stubbed out a cigarette on a fine piece of furniture.

Danny was known around town as a disturbed young man and a street hustler. A month before the shooting, the police had been called to Mercer House because he had become aggressive, shooting off a gun inside an upstairs bedroom and destroying valuable furnishings. "Jim realized the danger and sent him away to Florida. But not long before the shooting, he showed up on Jim's doorstep and said he would kill himself if Jim didn't let him in," says Barry Thomas, who also claims that Hansford attacked him out of the blue one day as he walked down the hall at Mercer House.

"He definitely would have killed Jim—definitely. No two ways about it," says Wade Bragg, proprietor of Friends, a gay cabaret. Bragg, who had seen Hansford around town for years, declares that "the child wanted to end, he wanted to die. He hit the top—Jim—and that wasn't enough. Nobody could have dealt with that child except with his fists." "Danny was trash," says a woman who runs a business near one of the squares frequented by homosexuals, using a word one hears a lot around Savannah, usually to designate someone not quite up to one's own standards.

Today, Jim says that Danny was handsome and well built, with a "wonderful smile—but he was pitiable, a sad case." During the

second trial, jurors heard almost two days of testimony from victims of Hansford's temper, and from doctors and mental health workers who had treated him.

Williams has told the story of the shooting several ways, but all of them hinge on Danny's out-of-control rage. Yet despite Hansford's history, prosecutor Spencer Lawton contended that Williams killed Hansford and then rearranged evidence at the scene to support his self-defense claim. Lawton cited a chair leg that sat on Hansford's pants leg; that there was no gunpowder on his hand to indicate that he had first shot at Williams, as the latter claimed; and that paper fragments, scattered by gunshot, were found on the seat of the chair that Williams said he was sitting in at the time Danny fired the first shot.

Sonny Seiler says these factors are easily explained by testimony showing that Williams sat on the desktop scattering papers while calling the police, and the presence of a number of people at the crime scene just after the shooting. Perhaps they bumped the chair, which was on casters and rolled easily; photos indicate the movement of objects on the patterned Oriental rug during the initial investigation.

"If you believe that [explanation], you'll believe anything," snorts a woman who has kept up with the case. Indeed, many Savannahians are critical of Jim Williams' role. "He's just another meteor," declares a native dismissively. "You know, one of those people who come here, make a lot of money or shoot somebody, then disappear."

Others became piqued after the trial. Bluebloods who testified as character witnesses for Williams were chagrined to learn that their glowing testimony directly followed graphic descriptions of Williams' homosexual affair with Hansford, and the revelation that he had bought him clothes, jewelry and drugs. The Nazi-flag

incident made seating an unbiased jury particularly difficult. And some think that Williams' von Bülow-like demeanor in the courtroom—his constant references to the value of his antiques, his lack of obvious remorse—contributed to his convictions.

Williams feels that envy of his wealth and position affected the outcomes of both trials. "I've learned firsthand that you're guilty until proven indigent," he says bitterly. Sonny Seiler says, "There's no question in my mind that the powers that be at the *Savannah News Press* don't like Jim and his kind," and he cites numerous references in the media to his client getting in and out of his Cadillac. "Jim knows that if one black shot another black on Saturday night, one detective might have come to the scene, and he would have served seven months, and be out on probation right now," says one citizen. "There are always the 'haves' and the 'have-nots,' and the prosecutor went out of his way to put have-nots on that jury," says Jack Kieffer, who attended both trials. "He [Spencer Lawton] kept harping on Jim's wealth, as well as, in a more subtle way, the homosexuality issue."

Savannah is a town where there has always been talk of illicit liaisons and orgies, both heterosexual and homosexual, and of relationships in which one party is kept by another. It's also a town in which gays and straights freely mingle, often hanging out at the same pubs, dancing at the same discos. Yet there is a slight, ongoing friction, almost like sibling rivalry; occasionally, what looks like blatant homophobia surfaces. In 1979, four army Rangers stationed at Hunter Army Air Field were charged with kicking a visiting businessman to death outside Missy's Adult Boutique, a porn shop frequented by both gays and straights. The Rangers cited a homosexual advance: one was acquitted; three others, tried separately, received battery convictions; none

served over six months. In 1983, the TRAP squad of the Savannah Police Department, in a concerted effort to clear certain squares of homosexual soliciting, arrested a number of men, some say by entrapment.

"No one is going to acquit Jim in a jury trial in *this* county, because of one, homophobia, and two, ignorance," says Wade Bragg, who is a member of the Georgia Task Force on AIDS. "I wear what I want, go where I want. But I carry a gun—you have to."

"On the witness stand, Williams said, 'He [Hansford] had his girlfriend, I had mine. We did have sex a few times—but it was just a natural thing.' Unfortunately, that was the way Jim chose to phrase it," says Sonny Seiler. "If it were not for the homosexual element, and years of slanted treatment by the media, he could get off."

Despite the physical evidence, Williams and others feel that prosecutor Lawton could have accepted Williams' self-defense statement, but instead prosecuted the case partly for political reasons. Says one Savannahian: "He had only tried one other murder case—the Ranger case, which he lost—and he was up for reelection. But he's been reelected now, and a lot of the taxpayers' money has been spent trying this case. He could bow out gracefully, be the hero."

The case now ranks as Chatham County's second-oldest active felony. The state supreme court decisions declare that the first conviction was overturned because "the state suppressed and failed to provide . . . evidence [favorable to the defense]." The second conviction was reversed because the court had allowed the introduction by the prosecutor of inappropriate testimony. Lawton says that even though the first two trials were reversed, they were fair trials and that they were reversed on error

rather than absence of evidence of guilt. Despite community pressure to drop the case, Lawton says he fully intends to retry: "It's the purpose of this office to prosecute crimes." Williams says that if retried, he will bring a civil suit against Lawton, charging the use of perjured testimony in the first two trials. Seiler adds that if a new trial takes place, the defense will bring in new witnesses.

A ten million dollar suit brought against Williams by Hansford's mother, Emily Bannister—who claimed in the *Georgia Gazette* that Williams had "executed" her son—cannot proceed until the criminal case is resolved. "But even with a conviction, the value of the deceased's life would have to be proved first," says Seiler. "Jim knows he did the right thing [in shooting Hansford in self-defense]. But he has spent over half a million dollars and twenty months in jail only to learn he has been illegally convicted a second time."

The question of whether Jim Williams can receive a fair trial in Savannah remains. "Do what you want, but don't tell it," goes an old Southern saying. By shooting Danny Hansford, Williams "told," making public an affair that might have remained private. For good or for bad, James Arthur Williams has entered Savannah legend, dragging Danny Hansford along with him.

And how does Williams feel now about his chosen home? "In the past, I would have been one of the first to object to the new federal buildings downtown [that some say need only the addition of shower heads to look like bathroom fixtures]. But now, if the sculpture in the squares were all torn down, if the historic area were destroyed, I wouldn't lift a finger." As he stands at the front door of Mercer House, a tour bus pauses, its occupants clicking

photos. "In fact, I think I'll just paint 'F—you' in radioactive paint above the doorway. Then, when their pictures are developed, they'll see just what I think!'"

1986

The Southern Body

A Southern friend and I were in New York, and after a few days of life among overpolished Manhattanites, we found ourselves homesick for a little talk with our own kind. As we scanned the room in our hotel's bar, we saw a hyped-up type talking about his latest movie; a beautiful black, shirt open down to *there* as in one of those male cologne ads; and a bearded individual wearing a Hawaiian shirt and an air of California malaise. But, alas, not one of those guys we knew in our bones before we were born, the ones who—as one friend puts it—"know how to act," and, more important, how to respond to our Southern wiles.

Just how do we Southerners manage to spot one another in most any kind of crowd? Well, there are some distinct features, gestures, signals, and symbols that make up the body Southern. If you, too, are interested in reading them, here are a few examples to get you started.

Beautiful dreamer: Lamar is the kind of guy who'll take a girl to the yacht club, and they'll have a grand time. He has sailed, ridden, and danced almost since he began walking. His natural habitats are the Battery (pronounced Bat-try) in Charleston, the Piedmont Driving Club (Margaret Mitchell's old hangout) in Atlanta, and the Country Club of Virginia in Richmond. Yet, while his life may look like a beach, a fraternity dance, there's also a real melancholy here: What our subject searches the horizon

for are his aspirations, his fading hopes for a literary life (that's a well-thumbed copy of *Look Homeward, Angel* in the pocket of his sports jacket). But nothing in his past has prepared him for the loneliness, for the real seat-of-the-pants stuff it would take to turn those hopes into realities. He has been brought up to be, above all, social. Thus, more and more of his life will be lived—via the magic of good bourbon—in the Land of Smashed Dreams.

Once a deb, always a deb: The reason Barkley is smiling and holding her cigarette that way is to show what a pleasant companion she is, and how open to fun. Time, for her, is not of the essence: She has all of it in the world to discuss the right length white kid gloves for the debutante ball (three inches above the elbow), or that *hilarious* thing that happened at the party last night. In college at Converse or Agnes Scott, she goes to dances and on road trips with young men like Lamar. Later, if she has a career, she makes sure it doesn't show too much. What she *is* serious about is her tennis game, the Junior League, and being mother to future debutantes. For her whole life, she will drink gin and tonics and wear the same dark-red lipstick, forties-style bob, flared shorts, and wedgies. Her worst cross to bear is the fact that since those Women's Libbers started up, no one appreciates her very real problems in keeping a good maid.

True grit: See the woman standing, iced-tea glass in hand, beside that paunchy yet powerful-looking guy, the local sheriff? The one who fairly oozes from her Frederick's of Hollywood outfit, who, thanks to her Claireoled bouffant and matching fuchsia finger-and-toe-nail polish, looks as though she's been candied? The one you suspect never goes out of the house without wearing three coats of mascara and bikini panties to match her outfit? Well, as in the poem by William Doxey, "Beneath that cute pink nipple beats a heart of raw gristle." Despite that cute little

sundress with the pink satin bows up front, Sherry is your basic pioneer woman. She drinks her Black Jack straight up and, likely as not, carries a Saturday Night Special in that frilly purse. Also, note the killer diamond on her left hand. A frog can only see what it can eat, it's said, and Sherry is like that: Pragmatism is her middle name.

Heaven can wait: The Reverend *knows* what's right—after all, it's written in The Book. He has the respect of his community, an answer for everything, and takes in stride the canned creamed corn and overdone roast beef served at the meetings of the Rotary Club. Yet, he's not above pinching his wife's posterior while she fries the chicken for Sunday dinner—or even sneaking a kiss from the church secretary. It's no accident that Jimmy Swaggart and Jerry Lee Lewis—not to speak of Mickey Gilley—are all cousins from Ferriday, Louisiana. Nor has the sensuality of the good Reverend's sermons been lost on the women of his congregation—if his wife gets fed up, starts reading *Ms.,* and leaves him, there are plenty more waiting in the pews. All this, and Heaven, too.

1986

The Invasion of Fort Bragg

Driving into Fayetteville, North Carolina, near Fort Bragg—one of the nation's largest army posts, home of the Green Berets and the combat-ready 82nd Airborne—is like entering a super-patriotic, high-testosterone enclave. The road to the base is named the All-American Freeway, a movie theater plays *Rambo* on both screens, crew-cut GIs whiz by on massive motorcycles, and topless bars and pawnshops—CHECKS CASHED 24 HOURS A DAY—E-2 & ABOVE—abound.

But Fayetteville is not the macho hotbed it once was. In the fourteen years since the draft ended and military service became voluntary, the army has been transformed. Many of those wearing the camouflage fatigues these days are young women; more than ten percent of soldiers are female. And while the community still has its share of "class-B dependents," as male soldiers call non-wives (women with a penchant for Army Rangers, a particularly hard-muscled breed with a reputation for being "wild and crazee," are nicknamed "Rangerettes"), it also includes many more army families. One-third of the lower-ranking GIs are married.

There's good reason for the army to be attractive to women. The would-have-been receptionist or manicurist can now be trained in an occupation at the army's expense (of 351 specialties offered, 302 are open to women), then promoted according to her performance and abilities, often pushing her well ahead of

her civilian sisters in responsibilities and wages. She won't lack for entertainment, either; at Fort Bragg's on-post Dragon Club, for example, enlisted soldiers dance to disco upstairs, hard rock and country and western down. If she gets pregnant, she may even be issued maternity fatigues!

Still, military life is not a feminist utopia. "We've taken a male institution . . . and turned it into a coed institution," General John W. Vessey Jr., the former chairman of the Joint Chiefs of Staff, told *The New York Times,* "and it has been a traumatic exercise for us."

Although "equal-opportunity workshops" are part of basic training, sexism does surface. Late last year, a female air force officer faced dismissal following her conviction on charges of fraternization and adultery with two married airmen, while of the two men, one was fined and the other received a reduction in grade. More routine are complaints that women officers aren't accepted by male superiors and subordinates. "It's hard sometimes, standing there giving an order to a sullen man a foot taller than I am," says a petite blond major who once commanded a company of many former Army Rangers. "And sometimes you wonder if maybe you should have gotten that job, but didn't."

Trained as a helicopter pilot, the major also wishes the army had a place for female jet-fighter pilots, a la Tom Cruise in *Top Gun;* however, American law and military regulations forbid sending women into front-line combat. But senior military men— some of whom look on women as surrogate daughters, or still think they should stay home and have babies—seem to have more reservations about that than the women do. "I blow up airplanes with missiles for a living," enthuses a woman captain. "I do everything from pressing the FIRE button to controlling air battles with a giant computer . . . and I *love it!*"

Life as the wife of an infantry soldier—a guy who, they say, comes home every once in a while with a rucksack full of dirty clothes and an erection—may be less exciting, but it still requires true grit. "The army comes first" and "If the army had wanted you to have a wife, it would have issued you one" are slogans one still hears around.

A woman who marries a soldier will find herself moving frequently, keeping the home fires burning while her husband is overseas or in the field. (When soldiers were deployed from Fort Bragg for Grenada, their wives were briefed by the army—their purses and diaper bags searched for tape recorders—but they didn't know much more than the public until their husbands, most of them, were home.)

For enlisted families, a fun Saturday night might be taking the kids to a drop zone to watch Daddy jump out of an airplane, then going to the Burger King across from the Smoke Bomb Hill Shoppette. With take-home paychecks as low as $800 a month, money is often scarce; some soldiers are forced to apply for food stamps. Wives with career credentials find that employers are wary of their transient lifestyle; whatever their qualifications, many army wives end up as unskilled workers—"at least those lucky enough to get jobs. The rest are stuck out in the trailer parks," says former USO director Jim Semple, who ran a "Wives Escape Program" that included aerobics, self-defense, and roller-skating.

What both female soldiers and wives say they appreciate most about army life is the travel, the sense of living on the edge and the heightened camaraderie among those committed to this very different way of life. "It's hard for the men to believe that a female can crawl on the ground, fire a weapon, sleep in the woods," says a young black sergeant, proving that the Spirit of Machisma, the

Romance of the Military beats as easily in a size 36-B breast. "But it's fun, it's different. And you never get bored!" Here are just a few of the women who share her enthusiasm and energy.

Remember the sexy physicist played by Kelly McGillis in *Top Gun*—the beautiful instructor of hunky young pilots who came to class wearing black-seamed stockings with her tailored uniform? Well, Sergeant Tammy McKenna, twenty-seven, is something like that, "When McKenna gives the guys a class on drugs and alcohol"—her present duty assignment—"it's not just a lecture, it's an appearance!" exclaims a male sergeant.

Before regulations changed, Tammy often wore black-seamed hose with her Class-A (dress) uniform. Now, "I sometimes wear fatigues with my jump wings—I've made five jumps— because when the guys see a woman wearing them, it definitely inspires respect! You know how guys are—they're all whoopin' 'n' hollerin'. Then I get in there 'n' take charge!"

The curvaceous McKenna probably looked good, too, when she appeared on "Braggin' About Your Body," an on-post TV show featuring aerobics. Besides the physical training the army requires, she works out at a spa three nights a week, "and I usually go dancing Friday and Saturday nights."

The sergeant is certainly aggressively energetic—or is it energetically aggressive? "I'm qualified with an M-16, as well as with German weapons," she says, about as gung-ho as the woman marine played by Jenette Goldstein in *Aliens*. "I'm really good with a weapon, and have my own little pistol," she adds delicately.

Despite the army's policy against women in combat, Tammy insists that "it would come down to that—women would be involved." (She's no-nonsense about men, too: her marriage to a

Green Beret ended after she went to Germany, he didn't: "For me, distance doesn't make the heart grow fonder.")

As a drug-and-alcohol counselor, she challenges her soldier-clients. "I say, 'See if you can have three beers a day for thirty days.' If they can't, they've got a problem." She also does marriage and family counseling, and handles cases of child or spouse abuse.

In fact, Tammy once could have been a candidate for counseling herself. Back home in Ohio, her mom, a former go-go dancer turned bartender, and her father, a foreman for a pipe plant, were divorced, and Tammy—"a rebellious teenager"—ran away at sixteen. She then went to live with her grandmother, and joined the military shortly after high-school graduation.

Now Tammy; her brother Keith, twenty-three, also an army sergeant; and her sister, Pamela, twenty-four, a clerk at the A & P Sav-A-Center, share the house McKenna recently purchased. For this ambitious sergeant, being "army all the way" has paid off in a secure lifestyle.

Melody Sexton, twenty-six, looks deceptively delicate, decidedly non-regimented. Still, her background may help her take the military life in stride. Her grandfather received a Silver Star in World War I; her father, a member of Merrill's Marauders—"a sort of forerunner of the Rangers"—lost a leg in World War II before her parents met. "Despite his disability, Daddy pushed himself, taking demanding jobs."

Melody is pretty tough herself. When husband Charlie, twenty-five, a second lieutenant, was in Officers Candidate School, she was determined that he be there when their son, Charles, was born. Melody was in early labor when she accompanied her husband to an important OCS dance. Wearing "a dress a fat friend

loaned me," she stood in the receiving line with him, and ate dinner at a table full of single men "who were terrified that I'd give birth before the meal was over." The couple made it to the hospital with seventeen minutes to spare.

The army has a class system, and Melody has seen both sides of it. Her husband came in as an enlisted man, rather than through military school or the ROTC, and she thinks that "gives us a special understanding.... Some people said we'd have to dump our enlisted friends. But what kind of people would we be if we did that?"

Many an officer's wife "wears her husband's rank," becoming the ultimate corporate wife; some feel that their spouse's career depends on their own participation in military ritual.

The social maneuvering can be fierce: another army wife once deliberately told Melody the wrong attire for an event, "but fortunately, I had worn my 'I'm not sure what to wear' dress."

Sometimes, Melody would rather "spaz out"—watch *Moonlighting* and OD on Snickers bars—than attend yet another officers' wives function: "There's so much tradition—the Dining Ins, the calling cards—as far as I'm concerned, they can keep it in England! It's not so much that I'm a rebel—it's just that I've never been one to bend to peer pressure. And in my view, if Charlie's good, he's good."

Right now, Melody feels lucky—her husband is at home with her and their two children, and if he's sent abroad for a three-year tour of duty, they will accompany him, expenses paid. But a one-year stint in Korea or the Near East would mean separation, as would combat. "It can be scary if I let it be—especially in times like these. Also, when you're separated, it takes time to learn to live together again. Recently, Charlie went on an exercise for a month to Wisconsin, and when he came back, he treated me like one of the guys, and I treated him like a three-year-old!"

But she's more concerned about her real three-year-old's reactions than she is about her own: "Callie thinks her daddy shoots people and jumps out of airplanes when he goes to work. And since our dog died last winter, she's been afraid that every time he leaves, he's gone to be with Shadow."

At her office, curly-haired Linda Burch, forty-two, wears camouflage fatigues and combat boots, just like her clerical help. But there's a big difference: Burch, commander of Fort Bragg's Criminal Investigative Division, also wears on her shoulder the oak-leaf cluster of a lieutenant colonel.

Indeed, Burch, who has been in the army for twenty years, is one of the few: only twenty-five percent of second lieutenants reach lieutenant colonel status, with an even smaller percentage of women making it. And in '85, Burch was selected to attend the prestigious Army War College, where, the sole female among a couple of hundred men, she studied warfare at the strategic level. She also has finished courses in military policing, drug enforcement and counterterrorism, and holds a valid Top Secret clearance.

Although Linda is smart, she's not fearless. She was still a "leg"—or non-jumper—"when it was strongly suggested that I go to jump school. I did it, but I made a lot of night water jumps," she says, blue eyes twinkling. "That is, I jumped at night, closed my eyes and wet my pants!"

Linda decided to try the military as a career when she attended an army summer program after her junior year at Kent State. At that time, women soldiers were still WACs, or part of the Women's Army Corps. "We weren't allowed to wear pants off post, and had to travel in a uniform of a light-green skirt and blouse," she says, speaking of a time when only single women were allowed to enlist,

and when a pregnancy meant a discharge. "People always felt like they had the right to come up and talk to me—if not to ask about their airline reservations, then to exclaim, 'What's a nice girl like you doing in the army?'"

Her first job in the service was as a recruiter, "You know, selling them on FTA—Fun, Travel, and Adventure! But don't write that down!" she says with a laugh (around the base, FTA stands for Fuck The Army"). Linda's current assignment, for which she is always on beeper call, doesn't interfere with her sense of humor. As part of her duties, she "investigates criminal cases above a certain level, such felonies as murder, rape, larcenies of over one thousand dollars and those involving hard drugs. Felonies don't happen between nine and five—but unless we have a body, I usually don't come back in!"

Sergeant Evangeline Davis, twenty-eight, is one of the army's many single mothers. But while some soldiers decide to have babies after coming into the service, Evangeline brought hers with her. Her daughter, Dacia, was born when she was sixteen: "I had to drop out of high school so I could keep her. I was working as a waitress and cashier, the only jobs I could get. So I tried the army out by joining the reserves, and I liked it." Today, she is a section chief, handling all the records for vehicles in her brigade.

Evangeline also supports her mother and shares a house trailer with her and Dacia. "Mother worked hard for fifteen years as a nurse's aide and as the single parent of six kids, and that really takes a toll. So now, she's living with me, and it's good for me, too. Because if I ever get shipped out, she can take the trailer back home [to Portsmouth, Virginia], and Dacia will have somebody with her.

"The army gives me a chance to have a decent-paying job, go to college," the black sergeant adds earnestly, explaining why she

"re-upped" for another six years after her first three. "There's less prejudice, things are more equal," Evangeline says of the army, which is about twenty-seven percent black. "Right now, I'm working on an associate's degree at Fayetteville State University, tryin' to get a packet together to go to Warrant Officer School," she says, referring to an opportunity that could mean more money for her, as well as put her at a rank above sergeant, but below that of second lieutenant.

Indeed, the sergeant may be the kind of soldier the army likes best: smart, hard-working—and hungry. One gets the feeling that however good she may look in fatigues, however one can imagine her with a full date book, Evangeline's life—at least for now—is all army, army, army!

"It's hard work dancing for these GIs" exclaims Malae Kdwadseur Mode Bureau Perkins on the sidewalk outside Rick's Lounge, dressed in high heels, hot pants and T-shirt. Malae, known as "Molly," danced topless at Rick's for eight years, until the club burned down last fall. She was born on the fourth of July in Thailand in 1953, and grew up with a fantasy of coming to the States.

"I like American men, their light skin, blue eyes, brown hair," confesses Molly, who met her first husband—like her other two, an American soldier—at nineteen, when she had already been dancing topless in Thailand for two years. "I am strong, but I am weak about men. And I meet about 200 guys a night—they're lonely, homesick.

"I like slow men, men who take their time," she says, warming to her favorite subject. "And if they don't know about sex, I'll train them." Not that she doesn't have complaints: "In Thailand, sex is simple. But American men are so violent, they want to tie

you to bed and all that stuff. And army officers think they so sophisticated. But they don't know nothin' about love, a person's feelings. An enlisted man, though—he show you a good time!"

Still, when Molly is committed to a man, she's faithful, playing the role of the affluent geisha. "My man eat only fresh stuff—no sandwiches, no McDonald's. And if he wants to eat at 5:00 A.M., I get up, cook for him. Each one I marry, I take care of him, buy him whatever he wants—clothes, cars—that I can afford," she explains; she sent her third husband a $100-a-week allowance ("plus $30 to $50 for his dinner") to go to welding school after he got out of the army. "But he doesn't want to come South, and I don't think I can stand the cold weather (in Chicago)." Tears fill her lovely dark eyes.

"Also, I have to be near army base to do my work, make money." In her country, "no one looks down on you for dancing. Everyone has to work—even children seven, eight year old." Molly supports her family in the Far East, and built her widowed mother of twelve "a house with two bathrooms."

Along the way, she admits she "got deep into drugs—coke, Quaaludes." She also has a taste for gambling: "If I wasn't a gambler, I be a millionaire now!" She likes to get together with other Oriental women, play for stakes, "just to have fun, with no guys around."

"A lot of time, I think when I about forty, can't get no more satisfaction, I go back to Thailand, have family life," she says. Though recently invited by her current soldier-boyfriend to a barbecue at an enlisted man's home (where she asked his wife what baby formula was, and whether she wouldn't like to work at Rick's, too), she never feels quite accepted.

"I love America. I love this country. But it don't seem like Americans love Orientals."

1987

The Drinking Season

In the Georgia town where I grew up, card playing was considered sinful. There was no senior prom at the high school because of a sanction against dancing. But I *was* used to the men "riding around for a few minutes" after church just before Sunday dinner, and to the change in Daddy's personality when he came back. (Indeed, his alcoholism is ever associated in my mind with the fundamentalist dictum on total abstinence.) In such communities, one's place in the social structure revolves almost totally around whether or not one drinks: the Methodists do, the Baptists don't ("at least in front of each other," as one wag observed), and the lines—for Sunday School and public consumption, anyhow—are cleanly, clearly drawn.

"Being in a dry county doesn't mean people don't drink," explains Roger Brashears, spokesman for the Jack Daniel's Distillery in dry Lynchburg, Tennessee. "It just means it's against the law to buy and sell it!" In every Southern town, no matter how small or dry, there's a way to get booze and a place to drink it, even if it's only the state-owned county line liquor store, the Seven-Mile Highway Bar and Service Station, or an illegal bar in somebody's living room. When I visited the house of my lover's Baptist parents outside Charleston—where both drinking and our sleeping together were forbidden—we sat on the back-yard picnic table admiring a beautiful moon. When I allowed as

how I would like to have just one drink, my friend said, "You can." Opening the door to the doghouse, he thrust past his daddy's hound dog, and pulled out the bottle of Wild Turkey his father kept hidden there.

The result of this kind of craziness is that a lot of us—however urban or adult we become—insist on blending our Bible Belt imprint with our proclivity for an altered state. Alcoholics Anonymous says that alcoholism is in part a spiritual disease in which the spiritual dimension, long anesthetized, must be restored. But, ironically, we Southerners—with our characteristic tolerance of ambiguity—see little conflict in the two conditions.

Among my own best times have been Saturday nights spent getting looped with Southern friends, then singing along with a player piano the Baptist hymns—"Just As I Am" and "Are You Washed in the Blood?"—with which we had all grown up. Once, I sipped whiskey while two equally drunk friends picked out those same hymns on a banjo and a steel guitar in a motel room in Macon, Georgia. As the fat tears rolled down my cheeks, they didn't notice, or even wonder why. After all, people cry in church, don't they?

At times, we even imbue drinking with positive moral values: "I don't trust a man who doesn't drink," or, "Somebody who doesn't drink makes me nervous," we say. These roller coaster curves in our attitudes toward booze, plus our penchant for whiskey, often amaze those from other locales. "It must be because it's more boring down here," says a puzzled New Yorker transplanted to Atlanta. "In Manhattan, people—at least the people I know—just don't *get* drunk," says *Esquire* columnist John Berendt during a sojourn South, sipping a vodka soda with a twist, "the easiest drink on the body."

"Up home, the bars are just as full at 9 A.M. as they are at 6 P.M.," adds a Savannah policeman who moved south from Detroit. "But

it's more of a social thing. Down here people seem to drink to get *drunk.*"

What such people don't understand is the associations alcohol has for us in terms of freedom from repression: Booze confers a fun-house license to those of us born wearing Baptist-designed chastity belts. Under its influence, we can turn loose those reptiles thrashing around in our ids, and instantly become children out for recess. Even more conveniently, what happens while we are drunk—as what happens while we are in New York or Chicago—can be said to not really have happened at all.

"In the North, I always felt mildly barbaric, a little too earthy, and I worried that I drank too much," writes Blanche Boyd in her book *The Redneck Way of Knowledge.* Boyd, who has since quit drinking, tells of a time when she drove an LTD with fuzzy dice hanging from the rear-view mirror to New York, where she drove her editors around while passing a bottle back and forth. "They said it was fun," Boyd says. "But hell, they'd never gone just *riding around* before!" She laughs, referring to that Southern drinking and driving tradition that still extends throughout our region, despite the stricter, saner sanctions nationwide.

Of course, Southern boozing has *everything* to do with sex. When we were little, our Baptist and Methodist Sunday School teachers first terrified us by describing missionaries who had been buried alive rather than deny Christ. Then the preacher scared us further by yelling from the pulpit about the two biggies, drinking and sex, one of which is bad because it leads to the other, or at least to *thoughts* of the other. (My father—a poetry-quoting charmer with a passion for bourbon, my mother, and, after they were divorced, a few others—was viewed by his Methodist family as headed for the Lake of Fire on both counts.) Now, sin, sex, and fun are as entwined, as entangled, as entrenched in the Southern

mind as kudzu—and stamping out one without stamping out the other two is highly unlikely. But in order to fully enjoy this contradictory trio, most of us feel we need to anesthetize the part of the brain that has to do with "sin." "Where's the bottle?" a man describes his paramour as saying when they met for an assignation: She literally couldn't enjoy the evening without the lubricating effects of a little booze.

But some Southern women never even have the opportunity to try it. At our house, the Christmas fruitcake was soaked in orange juice rather than bourbon, and women like my grandmother never tasted liquor at all. Her daughter, my mother, turned from the boredom of depression to the boredom of prescription drugs. And then there was the nervous wife of a stern Methodist minister prep-school headmaster who tearfully confessed to me her addiction to Nyquil: "I can't sleep without it and I don't know what to do." Obviously, being on the pedestal was not that much fun.

Growing up, I envied the freedom the boys had to get smashed, wreck cars, hang out in sleazy, neon-lit dives: They were out in the world, while I was cloistered, overprotected by my role as daughter, girlfriend, wife, or mother. No, I didn't want to go to war, play football, or even play pool. I still wanted to wear perfume, long hair, and frilly clothes. But inside, I was like the woman in the Hank Williams Jr. song, "Outlaw Woman"—I didn't want to *be* a man, I just wanted to drink and carouse like one.

Some Southern women, brought up less rigidly, do what is called "controlled" drinking. "My mother had two bourbon and waters every day promptly at five, and then played her piano," says a South Carolina banker's wife, now the mother of two debutantes. In Savannah, the Married Women's Card Club meets promptly at 4 P.M. Strong drink is served, gossip is exchanged, cards are played, and the whole thing is over by 6. "What a

woman drinks is a social profile," a young career woman told me. "Good old girls drink beer or bourbon and coke. The sophisticate or lady, white wine. And, oh yes—gin and tonic only in summer. On Labor Day, you change to Scotch, just like you change from white shoes to dark." When such a woman doesn't follow the rules, chaos ensues, probably to the delight of the men around her. "One night I wanted to be different, so I drank Southern Comfort all night, and I *was*," she adds, with chagrin.

On the other hand, Southern men are rarely embarrassed by such indulgences. A playwright who, at forty, still wears a Confederate medal in his Stetson, reminisces nostalgically about what booze has meant in his life: "One year I went to New Orleans with the high school band. The hotel was across the street from the Mirror Room or the Azalea Room or something like that, and I must have looked older than I was, because they served me. It was my first time in a bar and I loved it! Back home, I made spending money by driving to a wet county fifty miles away, buying the cheapest stuff imaginable, and selling it to local bootleggers. Later, at the University of Alabama, we always took Rebel Yell in a flask to the games. I don't know why. It was just always Rebel Yell. Now my son goes to the same school, but he sits with the Baptist Student Union." He considers this pensively, as though concerned that his boy might be missing out on one of the better parts of growing up Southern.

In the view of some Southern men, he may be right. "The afternoon of the game, we'd go to the drive-in and drink 'Sunday Shakes'—beer in the big plastic cups they sold it in on Sundays, when it was illegal. Then by game time, we'd be ready to kick ass, kill somebody," a thirty-five-year-old Charleston native recalls with obvious relish. Playing ball was serious business, but he and his buddies also made time for recreation: "We'd go to a bar or a

beach house on Myrtle Beach, where we'd get drunk and talk about who was the best football player, who had the best car, who had the best-looking girlfriend, who had the best-looking mama—stuff like that. I'll never forget old Eddie, sitting out on the porch wearing his football helmet with the deer antlers off the living room wall stuck through it, washing Cheese Bugles and Tums down with a Pabst. . . ."

Yet some Southern drinking is not so jovial. One of the South's sadder sights may be a country-western bar at closing time. The lights suddenly go on, revealing the trash on the dance floor and the empties on the tables, while lone men lurch out the doors in their frayed good white shirts and cheap polyester pants, another harsh work week ahead of them after a night of drinking to tear-jerking music without the women they had hoped to meet. I used to date a TV sportscaster who couldn't and wouldn't drink: He said he was afraid he might burst into tears. For while drinking seems to make *everything* possible, it actually makes many things—like really good loving—*im*possible.

In the lives of drinkers, things just *happen*—often as mysteriously to those involved as to the spectators. Ever into what psychologists call "denial," we don't even connect these events with our taste for the hard stuff. "I always get this way when I have to leave somebody I love," my oil-rigger boyfriend told me, grinning ingenuously after I had stopped the car for the third time so he could throw up during a fifteen minute trip to the airport: In his view, there was no connection between his nausea and the two fifths of Scotch he had consumed the night before. In Savannah, where I live, we have what some call the "Savannah Syndrome": Facilitated by booze, each day blends easily into the next, eliminating anything possibly related to ambition. Down farthest south

in Key West, the "Keys Disease"—in which one goes out for a loaf of bread in the morning and doesn't get home till midnight—is epidemic. And recently, sitting in a bar on the Savannah River on a Sunday afternoon, I realized that two out of the ten patrons had been shot by their lovers during drunken spats. "But that was three years ago!" exclaimed one of the shootees when I asked him about it. "A lot has happened since then!"

But if *anybody* has the market on grief and boozing, it's the Southern writer, especially the male of the species. (On the other hand, scratch a Southern drunk, and you're likely to find a guy who aspires—at least verbally—to the romance of the writing life. "He drinks because he can't write" and "He can't write because he drinks" are the ways we put it.)

As for me, I've often wondered whether I do the things I do because I'm a writer, or whether I'm a writer so I can do the things I do. But so far, my male peers are the only ones I've seen swaying drunkenly at a podium and hiking a pants leg to show a hairy, white calf while soliciting "any willing coeds under twenty-one to meet me after the reading."

Now, I don't pretend to understand *why* these guys do the things they do, but I do know that when I see it, I feel—despite my own excesses—the same way my mother and grandmother did when Daddy sat with his face in the gravy, raising it occasionally to murmur something about all the men he could buy and sell. And the source of that feeling is the same: He's one of ours, a blood brother, so what he does reflects on us as well.

"Southern men are the only men in this country who've been defeated," a Southern scholar once told me, explaining why, in his view, we are so inclined to melancholy. But according to Dr. Gerald Brown of the National Institute of Mental Health, this bottomless grief might be caused by the booze itself. "A little

drinking brings out our natural personality," he says. "But alcohol in any amount has a depressant drug effect. Excessive drinking inevitably lowers the level of serotonin—a substance that has an inhibitory influence on brain function and behavior."

Alcoholism is a serious disease, but in line with our storytelling tradition, one can probably hear some of the most raucous—if disturbing—drinking stories at Southern AA meetings. "One night, I was listening to 'Why Don't We Get Drunk and Screw' on the jukebox, and the next morning, I sailed my boat for Key West, where I stayed for a year," says a man who once had a good time drinking, then had to change his ways. "But after a while the drinking wasn't fun anymore. I was waking up at 4 A.M. to drink, again at 6 A.M. Then I drank all day till I passed out, and the next day it started all over again. And finally, there just wasn't any night and day."

Everyone who drinks even moderately worries at times that this might happen to him. And researchers say that some of us are born with neurons that, once they have tasted booze, just scream out for it. According to Dr. Doug Talbott of Atlanta's Ridgeview Institute, an alcohol and drug treatment center, the brains of addicts actually cry out for their drugs of choice, with different synapses craving different substances. And, says Talbott, the addict's drive to obtain these substances is at least as strong as the desire for food, water, or sex.

The good news is that while alcoholism runs in families, and many of us are genetically programmed for the disease, not all of us who drink are destined to become drunks. Dr. Paul Wender, author of *Mind, Mood, and Medicine,* says that in the future, it may be possible to find out whether fetuses carry the gene for alcoholism before birth by amniocentesis. "It's just a matter of time," he asserts, suggesting a possibility that—since some of the

world's highest achievers have been afflicted with alcoholism—will undoubtedly add fuel to the fire in debates surrounding abortion issues.

Though the pain caused by alcoholism can barely be assessed, the disease can be arrested—and not only by going to the lengths of some of the men in my family, one of whom committed suicide and two of whom shot themselves because they couldn't keep promises made to their wives to stop drinking.

AA's only requirement for membership is the desire to stop drinking, no matter how much or how little one drinks. And even those of us who are not life-or-death boozers can benefit from AA's positive message. Like many, I'm more sober now, if not completely so. I began to get into trouble, not necessarily with the booze itself, but with what happened while I was on it, the choices I made under its influence—some of which affected my life for years. So nowadays, I sometimes attend a meeting before going out for a *few* cocktails.

Meanwhile, all possible horrors aside, the word *whiskey* should be written in neon, serving as it does as God's salve, a balm, a kind of Vick's Vaporub of the spirit to creatures too often caught up in the tensions of the day to appreciate His many other gifts without attaining a certain state of mind. I once chose getting drunk and listening to Donna Summer on the headphones as anesthesia over a shot offered me by a doctor before a potentially painful biopsy. During another time, I staved off what my mother would have called a "nervous breakdown" by staying in bed drinking straight Black Jack and eating barbecued ribs and chocolate chip cookies.

In his book *The Art of Loving,* psychoanalyst Eric Fromm mentions a sense of isolation in the universe as the primary pain

of being human; he also mentions orgiastic, communal activities as a means folks have long used to overcome this sense of isolation. It's definitely the method we Southerners—as tolerant as we are of excess in everything from aristocracy to flowers to architecture to grief—tend to favor. It's said that the first thing one is asked in Charleston is, "Who were your ancestors?"; in Atlanta, "What do you do?"; and in Savannah, "What would you like to drink?"

The latter city's Chatham Clinic for Addictions was started in 1956, when it was discovered that roughly half the patients in an Atlanta clinic were from Savannah. "It was one long cocktail party," says a former debutante of her seventeen-year marriage in a town where hosts routinely offer go-cups to guests, as though they might not be able to make the two miles home without sustenance.

Indeed, for us, the drinking season never stops. Gilley's, and every other country-western bar throughout the region, are scenes of license, even mass frenzy, on any Saturday night. After Mardi Gras in Mobile and New Orleans, local Catholics have ashes pressed into their foreheads as expiation for their sins. On Georgia Day in Savannah, drunk grown-ups dressed as Indians and settlers are watched by children and other drunk grown-ups as they reenact General Oglethorpe's landing on the Savannah River and his meeting with Chief Tomochichi. And some South Carolinians manage to turn even Charleston's refined Spoleto Festival into one long imbibing match.

But my favorite drinking event is Savannah's St. Patrick's Day celebration, which is one of the largest in the nation. Drawing as many as 300,000 participants, it begins with Bloody Mary parties at 8:30 A.M., continues on with green beer, and is a three day, all out bash, during which we residents sip half pints of Black

Jack from paper sacks, kiss attractive strangers, and watch as out-of-towners make fools of themselves in the streets.

They *must* be out-of-towners—Southerners just wouldn't act like that!

1987

Blood, Heat, Mayhem:
A Memoir

Violence has been a part of my history, as entwined in my brain with my Southernness as kudzu or Spanish moss. My father, a dreamy, failed poet disguised as a tire salesman, could become violent, the drink tripping his fury—especially toward me, his firstborn girl-child. For whatever reasons, it was me—not my mother or little sister—over whose head he held the butcher knife.

Later, the things that "normal" Southern men did and said shocked me. When a friend told me of the ritual of a father smearing the blood of his son's first killed deer over the son's body, I thought he was joking. Another male friend laughingly told of a man who "shot a bunch of his hounds because they weren't pointing." My stepfather, a respected man in his community, sat on his porch at twilight shooting at small animals—squirrels, rabbits, chipmunks—while my mother, a total believer in the supremacy of husbands, sat nervously sewing or wringing her hands.

I grew up fearing black men, with their right to be angry at whites. Driving along in the country, I automatically avoided asking directions from crewcut white men of the *Deliverance* variety. Violence was common, but violence was something men did—from shooting rabbits to going to war.

As a Southern woman, I have often felt repelled by the brute ways of my Southern brothers. But I have also encouraged them, playing straight woman to their no-good, good-ole-boy crazi-

ness—buying their rationales, nurturing their machismo. Many Southern women, brought up to behave genteelly, need men to act out their aggression for them.

That's not to say that Southern women don't have their own propensity for aggression, even mayhem. My first mother-in-law was a little Southern woman who trudged to her civil service job outside Atlanta each day. At night, she locked herself in her bedroom and read the detective magazines, with bloody, corpse-strewn covers, that she kept stuffed beneath her mattress. I was self righteously revolted by her taste, preferring Frank Yerby novels of pirates and ravished maidens myself. This woman had raised one son—a son I eventually had to divorce because of his propensity for violence. She herself once slashed me across the breast with her long fingernails in a fit of rage. More recently, I sat across the lunch table from my new husband and noticed for the first time a scar on his lip—"Don't you remember?" he said when I asked about it. "It's where you threw that book at me!"

I once heard a Southern man describe as "the height of femininity" a woman named Honey, a telephone linewoman who had been kicked out of every bar in Savannah for her habit of pulling her gun from her purse when drunk. She was probably not the only one in the bar packing a pistol. According to the National Rifle Association, Southerners have the highest rate of ownership of both household and hand-guns. A friend of mine tells the story of a man in Oklahoma City who, seeking to protect his girlfriend from someone who had threatened to break into her house, called local police to see what would happen if, as a private citizen, he shot the intruder with his .45. "Well," the police officer considered, "don't shoot him till he's inside. If he doesn't fall inside, go out and get him. If he's heavy, the officers will shove him in for you when they get there."

"You think it's a myth that the South is more violent," says Dick Wood, a Savannah Industrial designer originally from New Hampshire. "Then you move down here and realize it's true." Wood says while he was in the Northeast, he never met a woman who had been battered; since moving to Georgia, he has met several. Lyn Mumma, a former New Englander who is now manager of a psychiatric hospital in Savannah, held an earlier job in rural Georgia. "I used to counsel spouse abusers," she says, "and these guys would come in with a glazed look in their eyes. 'Well, if she had done what I told her, it wouldn't have happened,' they would say. There was no reasoning with them. It was as though they thought violence was their right."

It was probably some sort of internal radar that led me to Savannah. Something about the city—small, jewel-like, and awash with azaleas, with one of the largest historically preserved areas in the country, yet also an international seaport—has made it an ink blot test for the best, and often the worst, in human nature. Early in its history, pirate ships made port here; during Prohibition, the town offered continuous drinking and gambling. And in 1986, the FBI reported in a survey based on the number of homicides per 100,000 inhabitants that Savannah's murder rate was one of the highest in the nation. (Chief of Police David Gellatly says the census is only conducted every ten years, so the FBI didn't take Savannah's population growth into account.)

Since moving to Savannah a decade ago, I've dined at the mansion of an antique dealer known for his elegant parties—and for being found guilty of the murder of his young male lover in two separate trials; a third ended in a mistrial. I've discussed poetry with a refined English professor only weeks before he was done in by two youths he had picked up for sexual purposes. I've

attended a cocktail party where my hostess warned me not to mention a grotesque sex-and-drug-motivated murder that had occurred in her building. She discreetly motioned toward another guest. "Her son was suspected of it, you know," she whispered.

And I have experienced more direct violence: I lay in bed in my apartment while my upstairs neighbor was brutalized and nearly raped. I was pinched by a passing bicyclist as I came out of a nightclub. In an attempted mugging at nine-thirty on a warm Friday evening on the sidewalk in front of my Victorian apartment, my daughter's date was shot in the side, the bullet ricocheting off a rib into his forearm.

When I moved to this city, I was writing a book about growing up Southern and female. Since then, Savannah has become a metaphor for something inside me, something that came bubbling up as I wrote my book. When I found myself compulsively clipping bloody stories from the newspaper, I realized I needed— if only for the sake of my psyche—to investigate.

Last year, on the television show *20/20*, I heard a representative of Atlanta's Centers for Disease Control call murder "a contagious disease." Now, as I exit 1-85 and drive into the innocuous Kroger Office complex and toward the Davidson Building, one of CDC's several sites in Atlanta, I muse over my sense of the South as a place that has a special relationship with violence. And as I walk on neutral-colored carpets through muffled hallways lined with gray file cabinets, I wonder what these *scientists* can tell me about violence that I don't already know.

Jim Mercy, a soft-spoken sociologist in the Division of Injury, Epidemiology, and Control, begins by explaining that his colleague's statement on *20/20* about murder being "contagious" wasn't meant in the literal, viral sense. Rather, his colleague was

speaking in socio-economic terms. Furthermore, says Mercy, the South isn't the region with the highest homicide rate; that honor goes to the West. And while the South's homicide rate is very high, the reason isn't inherent violence, but rampant poverty. "State by state, the South has more people below the poverty line," Mercy explains. "Most murder victims are young, urban, male, and poor—which, in the South, means black. Murder is the highest cause of death in black males age fifteen to thirty-five." As Mercy speaks, I recall the news that morning: Two black students had been stabbed at an Atlanta inner city high school. "However," says Mercy, "a tradition of violence does play a role. People who are exposed to violence as children are more likely to act out violently as adults in rather dramatic ways."

Leaving the CDC, I plunge into rush hour traffic and drive across town to visit Doris Zumpe of Emory University. Like many Southerners, I've long assumed that our region's extreme heat has something to do with our propensity for violence. Zumpe researches the behavioral effects of hormones in animals at the Department of Psychiatry at the Emory University School of Medicine. As a side effect of her research, Zumpe has studied changes in climate and its relationship to certain crimes.

"There are," Zumpe says, "certain forms of violence—assault, rape, domestic assault—that seem to parallel changes in temperature, with these crimes peaking at the time of highest temperature. But it's a misconception that the South has more crime because of its hotter climate. It's simply that certain crimes peak earlier here."

Not murder, however. Murder rates remain consistent throughout the year, regardless of temperature.

I am confused as I drive back toward Savannah. Despite Jim

Mercy's statistics and Doris Zumpe's assessment, my feelings just don't fit the facts. And I am a white, middle-class Southern woman, not an urban, socio-economically deprived black male. I've never played a game of football, never been in a barroom brawl, never fought on a battlefield—though I have been exposed since birth to men who do those things. All I know is that I grew up believing the South to be a more than ordinarily violent place, and I had my reasons.

My sister's grandfather-in-law was murdered in rural Alabama over water rights to his land. His body was found, but no attempt was ever made to find his killers—rural justice. Her mother-in-law, the widow of a railroad man, would smash turtles with a hammer, as though they were cockroaches, at the bank of the pond where she was fishing. When a friend and I went into a French Quarter bar at noon for fifty-cent martinis, I noticed bloodstains on the doorstep. "The geeks were here last night, bringing in their cockfights," he explained. When I taught poetry in a high school in the north Georgia mountains, one student wrote an admiring poem about a real-life character, a gas meter man she called "The Man Who Did What He Said"—which was cut the head of a dog with his pocket knife when the dog wouldn't stop barking at him after he had warned its owner.

I once worked briefly aboard an offshore oil rig, subjected daily to roughneck ways. There, a forty-eight-year-old Texas tool-pusher, a man esteemed and respected by his men, told me stories that, for me, embodied the ambiguous blending of violence and sentimentality that is the South. "One year," he said, "I was in so many fights that I changed jobs nineteen times. I was nineteen when I made driller, the wildest one in south Texas, and the girl I married was the prettiest. Later on, when a boy was mean to my boy at school. I went to his house, called his daddy out, drew a

circle in the dirt, told that boy to stand inside it and stay there while I beat his daddy up. After my son was burned up out at the rig, I tore up the truck he had been in when he died, and burned it. My hair turned white overnight, and so did my wife's. I didn't care whether I lived or died. Twice I fell off the derrick, forgot my safety belt, had a concussion, went into a coma. But at the funeral, my son's baby—my grandbaby—crawled into my lap as though he meant to take my boy's place. I believe in things like that."

And so do I.

Yes, I know that much of what non-Southerners consider the endemic violence of the South may not exist. It may be just one more result of bad movies, old stereotypes, an inability to understand that the drawling killer in the news is not necessarily the average man on the street. But there is *something* here, no matter what the scientists and statisticians tell me. It is in me, and in many—if not most—Southerners I have known. A smiling demon in the Southern soul that responds to violence in a peculiar, almost loving, way. It is a question not so much of numbers, perhaps, as of attitude. It is also a question of effect.

While writing this essay, I woke to nightmares of blood-soaked bandages that turned into blood-soaked earth. But I also had evidence that my longstanding love-hate relationship to violence was changing.

When I was mugged last fall—pulled out of a friend's Alfa Romeo at one in the morning, my favorite purse jerked from my shoulder by an Arnold Schwarzenegger look-alike—I merely felt angry and inconvenienced. And last winter, a man who shoplifted a tube of curl activator from a store in the next block was shot in my backyard by the security guard who had chased him there.

I heard the shots from my desk—retorts that sounded as harm-

less as firecrackers. I looked out the window, saw the police cars, the ambulance, and the gathering crowd.

And then I simply turned back to my typewriter and kept on working.

1988

Fatal Shame:
When Suicide Runs in the Family

Suicide, depression, and alcoholism have affected my family from the beginning. My mother, Ruth—a beautiful, talented Southern belle—showed signs of an excessive sensitivity, even morbidity, at an early age. After her divorce from my alcoholic father and her first "nervous breakdown" at thirty-nine, my sister, Anne—then a teenager—and other family members (I had already left home at sixteen) took turns sitting with her to keep her from killing herself.

When my mother finally overdosed at sixty, neither Anne nor I were surprised: throughout the years—despite treatment, remarriage, a new life—she had repeatedly told us she would do so.

"At the time, I remember thinking it was very brave—that ending her lifelong depression that way was the bravest thing she had ever done," Anne told me recently. "But about a year later—I had a job, small children, and was under a lot of stress myself—I began to be afraid, reading the obituaries, wondering whether my life was worth living. I was afraid my unconscious would kill me, say, when I was driving on the freeway.

"And then, I was worried about you, my older sister, because for a while you seemed to take on mother's depression, even her gestures . . ."

As she spoke I recalled a period in my own life when I avoided leaving kitchen knives out because I feared I might stab myself.

"I don't feel that way anymore," Anne went on, "But I still get depressed every year around this time."

She pauses as we both suddenly realize the date: it is October 2, the anniversary of our mother's death by suicide.

1992

Why I Like Tough Guys (The Real Kind)

A few years ago, I tried to explain to my fourth husband, Zane, why I wasn't as intrigued as he by the details of the Army's Bradley Fighting Vehicles.

"I'm only interested in three things," I began seriously, if pretentiously: "feelings, beauty, and the search for truth."

"I'm only interested in three things, too," he laughed: "car racing, jumping out of airplanes, and making love."

By then we were both cracking up, for our dialogue captured something about our relationship: Zane, fifteen years younger, a toughened ex-Army sergeant and paratrooper, a former sky diver and truck driver. I am a poet, writer, and teacher who often lives in my head or in a book. When his blue eyes first met my brown ones across the bar in a local pub six years ago, he thought I was a "schoolteacher," and I thought he was a blond hunk—at best just another sexy one-night stand. Going off with him that night was like visiting a foreign country—but unlike other trips, this time I decided to stay.

Like many Southern women, I had been brought up to choose the sensitive Ashley Wilkeses of the world rather than the tough Rhett Butlers. "You are who you marry," my mother told me over and over. The kind of men she favored for me were the white-collar ones who went downtown to Atlanta each day, a briefcase under one arm, a Brooks Brothers coat over the other. Oh, I had

tried to escape her imperatives via a failed first marriage to the Sean Penn of our town. But for a while, with husband number two, a young accountant-type, I achieved her goal. In the suburbs, I cried as I watched him through the kitchen window, carefully laying out perfect squares of zoysia grass.

Next I tried someone who was at least mentally muscular—a Boston intellectual, Columbia- and Yale-educated. Our relationship was built around his superiority—I, poor Ignorant Southern Girl saved by his Big Brain. An aspiring writer, he liked to tell me what books to read and how to revise my poems. He was also a good-looking guy who wore Italian suits, and had eyelashes so long that they lay on his cheek as he slept. But my passion wavered as I realized that I had to be less in order for him to be more: His mastery of the cutting remark chipped away at my self-respect. Too, he was less than flexible. "I can't be around those sociopaths!" he gasped when I suggested we go dancing at a low-rent disco. By the time he vetoed first a year in Mexico, then a move to San Franciso, I was getting the picture: I had more chutzpah than he did. When my first book was published, things fell apart at fast-forward, ending in a third divorce. He left the South, saying he hoped never to see another azalea or Southern belle again.

During the next few years, I dated college professors who wore starched pajamas to bed, and fast-track guys who orgasmed only at the right parties with the right woman on their arms. More tediously, I survived affairs with two Famous Southern Poets who were as well known for their sexism as for their writing, and who regularly proved their tough-guy status by giving drunken readings, during which they solicited women students from the podium.

It was then—fed up with trying to find what Mother would have

called "good husband material"—my search for the real tough guy began. To hell with middle class values—I just wanted to have fun! And for a while, I did. The wrong men were usually great dancers and great in the sack (though given to throwing my diaphragm across the room, murmuring things like "I don't want anything to come between us, baby!") For one thing they had a lot of practice: *monogamy* wasn't even in their vocabulary. Indeed, some of the men I took into my frilly Savannah apartment during that (pre-AIDS) period were downright dangerous, men who looked good but who turned out to be drug dealers or ex-felons. One, like a tomcat spraying his territory, threw damp towels around my bedroom and made deals over my telephone; then, warning me not to sleep with anyone else until he saw me next, left as abruptly as he had arrived—and who *were* those two armed mean-looking men who were always with him anyway?

Driven by an oft-unseemly curiosity (did I do the things I did because I was a writer, or was I a writer because I did the things I did?), I indulged in exotic travel adventures, working as one of the first women aboard an off-shore oil rig, where I was surrounded by muscular men who routinely commented things like "I'd marry yo dawg to git to you, honey." I soon had a boyfriend to protect me from the rest, a roughneck who when visiting me in Savannah, threw his bowie knife at the roses in my wallpaper and drank so much Chivas that as I drove him to the airport the next day, I had to stop the car to let him throw up.

I went alone to a Soldier of Fortune convention to research an article, where I was "saved" from a hostile black-clad biker by a "sweet"—talk about having to choose among Galahads!—illegal arms dealer, when I naively asked the meaning of the human hand skeleton hanging around the biker's neck. I danced with a witch doctor in a jungle disco in Guatemala; lived in a hotel-cum-

brothel in Costa Rica; then traveled with a Contra supporter to a refuge camp on the Nicaraguan border. Sitting in a village bar, I sipped rum-and-sodas, grateful that my friend, an Indiana Jones-type (who, true to form, had a wife in Illinois), had decided that because of bad weather we would not, after all—because of the weather— go up in the single-engine plane out back with the bullet hole in its side. But when he began a long conversation in Spanish with a Nicaraguan who looked at me with open hostility, I had the distinct feeling that his pal was not the kind of guy who, if we met in a dark place, would follow the Rules of War—nor think a woman was made for more than one thing.

Think life as a gangster's moll: it wouldn't do for the long run. In fact, it probably wouldn't even last long. These were not the real tough guys—these were cartoons! When my friend asked if I'd like to drive with him through Nicaragua and Guatemala in a convertible, I declined, citing a deadline on an article on "Fourteen Sinfully Sexy Guys."

It was near the end of this quest that I met Zane, a paratrooper with steel-blue eyes. Albeit a reader of Albert Camus and Joseph Conrad, Zane is from that delicious-looking blue-collar group, with biceps developed by actual work (of which many middle-class women only allow themselves surreptitious glances: "I wish there was a brothel for women, a friend once said to me plaintively. "There is," I replied; "Fort Bragg!"). At the time we met, Zane was in the Army, and I, a former war protester, was incredulous at his choice of the military. But though I didn't know it yet, my meticulous research had paid off: I had finally met a man who was not threatened by my aggression, my (many) opinions, or even my having had more lovers than he had. Instead, because he was so genuinely masculine, I felt more feminine by comparison—I may have been gutsy, but he had the real *cojones*. And for

the past eight years of our marriage, my choice of a true tough guy has been borne out.

For one thing, Zane, now an over-the-road trucker, has demonstrated time and again how true toughness compares to the pseudo kind. He's not, and never has been, afraid of expressing his more vulnerable feelings. He's an ex-football player who doesn't mind telling me when he feels on the verge of tears, when he needs time alone or about how he fears that time down the road when his parents will no longer be here. (I recall a moment when I realized I was falling in love: we were visiting his parents' home for the first time, and I saw Zane—not knowing I was watching—lean over and tenderly kiss his white-haired mother on the head.)

Then there's the physical stuff: when he was still an infantry sergeant, I visited him in Germany, where he never complained about getting up at 4 A.M. to take his guys out for a five-mile run or on a road march complete with backpacks. Nor was he jealous that I could still lay amid the covers, deep in sensuous sleep. He wasn't only unafraid of jumping from planes—he *loved* it. When we said goodbye in Amsterdam, just before his Bradley platoon went off to Saudi, it was me who felt my eyes filling with tears; he was just about to do what he had trained for, what he had committed to as his duty. Whether or not the war was the *right* thing, *he* had to do the right thing.

"People have too much physical fear—it's not that easy to get hurt," he said one day as he straddled a deep stairwell, standing on tiptoe to replace an air conditioning filter in my Savannah apartment. It's the same stamina that carries him through each week as he drives his semi cross-country and unloads it.

But the primary thing that this genuine tough guy is willing to do is to be honest about himself and make changes. When we met, Zane had a long-standing habit of dealing with "problems" phys-

ically. I'll never forget screaming as he wrestled with a man fifty pounds heavier in the gutter of a busy street because he thought the guy had insulted me (I hadn't even noticed). When he threw a TV set through the second floor window of my apartment during an argument, almost hitting a neighbor's BMW, we broke off for a while. He wrote a letter of apology to the letters-to-the-editor section of the national magazine for which I was then writing; but more importantly, he stopped drinking—the trigger for his rage—and went into therapy to look at how he had developed such a temper in the first place. Denial may not be a river in Egypt, but it's not part of a real tough guy, either.

These days, Zane says that being a man means admitting when you made a mistake, and shutting up and listening when the woman in your life is right. But sometimes the differences come up—like the time we argued about the Tailhook incident. And more recently when a trap Zane had set behind the refrigerator clamped down on a tiny mouse, I screamed in protest. Then I remembered that I was talking to a man who a few years before had been looking down into a pit full of dead Iraqis in need of burial. However sweet he may be at moments, Zane is still one of those mysterious creatures—a Man—who takes it upon himself to keep order in the world, no matter how unpleasant that task might be.

I never considered Brad Pitt a heartthrob until I heard that he lets hundreds of little green lizards run wild in his house, and that a couple of his famous girlfriends had left him, complaining that he didn't bathe often enough; but especially that he was generous to down-and-out relatives. Guys who don't have a soft spot, guys who won't change, guys who are less than kind—they don't qualify. Nor do the self-labeled: According to one biography, author Norman Mailer—quintessential self-designated tough guy—feared Southern men when he was stationed at Fort Bragg during World

War II; he considered them the essence of machoism. It's come out that Picasso (whose life Mailer, ironically, recently chronicled), no matter how great an artist, was terrible to women and others. Guys like Mike Tyson and O. J. may have been tough in the sports arena. But were they really willing to look at themselves? That takes real guts. True toughness is like true north. It may be found in a weight room or on the sports field. But it may not. And to me, it's the only kind I find worthwhile in a man.

1996

Bad Girls and Artists:
When Southern Women Break the Rules

The night after I signed the contract to write *Fatal Flowers,* my story of growing up Southern and female, I dreamed that I had been shot; I knew I had committed myself to writing the book in an honest way, whatever the cost. I knew that I intended to speak openly, indeed, even personally, about anger and sexuality, the two subjects I had been brought up never to broach.

"You broke the code!" a Semi-Famous Southern Poet said of what I revealed in the book. I knew what he meant: among other things, I had told what really happens between Southern men and women, such as the way the men often lied, indulged in a crude sexuality, and otherwise expected to be treated like King Baby. The Famous Southern Poet, the Semi-Famous Southern Poet's idol, had been my first writing mentor, and then my lover; I had described his callousness in detail in the memoir. Worse, toward the end of the book I had described the period of sexual freedom in my life (including affairs with women) through which I had finally freed myself. "You'd better get married again before this book comes out!" a male friend said after my third divorce, speaking of the assumption that no Southern man can stand such an outspoken woman.

Yet, even before *Fatal Flowers* was published in 1980, I knew there would be a price to be paid for my honesty. Indeed, one of my epiphanies came at age fourteen, when my best girlfriend's

father, a carpenter, angrily tossed a *Life* magazine in the trash, raging "Now they're showing big black niggers on the cover!" In that split second I realized that what applied to blacks could also apply to me, a white woman, if I failed to stay in my place.

But early on, I suspected that the freedom that almost all men experience—to move freely within their bodies and the world—is only experienced in the South by the woman who breaks the rules. While economic and sexual responsibility may be hard, I had willingly set myself on a path, a trajectory, almost like a religious calling, accepting in advance the sacrifices to come.

In the South tradition and character get mixed up: A "good" woman is one who follows the rules and doesn't make waves—that is, make anyone uncomfortable—rather than one who is strong in her own right. The rules are to caretake, to put family and others first, before any talents or drives of ones own, and never, ever, to speak directly of anger or sex. "If you can't say something nice, don't say anything at all" is invisibly embroidered on every Southern girl's pillow.

But in my own case, I had learned early that donning the purdah of propriety doesn't guarantee a woman's happiness. I had watched my mother, Melissa, a beautiful Southern belle, give up her dreams of becoming a writer to first caretake our alcoholic, if charismatic and Valentino-handsome, father; then a stiff mountain-man from North Carolina who insisted that she replace her love of shopping and visits to the Carnegie Library with home canning and biscuit baking. When she did manage to publish the occasional article—several for the *Atlanta Journal-Constitution* magazine—she often did so under a pseudonym, afraid that her mild-mannered words might offend. After her suicide, Anne and I were dismayed to see that she had destroyed her best and most personal pieces of writing.

And then there was Grandmother Carroll, the Perfect Southern Lady, rarely seen outside her home or Tucker First Baptist Church; the woman I saw pampering everyone but herself; like everyone, I adored and respected her. But how much fun was it, really, to shell peas all morning, cut the corn off the cob, and the most tedious job of all, hand-grate the coconut for one of her famous coconut cakes, then serve it all up to Granddaddy Carroll, who like most Southern men I had observed, shoveled it all down within minutes sans comments? And perhaps I was affected, too, by the time I heard her—the inevitable colander of beans on her knees as she strung them—telling Aunt Betty that no, the article in *Good Housekeeping* that cited women as enjoying sex more as they grew older was definitely not accurate.

All in all, being a good woman to a good man didn't sound like that much fun. Yet for a long time, I was a country divided: Grandmother, possibly intuiting my capacity for anarchy, approved my first marriage at sixteen, encouraged my second at twenty ("such good husband material," as opposed to the first, a wild boy who drove his Chevy junker down country roads at ninety miles an hour) and accepted my becoming a mother at eighteen as natural.

But just when the women of my family thought I was safely ensconced—three beautiful children, a nice professional husband, a split-level house in the suburbs, complete with a barbecue pit and built-in, pink appliances—things were rumbling from beneath. Only a few years before I had been a literary virgin who had never heard of Emily Dickinson or T.S. Eliot. But after an evangelizing experience in evening classes at Emory University, I was writing poetry and questioning my roots while reading Betty Friedan, Simone de Beauvoir and a column called "Disturbers of the Peace" in *Mademoiselle* magazine.

Still dressed in the de rigueur "pretty" clothes required of me

as a Southern woman, I was also a twenty-something hippie mom who marched in anti-war and civil rights demonstrations and who identified with the students demonstrating at Columbia and Kent State more than with the members of the local garden club. Dust balls were hanging out in my living room, along with my new activist-poet pals, and my young architect husband was wondering who he had married.

And that, as they say, was just the beginning. I may have *looked* like a suburban housewife, but inside I was a wild boy, just waiting to break out, a rebel who wanted to know more than is allowed. Driven by an almost unseemly curiosity, plus a desire to lead a life as different from Mother's as possible, I would soon find myself breaking just about every taboo with which I had been brought up. First, I would pen a collection of poems, *A Sexual Tour of the Deep South,* in which I would express the anger Mother had never been able to express for herself; though *Rolling Stone* and *Ms.* would laud my work, the book would make me persona non grata in more conservative circles (when I was asked to read at Mother's alma mater, then called the Georgia State College for Women, in Milledgeville, a member of the English department retracted her invitation after reading the book, calling the poems "too sensational"). I would live alone, support myself, and have exotic travel adventures, from dancing with a witch doctor in a jungle disco in Guatemala to living in a hotel-cum-brothel in Costa Rica to working as one of the first women aboard an offshore oil rig, barely escaping with my feminism intact. The latter experience would result in *Sleeping with Soldiers,* a book in which I turned the double standard, alive and well in the South, on its head.

Grandmother Carroll clipped every news story about me or my writing, but didn't read them, thus protecting herself from

what they said. When, after a second divorce, I declared my views against marriage, and espoused the new women's lib in a 1969 interview for the *Atlanta Journal-Constitution* (in the accompanying photo, I wore a miniskirt), Anne says that the article was only spoken of among the women of my family in whispers. Later my cousin Jo Anne would tell me that Aunt Florance had thrown my latest book across the room, unfinished, before returning it to the library.

For it's not just Southern men who try to keep Southern women in line: much of the psychological foot-binding is done by the women of the clan for the same reason many Chinese women allowed their little girls' feet to be bound, or some African women allow their daughters to be genitally mutilated: to protect them from the fates that befall the woman who doesn't follow the rules, such as ostracism and the threat to marriageability; indeed, the very tenuous threads holding their lives together.

Erica Jong and I discussed how we were shocked by some of the people who were shocked by our writing, only to find out they were secret rule-breakers—as I, the outrageous poet, had discovered while teaching in south Georgia in a church-dominated town that turned out to be a hotbed of affairs among teachers, secret abortions, and love letters flushed down toilets. "Do what you want, but don't tell it," I had grown up hearing; it was the telling, not the doing it, that was the taboo, and that was the one Erica and I had broken.

We had both been disillusioned to find that women who followed the rules seemed to think we were dummies who didn't know "which side our bread was buttered on." Why didn't we take an easier path, a question that puzzled some men as well. "Don't you know you're sitting on a gold mine?" asked one, implying that I could have made an easier living as a proper, if cheating, wife. As

164 Confessions of a {Female} Chauvinist

one stunningly commented to me, after I had published three books, "Why don't you get married again and join the Junior League—any man who had you behind him would be sure to get ahead."

Indeed, financial and professional insecurity are among the prices a woman who breaks the rules may pay. Often there is not a spouse for emotional or financial support. Nor are there always adoring colleagues. A woman who speaks her mind will be subject to subtle and repeated sanctions. A drunken, womanizing Southern male author will be more readily invited to a Southern school to speak than a woman who has written, however artistically, of what she really thinks. At prestigious Agnes Scott College, a well-known Southern novelist stood swaying at the podium, inviting young women in the audience "to meet him out back after the reading." Later that evening he was carried prone from Manuel's Tavern; a half hour earlier, when I had asked him a literary question, he had kneeled on the floor, embracing my knees in his stupor. Yet, he was undoubtedly more acceptable than I was. "This is Rosemary Daniell. She lives on grants and things," a good ole boy once said, introducing me as part of a group poetry reading, despite the fact that I had published more than the other (male) readers, for whom he had given lengthy introductions.

While writing *Fatal Flowers* I lived in a furnished railroad flat in Savannah, without a telephone or television, off money from the sale of a house and intermittent gigs as poet-in-residence for the Georgia Council for the Arts. After the book tour, four women came from South Carolina to interview me for their Junior League magazine. As they sat in my unrestored Victorian apartment they twitched as the fleas from my cat bit them on the legs. Later one of the women confided that she had been shocked that day at the

lack of security in my life. I, on the other hand, had felt sorry for *them,* stuffed as they were into control-top panty hose and traditional lives.

True, I had only five hundred dollars in the bank, and had to ask my editor for an advance against royalties. But I was going out dancing that night, and I had just written and published a book that had freed me from past demons, providing a force for healing in my life.

Yet there is rule-breaking, and there is rule-breaking: rather than mere anarchy, breaking the rules and paying the price may be a requirement of creative achievement for Southern women.

"The women in my family were so proper that I would have married a trailer if I could have!" commented Brett Butler, the Marietta-raised comedienne. Like many artistic women who become rule-breakers early-on, family pain had quickly disillusioned her about the benefits of conformity. At an age when many girls are worrying about prom dresses, Brett, already on her own, was admitting her proper mother to a psychiatric hospital.

"When I was eight I wanted to run away with the Art Mobile," jokes Sarah Rakes, a painter whose vibrant works have shown in Chicago and who sold a painting to Matt Groening, creator of *The Simpsons.* "My daddy was an alcoholic; my mother was an addict, causing me to leave home at age fifteen—but I had found art. The first time I saw paintings—an impressionist exhibition at the Art Institute of Chicago—I burst into tears."

Not that the path is easy. Sarah was traveling to Connecticut from Bentonville, Arkansas, "home of Wal-Mart," via Athens, Georgia—"Not the best route, I now realize"—where the only work she could find was in "a terrible bar." There she met her husband, Mike, and they moved to North Georgia where they now live with their three children, surrounded by the Chattahoochee National Park. "We were building the house ourselves—I couldn't

afford disposable diapers. I would change the baby, nurse him, then stack lumber. I had more or less given up on painting—thinking I would just garden, or do something to bring some groceries in. Then I did some pictures for our house, and three of them were accepted for a juried show."

Others succumb to the rules, then later decide that the price hadn't been worth it. Jalaine Halsall, a brilliant poet and only child, became a freshman at Agnes Scott College at age fifty, winning the prestigious Robert Frost Prize in Poetry. She had been politicized back in the sixties, during the Vietnam war and the civil rights movement, alienating family and old friends when she was dropped from the rolls of the Tucker First Baptist Church after questioning why there were no blacks in the congregation.

If there is one characteristic that separates the rule-breakers from the rest, it is an intolerance of lies, of hypocrisy. "The truth is the truth," says Jalaine simply, as though anything else would be unacceptable. But the truth-tellers often learn that such candidness isn't always appreciated. Friends dropped away when Jalaine began to work for George McGovern's presidential campaign. "I was banished from my family, became a pariah." But she remained married, if long-separated, and later took care of her aging parents, who lived next door. When her father shot her mother and then himself, leaving a tableau that Jalaine was sure to find, she kicked over the final traces, freeing herself at last by finalizing her divorce, publishing her first collection of poems and enjoying a period of emotional and sexual freedom.

Time after time Jalaine has lived through the psychic shocks, the emotional upheaval, her search for the truth has caused, leading her at times to feel unable to go out of the house or even make a phone call. Brett Butler's drive to perform took her to as many as three small clubs a night, drinking at each one and begging for

a chance to go on stage. And in my own life, some of the adventures to which my curiosity has driven me—pursuing hostile sources for articles; fending off hands on the offshore oil rig; or being strip-searched to interview would-be Contras in a Costa Rican prison—have been less than relaxing. Indeed, at such moments I might—*fleetingly*—think that spending an afternoon polishing the family silver wouldn't be so boring after all.

Along the way each of us has developed means, whether healthy or unhealthy, for dealing with the stress. Jalaine likes to go out on her property, rip the kudzu and muscadine vines from the trees they are strangling. Brett drank so much that she finally had to stop. For a long time I would go to bed, indulging in a feast of Black Jack, barbecued ribs, and chocolate chip cookies, an excess I have since replaced with a cup of tea, a nap, and an Anita Brookner novel.

Frequently, when Southern women kick over the traces it's as though they don't know where to stop. Indeed, humor often becomes a tool; "I may look like a white girl, but I don't dress like one!" says Sarah, who, despite her smarts, likes to characterize herself as a K-mart-shopping, Kentucky Fried Chicken-eating housewife who just happens to paint. "During the commercial breaks Oprah kept telling me to pull down my skirt, but I told her I had it up for a reason," Brett Butler says. Shock has become Brett's stock in trade; "While most girls were losing their virginity up at some prep school or other, I was losing mine in a pickup truck with my feet on the roof, looking up at the deer rifle and the gun rack!" she declares in a riff called "The Girl Ain't Right."

Yet, however rebellious a Southern woman has been, early imprints will win out. Brett was breaking all the rules by sixteen; but at thirty-nine she was writing voluminous thank you notes to her fans: "I used to even send them *money,* until somebody told

me I didn't have to do that!" Like any dutiful Southern girl, she was packing that very day to visit her grandmothers in Georgia. And ultimately, time is on our side: once a Southern woman is a bona fide eccentric, a "character," all is forgiven. By virtue of her talent and drive, Brett has become a celebrity; Sarah, Jalaine, and I have become known for our very differences.

On the other hand, women from other parts of the country think Southern women are being affected, when they're really just being themselves. When *Fatal Flowers* came out I wore pink for the book tour—a pink dress with a lace collar, a cherry crepe suit, a pink felt cowboy hat and cerise high-heeled pumps. "You really know how to play a crowd," a New York friend said when I spoke at the Atlanta Historical Society, declining to read the last line of a poem because it had a four-letter word in it, and there was a woman who looked much like Grandmother Carroll on the front row. Indeed, I could have been accused of what the writer and Georgia native Frances Mayes describes as "aggressive femininity." But this was not an act. For the first time in my life I felt balanced, in sync. I had expressed myself in print; now I was free to be nice.

The woman who has integrated both aspects of herself is likely to be the most puzzling of all. "How can you walk in shoes like that?" said a Detroit native, dressed in her usual grimy Nikes, of my perfectly comfortable, but strippy, sandals as we walked down the street in Savannah. "You're like a combination of *Harper's Bazaar* and *Screw* magazine," grumbled a feminist spokesperson who would later criticize me for my entrenched heterosexuality. "They think you're too macha," Blanche Boyd, a Charleston-born novelist who left the South for Connecticut, said to me of the editors at *Ms..* ("When I have some bloodless poems, I'll send them," I responded to a note in which the poetry editor had written that my poems had "too much blood in

them.") To the feminists, I was too macha or too femme; to the traditionalists, I was notorious: I had written about sex, hadn't I?—and not just pot-boiling, romance-genre sex.

True, one can't break with convention without paying a price. But the cost of succumbing, reluctantly or not, to the chador of propriety may be even higher. During the past twenty-five years, teaching creative writing in the women's prison in Hardwick, in high schools in Fort Valley and Macon, and to my Zona Rosa workshops, I've watched the way women shoot their creativity in the foot by clinging to traditional values while etherealizing marriage and motherhood. (Indeed, a happy early marriage, plus a mother too nice to rebel against, might be the worst things that can happen to a woman's drive and talent.)

Time after time I've have met women, starting with Mother, driven near mad (or bored out of their skulls) by the requirements of propriety: A woman from Alabama had a life-long stutter that had begun when her father had greeted her proud news that she had been made editor of her college paper with the disgusted comment that "Women just don't do things like that!" A pretty but overweight school teacher in North Georgia had almost died from a diabetic coma; but had waked more concerned that the aging parents with whom she lived had found the love letters from her one love affair: once back home, she burned them, placing the ashes in a Planter's Peanut jar on the mantel in her room.

An unhappy stockbroker's wife in South Carolina told me over martinis at her husband's club that she wanted to go back to being the artist she had been before becoming a matron and the mother of four. "Searching out white kid gloves—they have to be over the elbow!" she said bitterly of the chores befalling her along with her daughter's upcoming debut. "Oh, she had a kind of

breakdown—wouldn't wear the right kind of dress to a wedding, embarrassin' her poor husban' and everyone!" someone said vaguely when I asked after her several years later.

I, too, had stayed in the same place, remaining rooted in the Deep South, mired in the red clay and kudzu, half inspiration, half oppression, that I sometimes thought of as the source of my creativity. Somehow I had sensed early on that bucking my early imprints, in the very place where they had begun, would work better than running away. But along the way, I have met women who *have* taken the geographical cure—who have struggled to literally escape their Southern roots through relocation, sometimes throwing the baby out with the bathwater. I once had a drink in the Grammercy Hotel with a harried New York transplant who had just reviewed *Fatal Flowers* and hated most everything about it—and who also confessed with longing that she was really from South Georgia, and wondered how it would be to go back there again.

After a divorce trial in Beaufort, South Carolina, in which she was cited as having lesbian affairs and wearing a T-shirt with no bra, Montana lost custody of her daughters, and left the deep South, a twenty-thousand dollar settlement in hand to start life afresh in New York. Naturally, the money didn't last long; the last time I saw Montana, she wore a crewcut and high-topped tennis shoes, was painting office building stairwells for a living, and had become one of those women with a bitterness about growing up Southern and female.

Indeed, bitterness is a danger for the Southern woman who denies either her roots or her own integrity. On the *Angela* show in New Orleans, when I did writing exercises, or "exorcises," with women in the audience, rage emerged as the one emotion the women were seeking to resolve. But this rage is the very thing from which the woman who takes responsibility for herself has

been freed. "Take what you want and pay for it," goes a Spanish saying.

Yet paying the price is not the same as having regrets. By the time the payments came due I was already so entrenched in my path—a trajectory to which I had committed myself long before—and so out of touch with middle-class aspirations—that the prices didn't seem excessive at all. No lightning bolts had struck. I have had the good fortune to meet an earthy Southern man who hated hypocrisy as much as I did. And then there's that best kept secret—that breaking the rules is often more fun than keeping them; that, while there's stress, there's also a near-addictive high, a daily excitement.

At age eleven I would walk in the city dump behind my other grandmother's house, on Atlanta's Bolton Road, meandering among the Old Crow bottles, the truck tires, and sprung sofas, caught up in radiant fantasies of someday, some way, doing something special. Our little family may have been dysfunctional, but I already sensed that the universe was about to provide. When I found words, a way of detaching from experience through language, I knew I had found my path, as well-lit as an airport runway, the lights of truth guiding me safely back to myself, a deeper self than I would have become had I obeyed convention.

And then there are the new Southern women who bypass the whole thing. "Rules? What rules?" my daughter Laura asked, puzzled, when I told her about this article. But Laura, a professor, world traveler, and rule-breaker herself, had grown up watching me break every one of them!

1997

Georgia:
The State of Everything

W hen I was a young writer, I yearned for life in New York and Paris. As James Joyce had recommended, I aspired to "cunning, exile, and silence." Little did I know that Atlanta and Savannah, and all that lay between, would provide everything I needed for my art, and more.

I was born in Georgia Baptist Hospital in the middle of the Depression and downtown Atlanta. When my sister Anne was born five years later, a nursemaid walked me from our family's little apartment to Peachtree Street, where I bought Hershey bars that still only cost a penny and sold the poems I had written, decorated with drawings of Mickey Mouse and Donald Duck, for two cents.

And though I was raised in the then sleepy city of Atlanta, I was imprinted with the rural South as well. On Grandmother and Granddaddy Carroll's farm, I avoided the intimidating peacocks, plucked warm eggs from the hens' nests, watched new colts bound around the barnyard, and my boy cousins jump from the hayloft (one of whom I would later kiss, in my first real kiss, in that sweet smelling hidaway). I would watch Pearl, who worked in the house, spin an unlucky chicken by its neck—Pearl might even let me stick my fist into the still warm carcass, pull out the glistening blue entrails, which just might include a near-formed egg. Then I would help Grandmother pick the vegetables from the garden we

would eat only a couple of hours later at "dinner" as it was called then. And what Grandmother served each noon was indeed a feast— fried chicken or "souse meat" (head sausage), cream gravy, turnip greens cooked with fatback (which Mother fried for us at home to a crunchy-salty melt-in-the-mouth texture that went perfectly with grits), creamed corn, fried okra, biscuits or cornbread, and homemade caramel cake or banana pudding, all washed down with sweetened iced tea. In the evening, in what was the equivalent of an English tea, Granddaddy ate bowls of pot likker saved from the turnip greens, and crumbled leftover cornbread into a glass of buttermilk.

Years later, while I taught poetry in the schools, I lived and worked in Brunswick, Dalton, Dahlonega, Clarkesville, White Mountain, Helen, Dillard, Demorest, Valdosta, Newnan, Fort Valley, Gordon, and Macon. The very sound of these names raises rich sensory memories, from the pine-covered slopes of Clarkesville, at the edge of a dense national forest, to the flat country-music heartland of Macon, to the sweet coastal musk of St. Simon's Island. To reach Gordon, I drove past mounds of tender white dirt, dug from the kaolin mines. There, in Mae Bob's Cafe, a caramel cake just like Grandmother's stood under a glass dome. In nearby Tombsboro, I ate shrimp as fresh as any from the coast at a restaurant that raised them in pens out back.

The waving green corn fields, the cotton fields in full bloom, snowy white and endless, are a vista I have seen since early childhood. Before the freeways were built, we drove through these landscapes to reach almost any other place in the state. Reading Harry Crews' masterpiece, *Childhood: A Biography of a Place,* and his description of a South Georgia hog killing, I recalled, as though embedded in my very DNA, seeing such an event on my grandparents' farm at around age four, the same age Crews had

been. It was as though some dream from my Southern—read Scotch-Irish-English—collective unconscious had been waiting in my brain cells, like one of those paint books I had as a child onto which one painted water and the color appeared.

Part of my atavistic self loved horses, craved them, despite my Atlanta upbringing, and the fact that the first time I had ridden on my grandparents' farm, I had been carried along at breakneck speed clinging to the animal's neck as it galloped along a dirt road. My first book was a story about a boy and his horse, written on blue horse paper, tied together with shoe laces, illustrated with deformed looking horses (which I spelled "house"), and which had a plot remarkably like that of my favorite book, *My Friend Flicka*.

Or was that first furious horseback ride merely a fantasy, like my belief that, when I was five, a black snake had curled around Mother's ankle as she stood on the grassy strip beside the sidewalk before our house in Atlanta, talking to a neighbor? Now I know that such a thing did not happen. Yet I see each event clearly in my mind's eye, and I attribute such waking dreams to the Southern imagery that early on crammed into my brain.

As Flannery O'Connor wrote, "Everyone who has had a childhood has enough to write about for a lifetime." Carson McCullers and Margaret Mitchell also had their roots here. Mother aspired to follow Ms. Mitchell's footsteps; Daddy treasured a small blue book of poems written by his roommate at the University of Georgia. My great-grandfather, a Methodist minister, read from Milton at the dinner table; his wife, my great-grandmother, could recite whole hunks of Shakespeare. Indeed, I have come to realize that my creativity is inseparable from Georgia's red clay and its kudzu (with vines as thick as a man's arm, atop which wild pigs can walk). Sitting in rocking chairs on the front porches of

my grandparents' houses, the endless litany of stories told by the adults fed my search for the truths of the human condition.

Atlanta, now the New York of the South, fills any longing I have for glitter, for great restaurants, art galleries, and theater. Contrary to what writer Carolyn Myss claims, in Atlanta, God *does* take a room at the Ritz. And then there is my other home: Savannah, which Pat Conroy once called the Paris of this country, where I now live, fulfilling my taste for cobbled streets, Victorian architecture, Spanish moss, and the nearby sea with its docked sailboats and feasts of fresh shrimp, oysters, and blue crab.

And there is the more exotic: I once spent a month on Ossabaw, on one of Golden Isles, forty-five minutes by motorboat from Savannah. "This is just like Vietnam," commented one of my fellow writers, a veteran of the place. Or one could have been in Africa, for the island is a jungle, overgrown with tangled vines and palmettos, except for the clearing around the big house, and the tabby houses near the beach. The island is amok with wild things—horses, cattle, donkeys, boars, and alligators, a reminder that camels once roamed Georgia, brought here to work on the plantations.

My friend Jalaine, a poet and, at midlife, a woman with the means to leave, has remained on the same fourteen acres in the Atlanta suburb where she, Anne, and I rode a bus to Tucker High School. With its hundred-foot pines and occasional deer or black snake, the land contains all she needs for life and art she says.

A man who visits the United States from South Africa each year to tour in a motor home, went, during his first visit, to Plains, Georgia; he loved the town and its people so much that he goes back each year, content not to fulfill his original plan of touring the entire country.

I too have traveled—to Amsterdam, Berlin, Hamburg, London,

Los Angeles, New York, Paris, Prague, Guatemala City, San Jose, and Mexico, as well as many points in between. But I always come back to Georgia, my State of Everything.

1998

The Pill and Me:
Before and After

What many remember most about the sixties is where they were when JFK was shot. But I, and many other women, remember something else.

I am sitting on a straight chair in Dr. Benson's office at Peachtree and Ivy Streets, across from the Imperial Hotel, in a building that perches over the recently built freeway. The doctor facing me in his starched white coat is not the kindly one who delivered my second child just three years earlier, in 1959. Yet he is to mark an equally important moment in my life: he has just written my first prescription for the Pill.

"This changes everything!" I blurt, startling him. Yet how could he know that beneath my Decatur housewife guise, the dress I sewed from a *Vogue* pattern, beats the heart of an anarchist—indeed, I don't know it yet myself. I only know that I recognize the colors, lights and fireworks exploding in my head—that I have seen them before, floating, unbidden, when I showered in the morning, removing the sometimes-bloodied diaphragm I had dutifully inserted the night before; my one respite from the children crying for breakfasts, my young husband's rush to his architectural office in downtown Atlanta. They pop like small bubbles in my brain, fleeting snapshots of a life outside the suburbs, the diapers, the dirty dishes—that I would one day do *something* else, something outside the confines of my small family, that house.

All I know this morning, sitting in the doctor's office, is that possibilities now exist that never have before. That because of one small pill, my world, and the world of the women around me, is about to change.

I had two main boyfriends in high school and I married them both, T. J. at sixteen and Paul at twenty. I was the mother of three children soon after my twenty-third birthday.

In 1949, when I was thirteen, we had moved to Tucker, Georgia from Springlake Park in Atlanta to be near my maternal grandparents because of Daddy's drinking and gambling. There, at my Grandmother Carroll's kitchen table, just a mile down Lawrenceville Highway from our own little house, I heard constant talk of what happened to girls who went astray. "It followed her daughter and her daughter's daughter after her," Grandmother Carroll would say, referring to a woman who had become pregnant out of wedlock. That a woman could be "ruined" through her own actions, while the man got off scot-free, was a given, and Anne and I were constantly admonished "not to let a man kiss you until you are engaged, because it might lead to other things." This was especially important because, as she told us, "You *are* who you marry."

And I observed the attitudes at the Tucker First Baptist Church: The woman welcomed when she answered the call one evening to "rededicate her life to Christ," only to be ostracized by the congregation because of her illegitimate child as soon as the service was over. The pretty blonde teenager who had just moved to town, who wore baby-blue leather penny loafers and whose parents put "their" baby in the church nursery on their first Sunday there. And later, the tenth-grade classmate, a girl given to blushing as redly as her hair, who "went away for a while;" tears streaming down her mother's equally florid face the whole time she sang in the choir. And later still, the Rich Girl whose prominent parents, owners of most everything in town, flew north to snatch her from the dens of

iniquity she had apparently entered as a Yale Drama School student, who suddenly reappeared in the next pew, humbled in her fur jacket. And then there was the bad end come to by the very preacher who had exhorted us so vehemently about the sins of alcohol and sex—who had been fired after being caught kissing the spinsterish church organist around the same time that his sixteen-year-old daughter came up pregnant with twins.

Mother and Daddy, two beautiful people who I uncomfortably suspected of their own secret passions, owned one dark book on sex, a tome I surreptitiously took down from its hall shelf to read in my room; illustrated with line drawings, it spoke of the delicacy of women, the brutality of the wedding night, and the importance of keeping young girls from reading romantic tales, in order that they not become inflamed. (Was that why Mother had forbidden me the *True Confessions* and *True Romance* magazines I stashed under my mattress, and not because they were tacky, "lower class," as she claimed?) That these admonitions segued directly into gory descriptions of "female trouble," "fallen wombs," and untreatable breast cancer, led me to connect sex early on with dire consequences.

At Tucker High School, I was among the "popular" girls, a "fat" (though photos belie this) red-haired (I had hacked my long brown hair off with pinking shears, pouring a bottle of peroxide over the remains) cheerleader with—as Anne, following in my footsteps, later complained—the reputation of having more dates than any girl in the school's history. Before the principal banned our "sorority," we of the Secret Seven met to wear only slips, smoke cigarettes, and giggle over talk as thick with innuendo as the smoke spiraling around our heads. But *never* did we discuss actual sexual feelings or, God forbid, *acts*. To do so would be risking our reputations, our value in the marriage market: *everything*.

Even when classmates suddenly wed—at fourteen, fifteen, or

like me, at sixteen, and we soon saw them swollen with preg-
nancy (and some cute boy taken off the market), we verbally
attributed the urgent weddings to "love." When I ran into an
"older" girl while Christmas shopping at Kresge's who had mar-
ried at fifteen, she told me that, at eighteen, she was the mother of
three. It was like seeing someone in a car wreck. I could only be
grateful it was her, not me.

But I also felt envy: For her, married since fifteen, it was *over
with*, all decisions made, her life laid out before her. In the face of
the imperative to remain pristine, pure—despite my own forbid-
den desires, and my desire to be popular with boys—I felt like the
knob on Mother's pressure cooker, rattling from the frightening
steam building beneath its lid. Sunday night dates to church
inevitably ended up in wrestling matches ("If you love me, prove
it") in the front seat of some junker at the base of Stone Mountain,
then deserted but for other parkers and a shack selling RC Colas
and MoonPies; that night I would dream of burning in hell fire, the
preacher's shouts, the flames, combining in my mind with the
strange desires I had felt as the boy and I kissed.

Then there were the dates "downtown" to The Fox Theatre,
with the richer boys whose daddies had big cars, which meant a
trip to The Varsity afterwards, where I scarfed down chicken
salad sandwiches, chili burgers, Varsity Oranges—anything to
subdue my anxiety, while further fueling my voluptuousness.

Boys, with their strange whiskers, their different physiques,
were already alien, as foreign as creatures from Mars. And I knew
that cute, or even nerdy person, so apparently "normal" during
daylight and even the movie we had just seen, was likely to change
on the way home, becoming a werewolf made up of mouth, hands
and that insistent lump I didn't even want to acknowledge yet.

("What came before the Pill?" my husband, Zane, fifteen years

younger than me, quipped when I asked about his high school years in Charleston; "Fellatio. Or a hand job and a Coke cup! And then the girls started getting those cute little white disks [containing the Pill]!" When I described the pressure boys exerted, the pressure girls felt to resist, he looked puzzled; all he recalled was beach music, "Sunday shakes" [beer sold illicitly on Sundays], and fun-loving girlfriends seemingly unconcerned with consequences. But another man said that in rural North Georgia, young women used fellatio to keep themselves virginal until marriage.)

When I lost my virginity at age fifteen, he was sixteen, blond and "cute." Afterwards, though the sex had been more painful than I had imagined, and no pleasure or amorous words had crept in, I imagined myself in love. Despite the fact we had used the condom that he, like all the boys I knew, carried in his wallet, that I had even helped him roll it onto his penis—that frighteningly hard and erect penis!—I dreamed of the pregnancy that I hoped was growing inside me, the pregnancy that would solve everything. I saw myself walking into the Tucker First Baptist Church, my old green wool coat covering my full belly, a married woman saved from the guilt, the wrestling matches—a good married woman at last.

Instead, everything Mother and Grandmother had said came true—he never called again, and, worse, he *told.* Soon I was a hot number, my phone ringing off the hook. Now my guilt was that of having "given in." My next boyfriend, an "older man" of twenty-three, broke off with me, despite our sex, when he found out I wore falsies under my cheerleading sweater. When T.J., a wild boy already out of high school, insisted on marriage (and sexual things that I didn't know about), I was relieved: After all, I was "ruined." Whether I even liked him was beside the point. When

he made me choose between him and Paul, my one "nice" boyfriend, naturally I chose him. As soon as eleventh grade was out, my unemployed bridegroom and I were on our honeymoon trip to Jacksonville Beach, the embarrassing pink douche bag Mother had insisted I take for birth control wrapped inside my trousseau lingerie.

"Why so serious?" the nun said as I lay in St. Joseph's Hospital at age twenty-three, after the birth of my third child. She had come into the room to see me desperately clutching a copy of *Love or Perish*, by Smiley Blanton, the book through which I was seeking to retain my sanity. "See you next year," she said cheerily, leaving the room, and me, to my fantasies of dropping the baby from the high bed, or jumping from the window to land in the arms of Jesus, where I would float away on a white cloud. I didn't know about postpartum depression, only that something was terribly wrong. Again, we women didn't discuss how difficult it was to care for small children—the constant fracturing of time, none of which was left for oneself, along with the demands of mostly-absent husbands.

For the next year, I would battle anxiety attacks that made me fear that I had a brain tumor. My second husband Paul didn't know what to make of my tears. "All the young mothers feel that way," said my new doctor, cheerfully prescribing tranquilizers and a visit to the beauty parlor. But within a year, I would begin to save myself: I would read more books. I would begin to write. And within three years, I would have the Pill.

Some women were angered when, in May 1990, Barbara Bush told the graduating class at Wellesly College that "At the end of your life, you will never regret not having passed one more test, not winning one more verdict or not closing one more deal. You will

regret time not spent with a husband, a friend, a child, or a parent." We were angered because Barbara Bush had done none of the former. And because we had already learned what men have long known: to seek joy through work, risk, adventure. It is painful to consider the lives of women past, their creative and other potentials stamped out in the rituals and demands of daily life. Mother, who Anne and I discovered had burned her best and most personal pieces of writing, had been one of those: a beautiful woman who was also a talented writer whose gift was lost to duty and guilt, and ultimately, to madness. And this is why, today, despite that I have not been blessed with what many tout as a woman's crowning glory, grandchildren, I support and applaud my two adult daughters in their chosen work; one as a painter, the other in psychiatry. For I have also seen the satisfaction experienced by women friends who neither married nor had children at all. Indeed, I have wondered if women have been sold a bill of goods—if, before the Pill, they were victims of the Stockholm Syndrome, in which the captive learns to love her captor, her captivity.

But thirty years ago, we were still a rebellion waiting to happen, and the Pill was to be a major weapon in our insurrection. ("*That's* what we try to protect women from!" my boss said crossly at the real estate firm where I wrote copy, when I published an article in the *Atlanta Magazine* on the burgeoning women's movement in June, 1970. When I confronted him with my discovery that he was paying a male co-worker more than me, he said that at [a local radio station], they had "a girl who wrote *all* the copy" and was being paid far less.) My aunts were more shocked by the coverage in the *Atlanta Journal Constitution:* in it, I declared myself to be against marriage and was pictured in my office wearing a *very* miniskirt. "It was only spoken of in whispers," Anne told me, in order to keep Grandmother Carroll from knowing.

The times were heady for other reasons as well—the civil rights movement mostly behind us, we were now caught up in the Vietnam conflict, the student protests, the humanist psychology movement. But perhaps the best thing that was happening was that we women were beginning to talk to each other, to tell our stories—to tell the truth about the restrictions with which we had lived, the truth about our lives in the white-gloved South. Women were sitting around kitchen tables and at consciousness-raising groups deep into the night, passing around bottles of cheap wine, or even a joint, excitedly discussing our right to rage, the revolution in our lives.

Indeed, it can be argued that without the Pill, neither the women's movement nor the sexual revolution could have existed. In 1963, Mary McCarthy published a ground-breaking novel, *The Group,* in which a clique of privileged young Vassar graduates discussed sex in a way shocking for the times; in a graphic scene early in the book, one character, unmarried, goes to a doctor to obtain a diaphragm, only to leave it—and her sexual freedom—under a park bench when she is stood up by her lover. Her fictional life couldn't have been more different than mine, but I identified with her desire for sexual autonomy—as obviously did many other women. And I was even more excited during the sixties and early seventies by the publications of Simone de Beauvoir's *The Second Sex,* Betty Friedan's *The Feminine Mystique,* Kate Millet's *Sexual Politics,* Germaine Greer's *The Female Eunuch,* and Dorothy Dinnerstein's *The Mermaid and the Minotaur,* a landmark book in which Ms. Dinnerstein advised women to learn to separate sex and love, just as men had long done. A spate of other tomes offered advice on everything from running away from home, and one's children (Judy Sullivan's *Mamma Doesn't Live Here Anymore),* having orgasms sans men

(many of us hadn't known how to have them in the first place), to open marriage (George and Nena O'Neill's *Open Marriage).*

Though books by lost women had long told the truth, few had listened, or had been able to listen: "The life which is so strong in her imagination has already gone into her child," wrote Evelyn Scott of the early and continuous childbearing of the women of Brazil in her radical novel, *Escapade,* first published in 1923; "And every woman I have spoken to has made the same remark: 'The senhora has only one child! How fortunate she is!'" (In San Cristobal, Mexico, getting married—along with all that implies— is known among women as "committing suicide.") According to Jo Ann McNamara's *Sisters in Arms,* the Catholic Church, the convent, had been women's one retreat, one choice, other than marriage, childbearing, or the dependencies of spinsterhood (at times women were even put to death for refusing to marry and bear children). Now there were women who were ready to hear. And most importantly, there was at last a means—via one small white pill—to escape the fate of women of generations, even centuries, before us.

How did Grandmother Carroll, my aunts, the Baptist Preacher, and others respond to the Pill, the new Women's Movement, in Tucker in the sixties?

Grandmother didn't even approve of Catholics, so it's certain she wouldn't have approved of anything so new-fangled—at least until it became mainstream. (She had objected to my and Anne's wearing blue jeans, but later had begun wearing pastel pants suits herself.) As a direct conduit from the Tucker First Baptist Church, she would have undoubtedly agreed with her preacher's views. And maybe even the views of the doctors who were prescribing it: they were men, weren't they; and Grandmother was the ultimate chauvinist. Never would it have entered her mind

that a woman might use the Pill toward her own devices; that she might voluntarily sleep with a man just because she wanted to— even a man that wasn't "good husban' material."

As for my aunts, they were more concerned with the dustballs in my house and how I wore my hair than my method of birth control or my feminism. "Gloria Steinem's too old to wear her hair that way," one said to me pointedly, referring to my shoulder-length locks at age thirty; "and besides, she only thinks that way because she never met the right man." (I assumed that in that case, Gloria would have been sporting a permed bouffant like hers.)

But there must have been something in the water at Tucker High School that made some of us willing to take risks, to embrace the new. "From my first pill from the square brown glass bottle, I felt happy and free," my sister, Anne, says of the time when she had two toddlers, and was working full time as a nurse at St. Joseph's Hospital. (Would Mother have forbidden her to go to Emory in pre-med, a distinct possibility given her high SAT scores, had the Pill been available, and her marriageability been less an imperative?) Jalaine Halsall, who rode the school bus with Anne, later also the mother of two, published "Marching Back to Forsyth," an account of racial upheaval in that county, in the *Atlanta Magazine* in May, 1987. "I was always causing contro-versy, even if I just opened my mouth," she says.

My own pre-Pill fantasies—those little bubbles that had gone off in my head in Dr. Benson's office back in 1962—had held dreams of adventure, even sexual adventure. Not long after, as I sat in a therapist's office, distraught over the affair that was rend-ing my marriage to Paul, the doctor asked me to draw pictures of a man and a woman. When I drew a man with a suitcase, leaving for New York to visit lovers and friends, and a pensive-looking

young woman in full skirt, siting beside a goldfish pond, "pregnant with thought," he said that both of them were me.

Though I didn't know it then, I would end up living out many of those fantasies. At age forty, the publication of my first book, a collection of poems provocatively titled *A Sexual Tour of the Deep South,* established me as a woman who embraced sex but hated sexism. For a time, my third husband, Ben, a Yankee, and I indulged in the excruciating experiment known as Open Marriage (in which jealousy was considered politically incorrect). Later, I enjoyed a pre-AIDS period of sexual freedom unknown to women of generations before mine. (When I stopped taking the Pill at age forty-five, thinking myself safe, I promptly became pregnant.) As a free woman, I traveled alone in Third World countries, meeting new lovers along the way; I worked as one of the first women aboard an offshore oil rig a hundred miles off the coast of Savannah. ("You must have a strong masculine side," my friend Claudia said after reading my resulting book, *Sleeping with Soldiers,* in which I sought to turn the double standard on its head.)

Today, I look back and recognize how the Pill saved my life, perhaps even made it possible for me to become the woman I have become. I am now married for the fourth time, to a man whom I am free to enjoy for reasons other than the financial support of the family. I experienced economic freedom, and the ability to take responsibility for my choices, my actions, in a way that the "kept" women of the past were denied. True, there had been moments during the hardest times—standing in an unemployment line, dealing alone with difficult kids—that I had yearned for the order, the safety of the fifties. But only for a moment. As French actress Catherine Deneuve said, "I am too young for

regrets." And what I now think of as My Anarchist's Heart, could not have existed without the Pill, and parallel movements in society. Indeed, I was able to become what I most wanted to be: a free woman.

2000

I Wrote About Sex and Got Called a Whore

The night in 1976 when I signed the contract to write *Fatal Flowers: On Sin, Sex and Suicide in the Deep South,* my memoir of growing up female and Southern, I dreamed I would be shot. I knew I was committing myself to write the book in an honest way, to break the taboos against speaking openly about anger and sexuality.

I had already broken those taboos in my first, controversial collection of poetry, *A Sexual Tour of the Deep South,* published the year before in 1975; and I already knew a bit about the possible repercussions—among them, the censure of my male colleagues (and, as often, the women who colluded with them in their sexism), the absence of invitations to read or teach, and even danger, if the wrong person became angry or obsessed enough.

But shaken by my mother's suicide only months before—aching with the knowledge of her lifelong repression and the weight of her unrealized talent—I now had a burning imperative. One morning not long after her death, I lay in bed in my little apartment, feeling the pain of her life running through my body, raking it like a serrated knife; it was then that I realized what the poems, the anger that had sometimes frightened even me, had meant—that I had been the surrogate for the rage, the pain, that Mother had never been able to express.

And what was the use of telling her story, my story, the stories of other Southern women in my life, if I told less than the truth? To deal with my girlhood with a crazy mother, a drunken father—when I had known from age five that my beautiful, ravaged parents would never be able to save me—I had been theraputized to the enth degree; I believed—and still believe—that, as many before me have said, the truth will set us free. Indeed, I had taken Keats' words as my credo: "Truth is beauty, beauty is truth; that is all ye can know on earth, and all ye need to know."

Once my commitment was made, I was able to go forward without looking back, to sit at my manual upright typewriter day after day, often writing about things I had found hard to even tell a therapist. As I revised and revised again, the painful events made their way out of my psyche, and onto the yellow second sheets. For one way I was protecting myself from the material, its heat, was to write as well as I could—to use my arts to make beautiful, as critic Lionel Trilling said, that which in life would be painful to see, or even to hear about.

My pleasure in having *A Sexual Tour of the Deep South* published had been obliterated by Mother's death soon after. Had the copy of the book she had asked me to bring her in a brown paper bag, so her judgmental second husband, a North Carolina mountain man wouldn't see it, added to the melancholy that had ended in the moment of her finally gulping the pills? (Once, I had said to him that if my husband and I moved to that town, I would start a women's liberation group. "Do that, and we'll run you out of town with a shotgun!" he had said seriously.)

And there had been moments, none of which had had much impact on me: my feminist editor coming into a party for the book in New York to warn me about a vehement review in *The New York*

Times Book Review—"At the top of this list of trash," wrote the reviewer, soon to be the reigning queen of poetry criticism, adding that ". . . none of the women I know have fantasies like these." "Don't worry about it," my editor said consolingly. Since I barely knew what *The New York Times Book Review* was at the time, I didn't. Besides, my poems had received a rave review in *Ms.*, which was by far more important to me, coming as it did from the sisterhood. Then there were the women who more than confirmed the importance of my risk-taking, crowding up to me after a reading to press my hand and murmur, "You wrote exactly what I've always felt and never been able to say."

But there were many who wanted to put me in my place. The men on a reading committee with me, all published poets, had ignored me when I told them that my collection would soon be published; indeed, they didn't even acknowledge what I had said, one continuing to talk about having been scandalized at seeing Anne Sexton read: ". . . she wore this low-cut dress and leaned over the podium."

I would soon be wearing my own low-cut dress to read my poems, and these colleagues would be looking at the floor as I did so. "You just can't write like that!" a famous male poet sputtered at the University of Louisiana, where I was the one woman among six poets at a poetry event advertised by a poster in which one female leg clad in a black fishnet stocking performed a high kick, and where the female students clamored around me, asking for a caucus to discuss how they were put down in their writing by their male creative writing professors. There were threats or hang-up calls. And some puzzled interviewers, including a radio guy who asked of the first poem in the book, "Being There," what is this about? And my having to tell him that it was about a woman

castrating her fuckee. But possibly the funniest rejection was by a male pyschiatrist who had asked me for a date, but who called to cancel when he read my book, saying he was afraid of me.

But there were also men like novelist David Madden, who, when a man stood up after my reading at Loyola in New Orleans to ask what I was doing afterwards, came to my defense, saying "that was exactly why she wrote the poems—so you wouldn't ask a question like that!"

One of the down sides of having published is imagining in advance, even while I'm typing, the various reviews and responses, and also realizing that I must—I will—go on with my vision. Before I went on the book tour for *Fatal Flowers,* I prepared myself. I bought an all-pink wardrobe—the notion of appearing opposite of what my detractors would expect pleased me—and in a composition book, wrote every possible question an interviewer, however adversarial, might ask. Then I memorized my answers. When Carolyn See, in a review in the *Los Angeles Times,* wrote that Holt, Rinehart and Winston should have been ashamed of publishing it, that it should have been left under my lingerie in my underwear drawer, I was unperturbed—after all, California was a long way away. I was still naive—so naive that when my editor told me that one interviewer, when given the option of interviewing either me or Barysnikov, had chosen me, the import was lost on me. And the whole book tour—the posh hotels, the room service; the limos with me inside, wearing dark glasses, my thrift shop fur; as well as the amusement of TV anchors at my answers to interview questions—was a lark, totally unlike life in my one-hundred-and-fifty-dollars-a-month Victorian flat in Savannah. "Yes, and she left a whole lot out," my sister Anne took to saying in Atlanta when people asked her if everything in the book was true.

In Savannah, where I lived, perhaps the gossip center of the universe, I would hear whispers when I entered a party, or the liquor store down the street from my apartment. When a Savannah blueblood took me aside at an art opening to dress me down, I only listened quietly, her words making little impact; I had made my decisions long before. "I haven't read your book," a man said to me at a bar on River Street; "But I know if I wrote one, it would be better than yours." "Why?" I asked. "Because I was so good in English at the University of Georgia." "Well, I didn't go to college, but I was good in English, too," I retorted. And then there was the gay man who objected to none of the sex in the book—usually, the source of a reader's distress—but who crossly asked, "Did you have to tell every stitch in every dress your grandmother made?!"

"My mother gave me enemas, too," a camera man shouted after me down a long hallway after I had been on TV. The one thing I didn't like was people bringing up the most personal parts of the book to me at cocktail parties or in public places, even if to confirm that they had had the same experience.

Later, when my second memoir, *Sleeping with Soldiers: In Search of the Macho Man*—a book which had started with my short stint as one of the first women aboard an offshore oil rig, and in which I sought to turn the double standard on its head—was published, the controversy surrounding my books had become fun, a part of my identity, a source for stories. Computers had just come out, and with a tight deadline, I sent the final manuscript to a service where a group of women typed text onto disks; within days, a messenger came to my door, the bulky manuscript, untyped, in his hand: "The women got upset, and had to stop typing it," he said.

And some incidents were dark, even scary: the man who hid in the foyer downstairs at my apartment, only leaving when I asked the mailman from my second story window to flush him out. The

man in prison in New Jersey, who called to say that he didn't approve of my writing—he had gotten the book off the library cart; also that he would be getting out soon and was coming to Savannah. "A double homicide—but it's not as bad as it sounds!" he said when I politely ask why he was there. Then there was the body of someone called Black Jack, found in Mississippi with my telephone number in his billfold. And the 3:00 A.M. call from the brother of a movie star, wanting me to listen to his poems; then calling back to say, after I hung up on him, that he was coming over to chop me up into little pieces (that was the incident that finally made the light come on in my head: I didn't have to have my answering machine beside my bed!) Just in the way I had refused to back down in my message, my art, I refused to have an unlisted number.

In any case, I was used to it, for it had become a part of my identity: I was the outrageous woman, the risk-taker, the shaker and mover I had always wanted to be as a girl.

As an artist, obsessed with my own work and life, I was laissez-faire, non-judgmental toward others. (In fact, I felt that when judgement entered, impairing my ability to observe objectively, creativity flew from me.) There was a woman who, when I first met her, was a public relations person for the controversial editor of a famous porn magazine. When she took a friend, an Atlanta TV personality, and myself to a reception for him at an Atlanta hotel, she tugged me up to the man, saying, "you should publish some of her poems in the magazine." That she didn't know the difference in pornography and literature should have been a clue to our differences. The Floridly-Famous Prostitute, as I was to soon think of this woman, was soon to take up the life, somewhat like Margo St.

James in California, in a much-publicized and political way. With a coauthor, the Floridly-Famous Prostitute wrote a book about her experiences in brothels around the world. And when she continued to pursue a friendship, I didn't encourage or discourage her. For a time, she was in Zona Rosa, a writing group I led for women, where it became clear that she thought that because we had both written about sex, that what we had written was the same, and had the same intent. I was disconcerted when, over drinks, she said that I just wasn't into prostitution because I'd never experienced it—that I'd "given it away. . . . never gotten money for it." When I further protested, citing AIDS and the prevalence of addiction among young women prostitutes, she cited other, what seemed to me to be, contrived statistics. I looked away in distaste, changing the subject as she began describing in detail what she did with S&M customers. Then she asked if, when I was out shopping, I would search for bustiers for her—saying she could always get a hundred dollars more from the man, if she wore one." Since she was large, it was hard to imagine both that she would think that I could find such an item—and that I would choose to spend my time that way! But what was most disconcerting was her claim, despite that she weighed fifty or more pounds than me, that we looked alike: when I arrived at a major bookstore in Buckhead in Atlanta to sign *The Woman Who Spilled Words All Over Herself: Writing and Living the Zona Rosa Way,* the Floridly-Famous Prostitute was already there, at the little table that had been set up for me. "I started to begin signing and tell everyone I was you," she said, a mischievous gleam in her eye. She went on to say that she'd declined a talk show appearance, and some considerable bucks, to be there that night. A number of the Zona Rosans were there, too, and when I reported that the Floridly-Famous Prostitute had asked

to be readmitted to the writing group, they took me aside in protest, and I went back to her and demurred. I was becoming judgmental. And, for the first time, I was getting spooked.

At the January, 1998, Zona Rosa meeting in Savannah, Claudia, a group member, came up to me as everyone was leaving, and reluctantly pressed a thick paperback into my hands. "Here," she said; "I didn't want to show you this, but Clint"—her husband—"said you should see it. And so did Anne," she added of my sister, who was visiting from Atlanta. *Hell's Belles: A Tribute to the Spitfires, Bad Seeds & Steel Magnolias of the New and Old South,* (by) Seale Ballenger, I read beneath the hyper-colored publicity shot of Vivien Leigh as Scarlett in *Gone With the Wind.* As I flipped through the pages, I saw that it was a composite of short takes on various Southern women, in various categories, or what some in the trade call "a non-book." The categories included "Belles Lettres: Literary and Fictional Belles"—I saw that my colleagues, Dorothy Allison and Alice Walker were described in that section; "Politicos in Petticoats," "Sweet Southern Songbirds," and so on. A statement in the back read, "Conari Press, established in 1987, publishes books on topics ranging from spirituality and women's history to sexuality and personal growth. Our main goal is to publish quality books that will make a difference in people's lives—both how we feel about ourselves and how we relate to one another." According to the bio, the author Seale Ballenger, was "a native Alabamian (the cradle of the Confederacy) and 100 percent Southerner. . . ."

"Look at the index," Claudia said, looking uncomfortable. When I did, I read my own name, and flipped over to page 226, where I saw myself listed beneath the heading, "Marvelous Southern Madams and Other Shady Ladies": *Rosemary Daniell,*

Atlanta's retired hooker who wrote a book entitled A Sexual Tour
of the Deep South. *Last we heard she was running a chatline for
the "hornly"—horny and lonely.*

What I felt next—after years of controversy, reviews both good
and bad, and extreme responses to my work—was as though I
had been slapped. My face stung; then a sinking feeling moved
from my heart to my stomach. Someone had actually lied about
me in print, calling me what those critics—my disapproving col-
leagues—had undoubtedly long wanted to call me: a whore. For
the facts of my truth-telling, of my writing well—what I had
thought of as my "insurance policies" in taking the risks I had
taken in content—hadn't protected me from this outcome. The
words, blazing off the page, felt personal and vindictive. (Only
one other time, had I experienced such rage: a journalist I had
sexually rejected began his column by describing the damage
done to my Savannah apartment by a violent boyfriend, adding
"and some would say she deserved it." Ironically, the columnist,
puzzled at my anger, continued to pursue a relationship with
me). Also, I experienced a sickening wave of something else, as
though I actually were, by virtue of having broken the taboos
with which I had been brought up, in having led an unconven-
tional life and writing about it, guilty as charged. For a few days,
it was only the reactions of those around me—my husband,
Zane, who said he wished duels were still legal; my sister; my
brother-in-law; and the women in Zona Rosa—that kept me
aware that I did indeed have a reason for anger.

"This sounds like the work of the Floridly-Famous Prostitute!"
exclaimed a recovering prostitute who had once worked with her,
in my Atlanta Zona Rosa group when I explained what had hap-
pened. I called and emailed writer friends in Alabama, asking if

they knew a Seale Ballenger, but none did. Others suggested possible attorneys; I had never before needed a lawyer except for a divorce or a will. In the end, I called Chuck Driebe, an old boyfriend and a darkly mordant man who snorted with indignation when I told him of my dilemma: "You may have done a lot of things in your life—but you've never done that!" And I felt a little easier, knowing this was now in his hands. And I could be confident of one thing—Chuck knew how to be mean: I knew that from his behavior while we had been involved.

The correspondence that ensued between Chuck and the Conari Press in Berkeley, California, began with a letter in which William Glennon, the publisher, avowed that he couldn't imagine how such a thing could have happened, and if Chuck would give him my phone number, he would have the copy editor call to apologize to me. Another letter said the information must have gotten into a stack of unchecked material, "an email." A further message explained that Seale Ballenger was not the true author at all, and that the book was a composite created in house. As the months passed, Conari was continuing to sell the book in every possible venue, from Amazon.com to bookstores nationwide. But by April, after much tedium, we had come to an agreement out of court: Conari would pay a modest sum of money, send a statement to a list of booksellers and reviewers which I would supply to him, and most importantly, insert an erratum of my choosing in all extant copies, and reprint only with the correct information.

It was all over, I thought, breathing a sigh of relief. After I paid Chuck, I was $5000 richer. And when, a few months later, I saw the book featured in a flyer for Quality Paperback Book Club, I ordered a copy, thinking to see how it looked with the corrections.

The day the book arrived was a day on which my blood pressure went up, and up. Innocently tearing the package open, I

flipped to the index, just as I had that January evening, and still innocently, flipped to the page designated. What I saw was the same line—*Rosemary Daniell . . . retired hooker . . . chatline for the "hornly"*—*horny and lonely*—swimming before my eyes. I threw the book across the room, then plucked it up again from the floor as gingerly as a turd, grabbed my pocketbook and drove, in a bloody rage, to the supermarket, where I photocopied the pages, and faxed them to Chuck.

Because the Book-of-the-Month Club, of which QPBC was a subsidiary, was in New York, I would now need, it appeared—and Chuck agreed—an attorney in that city. But who? My literary agent suggested a big name, but also demurred a bit: was I sure I wanted to sue the Book-of-the-Month Club? They had published one of my books, *Sleeping with Soldiers,* in their Library of Erotic Classics. Then Joyce Maynard, who was currently living through the trial by fire lit by reactions to her book on Salinger, suggested Erica Jong's husband, Ken. When I emailed Erica, a longtime acquaintance and sister feminist, describing my dilemma, I quickly received a message, then a phone call, from Ken. I felt better, hearing his anger on my behalf, through the telephone line: "Those books should have been shredded!" he said. But then he went on to say that he couldn't take such a case without a large retainer (money I didn't have, since I had just spent all my available cash to put my daughter in an expensive rehab); and that the man my agent had recommended wouldn't have taken it as it was "too small." But he did know, he said, before my heart could sink again, a young attorney, Hilary Miller, who might be willing to take the case on a contingency basis.

During the next months, my blood pressure was up all the time, to the point that I was now taking medication for it. In their origi-

nal letters to Chuck, the BOMC had questioned whether I actually had been a prostitute: "Just because we published a book by her, doesn't prove anything about her previous profession," an attorney for the organization wrote. While Hilary carried on a protracted correspondence with both the BOMC and Conari Press (who weren't quite as obsequious this time; though again, William Glennon blamed someone in his office for dropping the ball by selling the rights to the BOMC without making the proper corrections—something about "plates"), I did my own research: Was Conari still selling the original edition of the book via Amazon.com? Yes. Was it still available through QPBC? Apparently, 7,000 copies had been sold before they quit—7,000 copies with words that were seared into my brain. Had anyone actually received the correction notices Conari had promised to send out? No one who I could find from a random calling. Was there anyone on the internet who had my name for whom I could have been mistaken? The Floridly-Famous Prostitute had a web page describing her services, and so did a woman named Zona Rosa in Texas, who provided similar delights, using the same name as my creative writing groups. And who did I want the correction statements to go to, once this was settled? Getting an actual mailing address for customer service for Amazon.com was possibly the most difficult; other book buyers were also apparently reluctant to withdraw a book from sale until they had that notice in their hands. But the most disconcerting experience was when a friend told me of her experience at a major book event, a dinner in which authors met with the public, in Columbia, South Carolina: Seale Ballenger—who it turned out was a he rather than a she—had been promoting *Hell's Belles*—right in the midst of the time Chuck and I were negotiating with Conari Press, right as William Glennon was reassuring us that he was retrieving all possible

copies of the book. "Yes, he knew about the lawsuit," my friend said; "But he claimed he didn't write that part—that somebody in New York did."

Eight months later, in August, 1999, Anne and I sat in the Yale Club, where I was meeting Hilary face to face for the first time. I was scheduled for a deposition that morning at the Time-Life offices of the BOMC; the attorney for Conari Press was to meet us there, too. During the past two years, I had vascillated between rage, and the feeling that someone was about to expose my darkest secrets, even while I rationally knew that I had already done that, time and time again, in print, and that I had nothing to fear. Now Hilary confirmed that during the deposition, the attorney would try to catch me off guard, to upset me. But now I felt strangely centered, ready, if possible, to get this over with.

"How do you like this headline?" a journalist asked about the piece she was writing on me for *Creative Loafing,* a Savannah alternative publication, "On Sin, Sex, and Suing." She had paraphrased the subtitle of my newly re-released memoir, *Fatal Flowers: On Sin, Sex, and Suicide in the Deep South,* which had just won the 1999 Palimpsest Prize given by Hill Street Press for a most requested out-of-print book. And I liked it just fine. My bank account was fatter, in fact, I had been able to pay off my Master Card, and my daughter's rehab bills. That day at the BOMC offices had turned out to be a series of bluffs for which Hilary was well prepared; the deposition never took place, instead we "settled," though the Conari Press attorney snarled, squinting through tiny eyes, as Anne and I left, that "it was a good thing" because he "would have kept me there all day." But his hostility did little to deflate my spirits. "I bought a book the other day—*Hell's Belles*—and it had a long glowing passage talking

about Rosemary and her work!" a friend told Anne.

Yet all was not over. At a reading and booksigning in Atlanta for a large crowd, I saw the Floridly-Famous Prostitute, broader than ever, coming though the double doors. Anne and I had bet whether she would appear—I had said no—but now she purchased books and stood in line with the rest. "I'm doing a one-woman performance in Savannah at J.R. Roberts' theater," she said, when she finally faced me at the table, "and you have to come!" "Well, I travel a lot—I may not be in town," I said, fudging. "But you have to come—you're in it!" "How am I in it?" I asked, alarms going off inside me. "There's a part about that time we were talking on the phone for so long that I was late to meet my trick, and that kept me from being arrested." she said, describing a conversation of which I had no memory. "How do you know J.R.?" I asked, changing the subject and flashing the director of a local theater who, along with his actress-wife, Anna, were personal friends; indeed, Anna had played me in *Native Voices*, a local production about Flannery O'Connor, Conrad Aiken, and myself. "Through work," she said ambiguously, and I recalled the time Zane and I had shared a limo with her to the airport in New York: how she had burbled on about coming on to the limo driver coming into the city. Before she left the bookstore, Anne overheard her talking with a man, arranging a tryst.

Back in Savannah, I wrote a letter asking that she not use my name in any of her works, and stating irrevocably that I do not favor prostitution, that while I knew some desperate women had to sink to it to survive, I considered it demeaning to women. "I thought you would be flattered!" she said over the phone two days later, pique in her voice. "But don't worry—your name will never cross my lips again!"

It had been a long two years. And I had, in the end, become

judgmental. Or had I just realized that I did have limits? But also I felt good. What had happened had been a feminist issue, an issue that had to do with women being able to speak their truths, honestly and without fear.

It is what I have spent my life doing, and I don't intend to stop, *ever*.

2000

Acknowledgments

With thanks to the staff of Hill Street Press—to Tom Payton, for your commitment and good taste; to Anne Boston, for the beauty and originality of your designs; and especially to Judy Long, who, with your woman's heart, understands this book so well. Thanks, too to Lisa Knighton for your support and interest; and to others at Hill Street for your involvement: Your high standards and your love of good writing, as well as of beautiful books, has made the creation of this one a joyful experience.